THE
Acrylic
Flower
Painter's
A to Z

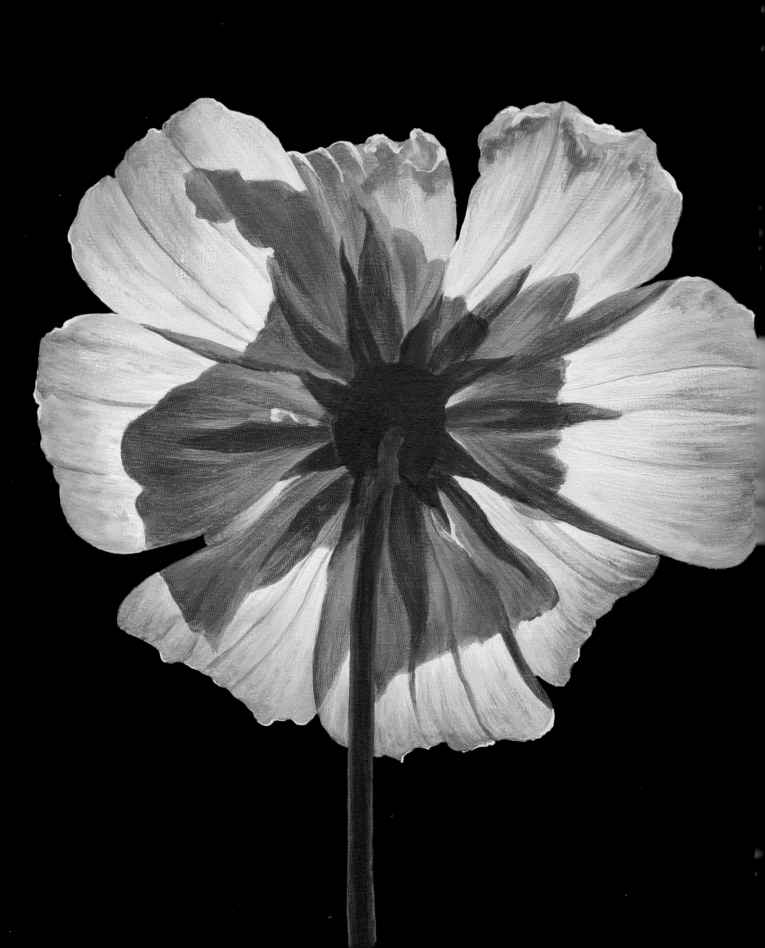

THE
Acrylic
Flower
Painter's
A to Z

An illustrated directory of techniques
for painting 40 popular flowers

LEXI
SUNDELL

Search Press

About this book

The core of this book focuses on how to paint 40 different flowers. The opening section looks at the main materials and techniques that every flower painter will need, and explores aspects of painting flowers in different ways and settings. The sample pages below provide a breakdown of the main sections to enable you to benefit from this book to the utmost.

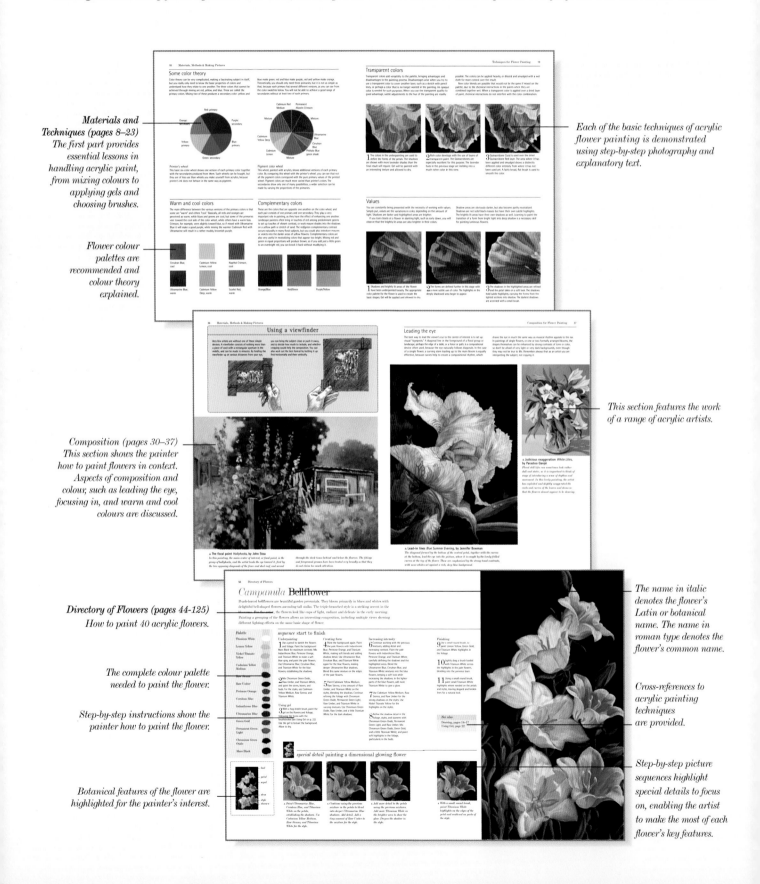

Materials and Techniques (pages 8–23) The first part provides essential lessons in handling acrylic paint, from mixing colours to applying gels and choosing brushes.

Flower colour palettes are recommended and colour theory explained.

Each of the basic techniques of acrylic flower painting is demonstrated using step-by-step photography and explanatory text.

Composition (pages 30–37) This section shows the painter how to paint flowers in context. Aspects of composition and colour, such as leading the eye, focusing in, and warm and cool colours are discussed.

This section features the work of a range of acrylic artists.

Directory of Flowers (pages 44–125) How to paint 40 acrylic flowers.

The name in italic denotes the flower's Latin or botanical name. The name in roman type denotes the flower's common name.

The complete colour palette needed to paint the flower.

Step-by-step instructions show the painter how to paint the flower.

Cross-references to acrylic painting techniques are provided.

Botanical features of the flower are highlighted for the painter's interest.

Step-by-step picture sequences highlight special details to focus on, enabling the artist to make the most of each flower's key features.

First published in 2007 by
Search Press Ltd
Wellwood
North Farm Road
Tunbridge Wells
Kent TN2 3DR
United Kingdom

This edition published in 2021

ISBN: 978-1-78221-986-6
ebook ISBN: 978-1-78126-981-7

QUAR.AFP

Conceived, edited and designed by
Quarto Publishing, an imprint of
The Quarto Group
The Old Brewery
6 Blundell Street
London N7 9BH

Project Editors **Donna Gregory**
and **Emma Poulter**
Art Editor and Designer
Jill Mumford
Managing Art Editor **Anna Plucinska**
Assistant Art Directors **Penny Cobb**
and **Caroline Guest**
Photographer **Lexi Sundell**
Picture Researcher **Claudia Tate**
Copy Editor **Diana Chambers**
Proofreader **Claire Waite Brown**
Art Director **Moira Clinch**
Publisher **Samantha Warrington**

Printed in Singapore

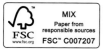

Contents

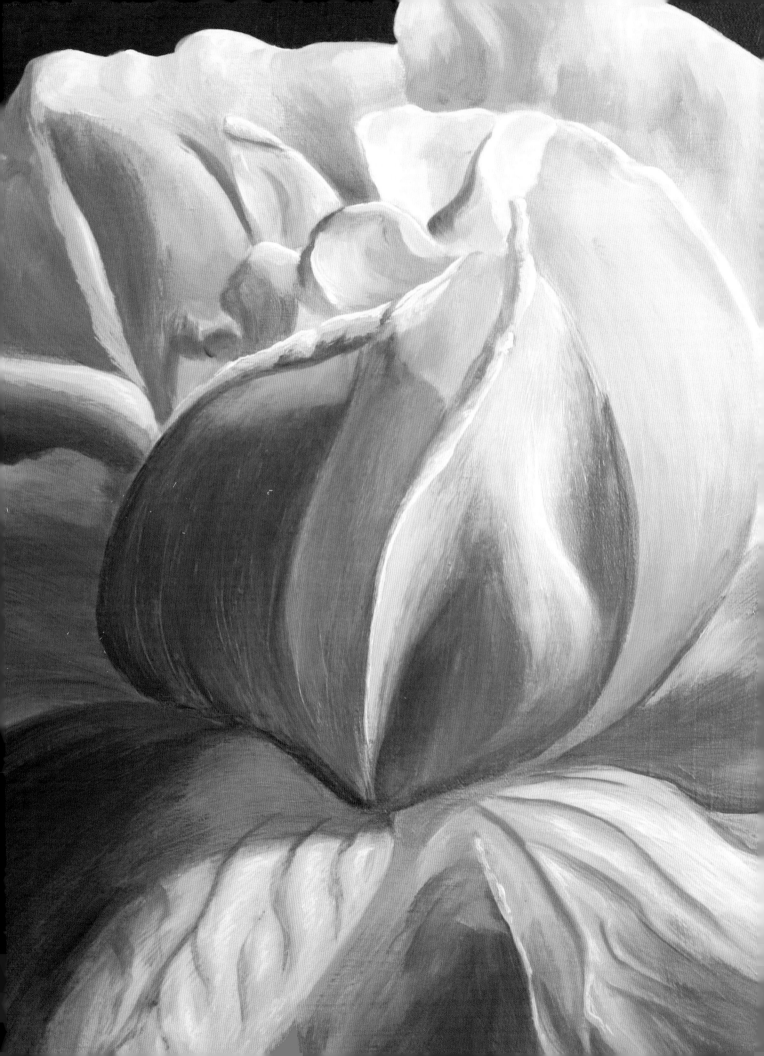

Introduction

There can be few people who do not enjoy the sight of flowers, whether growing wild in fields and hedgerows or carefully arranged indoors in vases. But for the artist they are more than just an occasional delight – they provide a superb and hugely varied subject matter, inspiring ideas for many different painterly treatments. The flowers themselves will fade and die, indeed their transitory nature is part of their charm, but the artist can capture them in the glory of their full bloom, thus immortalizing a moment in their life cycle and creating images that will never fade.

PAST AND PRESENT

Flowers have been painted in many different ways and in almost all cultures throughout the history of art, but today's artists are especially fortunate in having a far wider choice than previously – once-exotic blooms such as azaleas can now be seen in many parks and gardens, and a wealth of choice is offered by florists and even supermarkets. Those who can grow their own flowers can choose from a range of seeds and seedlings to decide which types of flowers interest them most.

◄ *The versatility of acrylics allows the artist to work from dark to light, enabling the creation of rich shadows.*

▼ *Solid areas of colour, like this black background, are hard to achieve in other painting media, and suit this colourful subject very well.*

THE MEDIUM

The great Dutch flower pieces of the seventeenth and eighteenth centuries were painted in oils, while botanical artists used watercolour, a medium still very popular with flower painters. But acrylic seems almost tailor made for the subject, because it is so versatile. You can build up a whole painting with transparent washes, much like watercolour; you can paint thin glazes over thicker applications to produce lovely translucent effects and you can work either from dark to light or vice versa, which is not possible with watercolor. Acrylic is also a forgiving medium, allowing you to make corrections by overpainting, but hopefully, this book will give you the confidence to use the medium to best advantage, so you can succeed without the necessity for correcting.

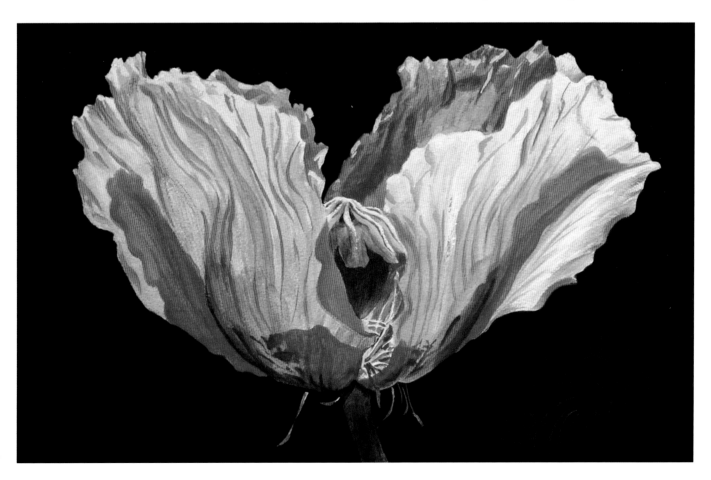

Materials, Methods & Making Pictures

This section lists and illustrates the equipment required to make a start with acrylic flower painting, gives valuable advice on the use of colour, and demonstrates the techniques you need to master, before going on to explore the art of picture making.

Materials
for flower painting

These pages offer advice on choosing paints, brushes and mediums, as well as preparing surfaces. Unlike other painting media, acrylic can be used on both paper and canvas of various types, so you will need to experiment to discover which surface suits your way of working.

Types of canvas

Canvas is usually made from cotton or linen, the latter being more expensive. Both come in a variety of weights and textures.
You can also buy canvas boards, some of which have a simulated texture, while others have light canvas stuck onto a rigid surface.

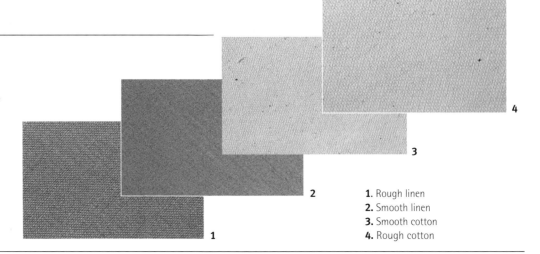

1. Rough linen
2. Smooth linen
3. Smooth cotton
4. Rough cotton

Stretching canvas

Stretching your own canvas is not only economical – it also allows you to prepare the canvas in accordance with your own specifications. Canvas is stretched over a frame made from mitred wooden stretcher bars, available from art shops in a range of lengths, widths and profiles – only stretcher bars of the same width and profile will fit together.

1 Assemble the stretcher and check that it is square by measuring diagonally from corner to corner: if the measurements are the same, the frame is square.

2 Cut the canvas so that it is about 50 mm (2 in.) larger than the stretcher frame. Pull the canvas overlap up the sides and over onto the back of the stretcher frame. Secure at even 50 mm (2 in.) intervals with staples.

3 Working one corner at a time, pull the corner of the canvas tightly across the back of the stretcher towards the centre. Fold one of the canvas wings in and over. Secure the fold to the stretcher frame using a single staple.

Types of paper

The best papers for acrylic painting are those made for watercolor. These are produced in different textures: Rough, Cold-pressed (also known as Not) and Hot-pressed (or Smooth). Unless very heavy paper is used it should be stretched before use, otherwise it will buckle when wet paint is applied.

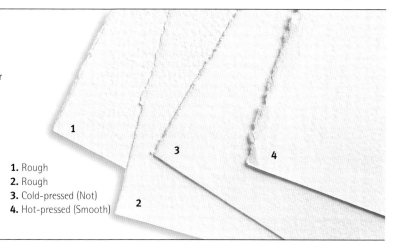

1. Rough
2. Rough
3. Cold-pressed (Not)
4. Hot-pressed (Smooth)

Stretching paper

When wetted, paper fibres absorb moisture like a sponge and swell, causing the paper to buckle. When the fibres dry, they shrink again – but not always to the original size – and the buckling can persist. Stretching the paper helps to solve this problem by ensuring that the sheet dries flat each time it is wetted.

1 Cut the paper to 2.5 cm (1 in.) smaller all around than the board, and place it centrally on the board.

2 Hold the paper lightly by one corner and sponge all over it with clean water.

3 Cut pieces of gumstrip to size, moisten them one at a time and stick them down along each edge.

Paints

With acrylics, you can paint in any consistency you like, which gives these paints what is perhaps their greatest virtue: versatility. You can use them in thin washes resembling watercolour, or apply colours with a knife in thick slabs. You can use thick paint in one part of a picture and thin in another; build up an infinite variety of textures; and also employ traditional oil-painting methods such as glazing. 'Flow-formula' indicates that a paint will be slightly runnier than some other paints, while 'full-bodied' paints will be thicker, and more suitable for oil-painterly effects.

Gel textures

Gels come in various viscosities, and are useful for creating numerous effects in a painting.

Coarse, stiff gels create harsh textures that do not lend themselves to the tactile qualities of flowers. Soft and medium gels are more compatible with the look and feel of flowers. Soft gels are used to create smooth textures or soft blends. Medium gels hold a firmer texture and can add textural richness to the petal surface.

Gels are not transparent before they have dried. They are quite unpleasant if they are disturbed when partly dry, so they should be allowed to dry before another layer is painted.

Brushes

To a large extent your choice of brushes will be dictated by the way you work – whether you apply the paint thickly or build up in thin layers. For thick applications, the bristle brushes made for oil painting are the best choice; while for watercolour styles and thin glazes you would use soft watercolour brushes. However, it is best to use the synthetic version of these, because sables could be spoiled by constant immersion in water.

Probably the best all-round brushes are those that are made specifically for acrylic work, which combine the characteristics of both oil and watercolour brushes and can be used for medium to thick applications.

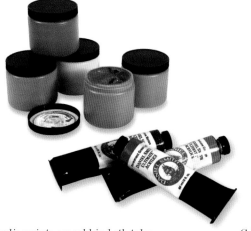

Acrylic paints are sold in both tubes and pots. Typically, the paint in the tubes is rather thicker.

Gel is available in pots and tubes.

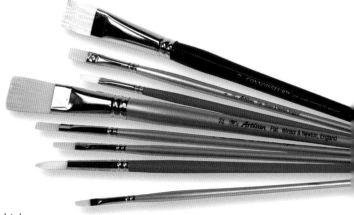

Acrylic brushes can be found in various shapes and sizes.

Palettes

Palettes for acrylic work must be of a non-porous material such as plastic or glass, so don't try using the wooden palettes made for oil painting. Artists who work on a large scale often use sheets of glass, which can be easily cleaned, but if you do this, use heavy glass and tape the edges to prevent cuts. Pieces of laminated board can also be used, but they will become stained.

To prevent the paint from drying out, spray with water at regular intervals, or use one of the special palettes designed for acrylic paint. Alternatively, you can make your own palette.

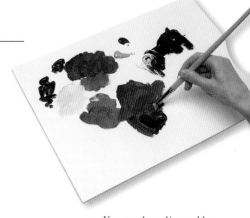

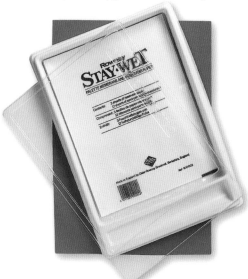

◄ *Stay-wet palettes have been developed especially for acrylic paint, and can keep the paint wet for several days, or even weeks. The paint is laid out on the top sheet, and enough water seeps up to keep it moist. You can make your own stay-wet palette as shown below.*

▲ *You can buy disposable paper palettes, which you simply throw away after use, or you can use an old telephone directory, removing each sheet when it has become filled with paint.*

◄ *Almost anything can be used as a palette – glass jars, large ceramic tiles, old plates and so on – and the paint can be covered with cling film to keep it moist when not in use.*

Making a stay-wet palette

You will need a plastic or metal tray, a piece of capillary matting (as used by gardeners to keep seed trays moist) and same-sized pieces of drawing paper and thin tracing paper or greaseproof paper. You won't be able to make a lid, but you can use cling film instead.

1 Soak the capillary matting and place the drawing paper on top. An alternative is to use blotting paper instead of capillary matting, in which case you don't need the drawing paper.

2 Carefully place the tracing paper or greaseproof paper on top, and you have your palette.

Arranging a palette

Artists vary in the way they arrange their palettes, but it is important to leave some space around the white so that it does not become sullied by other colours. Colours will vary according to the palette needed for the chosen subject.

◄ *Here the paints have been placed around the outside edge of the paper, with colours that will be mixed together adjacent to each other, where possible.*

◄ *In this example the artist has mixed colours directly on the palette.*

Flower colours

Painting flowers requires a larger palette than many other subjects, and although you can make a start with the basic starter palette shown below, you will soon need to add to it. The colours shown here are all those used in the Directory of Flowers, later on in the book.

Palette

Titanium White

Lemon Yellow

Nickel Titanate Yellow

Nickel Azo Yellow

Cadmium Yellow Medium

Cadmium Yellow Light

Iridescent Antique Gold

Yellow Ochre

Raw Sienna

Raw Umber

Perinone Orange

Cadmium Orange

Quinacridone Coral

Anthraquinoid Red

Alizarin Crimson

Permanent Red

Cadmium Red Medium

Cadmium Red Deep

Quinacridone Magenta

Permanent Carmine

Quinacridone Pink

Quinacridone Red

Quinacridone Violet

Ultramarine Violet

Carbazole Violet

Perylene Maroon

Cerulean Blue

Indanthrone Blue

Ultramarine Blue

Rich Green Gold

Green Gold

Permanent Green Light

Permanent Green

Chromium Green Oxide

Mars Black

Basic palette

If you are new to acrylic flower painting it is helpful to start with a small range of colours such as the one shown here, as this will teach you a lot about colour mixing and its limitations. For example, if you find you can't achieve a true purple or mauve with these colours, you will need to invest in a ready-mixed one (see page 18 for more about mixing secondary colours).

Basic palette

Titanium White

Cadmium Yellow Medium

Yellow Ochre

Raw Umber

Perinone Orange

Permanent Red

Ultramarine Blue

Green Gold

Chromium Oxide Green

Mars Black

Techniques
for flower painting

You do not need to be a botanist to paint flowers, but understanding their basic structures is a must. This section focuses on sketching the flower, encouraging the artist to look at flowers as a loose analogy of geometrical shapes, and explores various techniques to enable the artist to depict the subject successfully.

Drawing

Many flower-heads can be simplified into a basic circle. When a circle is seen in perspective, turned away from you, it becomes an ellipse. Practise drawing ellipses, because they are the magic formulae for solving a number of problems that beset the beginner. Hold a saucer up and look at it face-on, imagine it is a daisy and turn it slowly on its axis so that it is flat. Just for fun, as it is a loose analogy, lightly draw the saucer on three or four different planes, then put it down and turn its shape into a flower – a simple daisy.

Think about what happens when the basic shape is broken. For example, if your daisy had a limp petal hanging down on one side and you pushed it back into place, it would fit back into the ellipse; it would not have become longer or thinner, though it might look that way. Perspective and foreshortening need to be observed carefully, and the various angles can be worked out in a separate drawing with guidelines made obvious.

More complex flowers, where the basic shape is

not obvious, require more acute observation, but the principles are the same. If you do not understand how or why a shape is as it is, take the flower apart very gently and slowly, and see how it is put together. Look at the different stages and see whether an older flower has the start of a seed pod developing. This sounds obvious, but for a spray on a single stem you will need to show the progression from the wide open flower at the bottom to the bud at the top.

Grid method

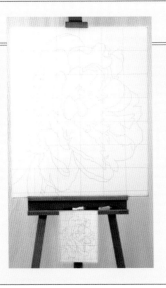

A simple method used for centuries to transfer a working sketch to the canvas is the grid method. Once the sketch is prepared for the painting, the grids are added both to the sketch and to the canvas.

1 Look at the level of detail in the sketch and consider how many squares across the canvas it would take to make it easy to transfer. In this example, six squares across the canvas make a reasonable number. Divide the width of the canvas by six to determine the size of the squares needed. Draw the grid on the canvas.

2 Divide the width of the sketch by six to find the measurement for the squares on the sketch paper. Grid the sketch with squares of the size calculated.

3 The drawing can now be transferred by looking at the lines in each square and drawing them in the equivalent square on the canvas. Numbering the grid lines will help if there are many squares.

Bell-shaped

Flowers of this type follow the three-dimensional shape of a bell; the stem supports the flower from the centre top, the petals fall around the axis of the stamen, which corresponds to the clapper. The shadow is deep on the inside, and there may be a curve to the back, inner edge.

Trumpet-shaped

A lily, with its stamens protruding out like symbols of noise, makes an obvious trumpet. Many other tubular flowers start as a conical shape, then the petals flare into the familiar trumpet shape. Make sure that the petals curve into a centre point, even when they disappear into shade.

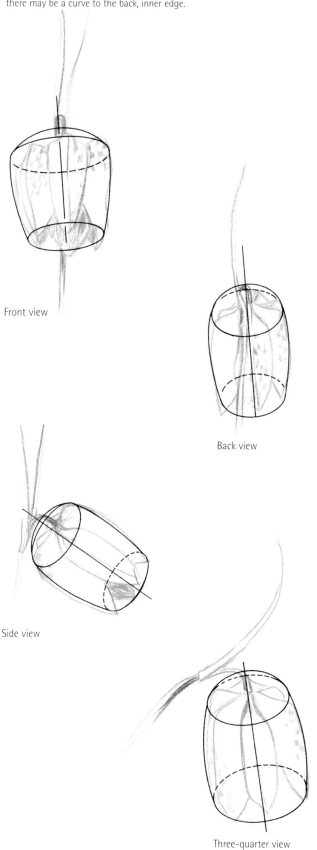

Front view

Back view

Side view

Three-quarter view

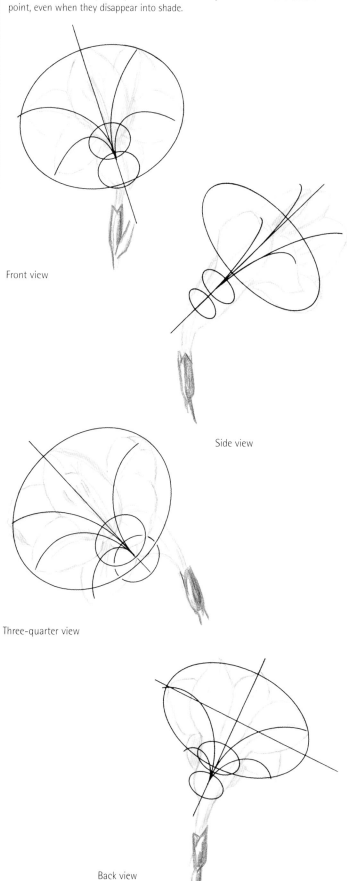

Front view

Side view

Three-quarter view

Back view

Multi-headed

Look for the overall shape of the whole cluster of flowers, a ball, a cone or something more irregular. Work out the planes of each individual flower and pay most attention to the detail of the nearest ones to you, leaving the ones away from the light source to dissolve in shadow.

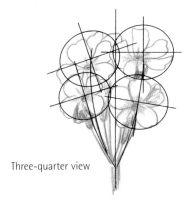

Three-quarter view

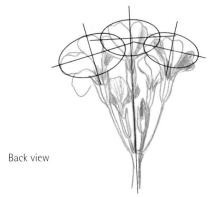

Back view

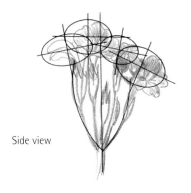

Side view

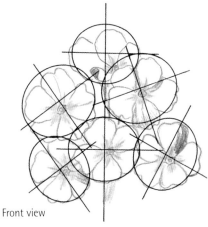

Front view

Spike-shaped

Even quite large flowered spikes, such as gladioli, can form an overall cone, so treat them as one shape. Note the central line of the stem and how the flowers surround it. Tackle the shading as a whole. For any close-ups, let the brushwork indicate the individual flowers rather than painting in each one.

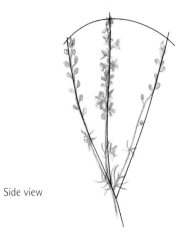

Side view

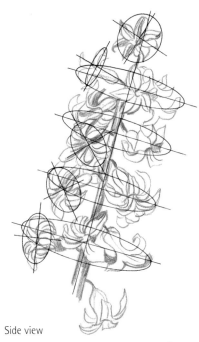

Side view

Side view

Rays and pompoms

In these flowers, the petals radiate out from the central point, and everything joins the stem in the middle. Turning a flat gerbera or daisy reveals ellipses, and when seen from the side, all the petals are equidistant and form rounds. The centre sometimes forms a dome or pompom.

Three-quarter view

Side view

Back view

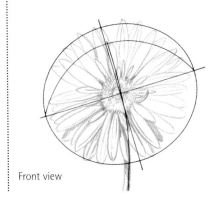

Front view

Star-shaped
Simple star shapes usually have a very distinctive clear centre, sometimes with a burst of stamens or a pinpoint of meeting petals. There may be a bulge or perhaps even a thin tube of petals where the stem joins the back. There are a few tonal variations to the open, flat petals.

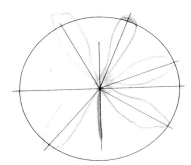

Front view

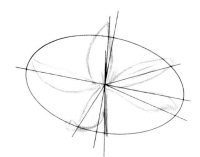

Three-quarter view

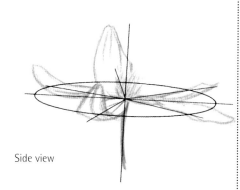

Side view

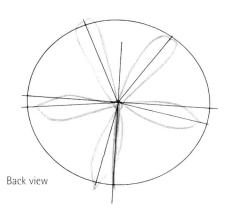

Back view

Lipped and bearded
A line drawn from top to bottom, through the wide petal, reveals that each side of these flowers is a mirror image of the other, giving you a basis for rationalizing their shape. The petals may have tricky overlaps or curves, so use the shadows to make sense of them in your painting.

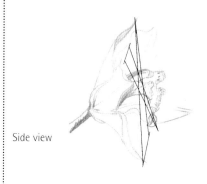

Side view

Front view

Three-quarter view

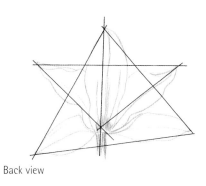

Back view

Cup-and-bowl-shaped
Buttercups are the simplest shapes in this category, all of which have a gentle curve of petals that forms a circle when looked at face-on. The buds tend to be rounded, and the fully open flowers are more bowl-shaped. Gradual shading allows the artist to curve the petals into deep shadows.

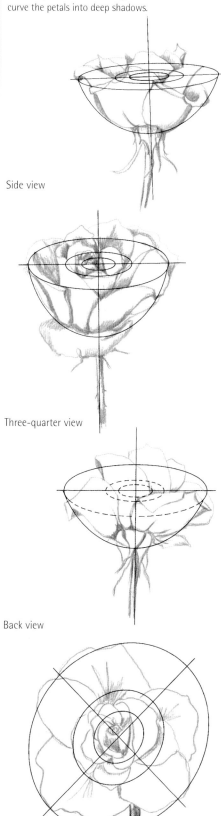

Side view

Three-quarter view

Back view

Front view

Some colour theory

Colour theory can be very complicated, making a fascinating subject in itself, but you really only need to know the basic properties of colours and understand how they relate to one another. The three colours that cannot be achieved through mixing are red, yellow and blue. These are called the primary colours. Mixing two of these produces a secondary colour: yellow and blue make green; red and blue make purple; red and yellow make orange. Theoretically, you should only need three primaries, but it is not as simple as that, because each primary has several different versions, as you can see from the colour swatches below. You will not be able to achieve a good range of secondaries without at least two of each primary.

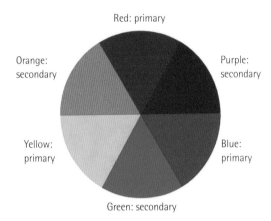

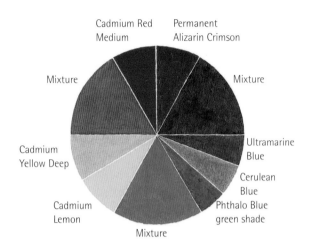

Printer's wheel

This basic six-colour wheel shows one version of each primary colour together with the secondaries produced from them. Such wheels can be bought, but they are of less use than wheels you make yourself from acrylics, because printer's ink does not behave in the same way as pigment.

Pigment colour wheel

This wheel, painted with acrylics, shows additional versions of each primary colour. By comparing this wheel with the printer's wheel, you can see that not all the pigment colours correspond with the pure primary values of the printed wheel. Pigment colours are much more varied than printer's colours. The secondaries show only one of many possibilities; a wider selection can be made by varying the proportions of the primaries.

Warm and cool colours

The main difference between the various versions of the primary colours is that some are 'warm' and others 'cool'. Reds and oranges are perceived as warm, while blues and greens are cool, but some of the primaries veer towards the cool side of the colour wheel, while others have a warm bias. Crimson, for example, veers slightly towards blue, so if mixed with Ultramarine Blue it will make a good purple, while mixing the warmer Cadmium Red with Ultramarine will result in a muddy brownish purple.

Complementary colours

These are the colours that are opposite one another on the colour wheel, and each pair consists of one primary and one secondary. They play a very important role in painting, as they have the effect of enhancing one another. Landscape painters often bring in touches of red among predominant greens to set up touches of vibrant contrast, or work mauve shades into the shadows on a yellow path or stretch of sand. The red/green complementary contrast occurs naturally in many floral subjects, but you could also introduce mauves or violets into the darker areas of yellow flowers. Complementary colours are also very useful in neutralizing colours that appear too bright. Mixing red and green in equal proportions will produce brown, so if you add just a little green to an overbright red, you can knock it back without muddying it.

Cerulean Blue, cool

Cadmium Yellow Lemon, cool

Napthol Crimson, cool

Ultramarine Blue, warm

Cadmium Yellow Deep, warm

Scarlet Red, warm

Orange/Blue

Red/Green

Purple/Yellow

Transparent colours

Transparent colours add versatility to the palette, bringing advantages and disadvantages to the painting process. Disadvantages arise when you try to use a transparent colour to cover another layer, such as a sketch with pencil lines, or perhaps a colour that is no longer wanted in the painting. An opaque colour is needed for such purposes. When you use the transparent quality to good advantage, subtle adjustments to the hue of the painting are readily possible. The colours can be applied heavily, or diluted and smudged with a wet cloth for more control over the result.

New colour blends are possible that would not be the same if mixed on the palette, due to the chemical interactions in the paints when they are combined together wet. When a transparent colour is applied over a dried layer of paint, chemical interactions do not interfere with the colour combination.

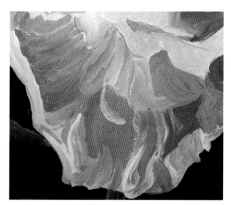 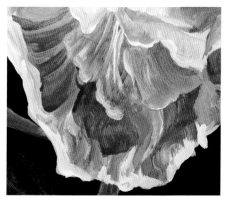 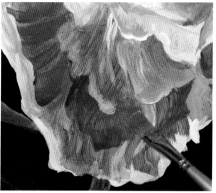

1 The colours in the underpainting are used to define the forms of the petals. The shadows are shown with more lavender shades than the final result will require. Gel will be painted with an interesting texture and allowed to dry.

2 Rich colour develops with the use of layers of transparent paint. The Quinacridones are especially excellent for this purpose. The lavender hues in the previous stage are melding into a much richer colour in this view.

3 Quinacridone Coral is used over the dried Quinacridone Red layer. The area where it has been applied and smudged shows a distinctly different colour intensity from where it has not been used yet. A fairly broad, flat brush is used to smooth the colour.

Values

You are constantly being presented with the necessity of working with values. Simply put, values are the variations in colour, depending on the amount of light. Shadows are darker and highlighted areas are brighter.

If you look closely at a flower in slanting light, such as early dawn, you will observe that the brightly lit areas are also brighter in their colours.

Shadow areas are obviously darker, but also become partly neutralized. Shadows are not solid black masses but have their own subtle highlights. The brightly lit areas have their own shadows as well. Learning to paint the transition of a form from bright light into deep shadow is a necessary skill for painting luminous flowers.

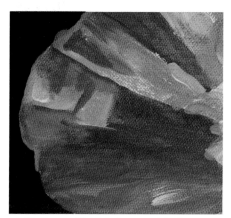 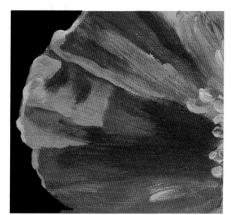 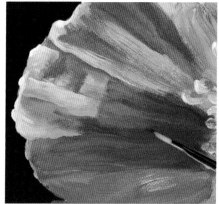

1 Shadows and brightly lit areas of the flower have been underpainted loosely. The appropriate colour palette for the flower is used to create the basic shapes. Gel will be applied and allowed to dry.

2 The forms are defined further in this stage with a more subtle use of colour. The highlights in the deeply shadowed area begin to appear.

3 The shadows in the highlighted areas are refined and the petal takes on a soft look. The shadows hold subtle highlights, carrying the forms from the lighted sections into shadow. The darkest shadows are accented with a small brush.

Lighting and posing flowers

If you intend to work from photographs, you will need to pay as much attention to the photography as you do to the painting, treating it as the first stage of planning the composition. If working outdoors, you will need enough sunlight to cast shadows that bring out the shapes and forms of the petals, but avoid too harsh a light, such as that at midday, when the sun is directly overhead. Look at the flower from various angles, so that you can try out different compositions, and try to ignore the background as far as possible by throwing it out of focus. Digital cameras are very helpful, because you can take as many pictures as you want, download them and discard any that don't serve your purpose. Also, if you have suitable software, you can paint out backgrounds and make other adjustments. But bear in mind that digital cameras may need supporting on a tripod for close-up work, because they are prone to 'camera shake'.

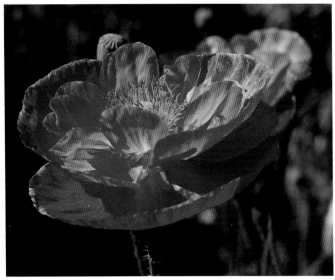

1 It is best to pose flowers outdoors in dawn light, ignoring the background and concentrating on the flower itself. This flower has lovely shadows and luminosity, but lacks a focal point of interest, so it would be a poor choice for a painting in this view.

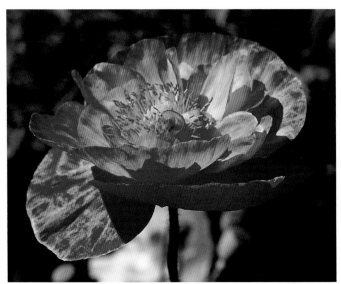

2 After rotating the flower and tilting it slightly, a better look is achieved. The overall shape is more interesting, but some of the shadows are too abrupt. This view also lacks a focal point, although it is better than the first photograph.

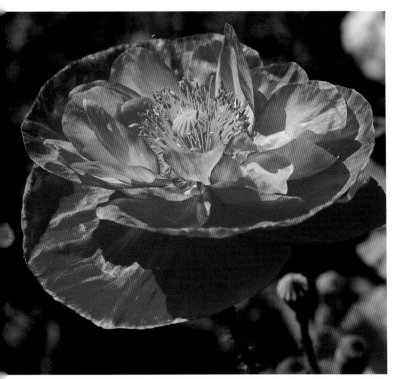

3 After rotating the flower further, a view is found that has a good shape, well-arranged shadows, good luminosity and a focal point of interest in the centre of the flower. This view could be used to create an attractive painting.

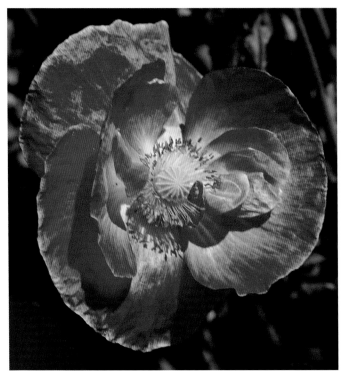

4 This view shows a flower directly facing the artist, which can be used to create an entirely different composition. The shadows add interest to this view without being overpowering. This could also be used for a good painting.

Painting light on dark

Painting light colours over dark ones creates interesting contrasts, and, conversely, so does painting dark colours over light ones. These two techniques are often used in conjunction with each other to develop richness in texture and tone in a painting.

When working with multiple layers of paint, the result can be a visually arresting treatment of the petals. The artist learns to recognize that deeply textured petals offer great possibilities for these techniques.

In the sequence below, adding another layer of gel texture further emphasizes the contrasts in the layers of paint. The medium gel is painted with a coarse brush and creates a different texture from the original gel layer.

The new gel surface allows a brush dragged across it to add a new pattern of lights or darks to the previous layers of paint. The rich interplay between light and dark colours can be used to paint luxuriously textured petals.

1 Relatively dark greys are used for the underpainting. The lighter areas are indicated, but still kept quite muted. This establishes a dark background onto which light colours can be added.

2 A layer of gel is painted onto the canvas and the strokes of the coarse brush carefully follow the forms of the petals. After the gel has dried, light colours are painted across the petals, allowing some of the original dark layer to show.

3 More emphatic dark colours are painted over the light colours. The dark colours start to assert the form of the flower. The texture of the gel is used again to catch colour from the brush, which is gently dragged across the surface.

4 A second layer of gel is applied with a coarse hog-bristle brush, again following the forms of the petals. The gel still appears milky and white as it starts to dry to its usual transparency.

5 After the gel has dried, another layer of light colours is painted over the dark ones that were applied in step 3. This texture allows the paint to create contrasting patterns with the previous layers.

6 This close-up view shows the richness of colour and texture that can be achieved with a simple palette. The light and dark colours have combined to form flower petals with great visual appeal.

Using gel

Medium gel can be used to create detail in paintings. Striated or grooved petals can be enhanced with a textured layer of gel. Other features in a flower can also be similarly enhanced.

The gel must be applied carefully so that the texture itself resembles the surface of the petal or other form. After the gel has dried and been coated with more paint, the texture can be used to catch contrasting colours from a brush dragged lightly across it.

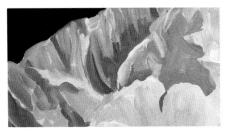

1 The petals in this flower are deeply striated, but the first layer of paint merely establishes the shadows and broader colour areas.

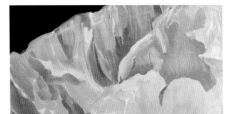

2 Notice the distinct striations or heavier streaks in the medium gel that has been applied to the canvas. They follow the forms of the petals and will greatly enhance the texture of the petals in the finished painting.

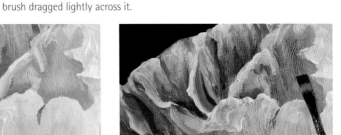

3 Several more layers of paint have been added to the petals. Observe the way the gel has helped to create the noticeable texture in the petals.

Painting with a coarse brush

Flowers often have deeply grooved or striated petals that can be painted effectively with a coarse brush. Since the bristles are more distinct and separate, the paint is applied with a wholly different effect from that achieved with a smooth brush.

When gel is applied with a coarse brush, the effect is magnified when paint is applied later with a coarse brush as well. Experimentation will show how to best use these effects.

Learning to manipulate the brushes and materials effortlessly will allow you to focus on the image instead of struggling with technique.

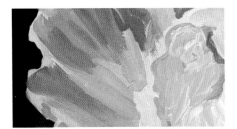

1 The petals in this section of the flower have a heavily striated and textured appearance that lends itself to being painted with a coarse brush. At first, the main shadows and highlighted areas are painted loosely.

2 The gel has been painted with a coarse brush. It has a milky and streaky look, which will dry transparent. When dry, the gel texture will take paint in a way that will enhance the look of the petals.

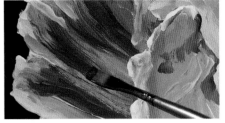

3 A hog-bristle brush works well for dragging across the gel texture, increasing the striated look of the petals. The photograph, however, shows an old brush being used. The bristles have clumped together and paint a nice pattern on the canvas.

Painting with an old brush

Old brushes have many uses in painting when they are no longer good for their original purposes. If you are ready for a challenge, these brushes present new opportunities in painting.

Flat brushes may develop a clumping of bristles, which can be helpful when painting areas that show more character when painted with a coarse brush.

Round brushes sometimes develop a horrible splayed tip, which makes them useless for carefully controlled lines. The scattered tips of these brushes can be dipped in paint and used to create a stippling effect. Tapping the splayed tip on the canvas creates many small irregular splats that can be beautiful when used well.

1 The shadows and highlighted areas are well established in this painting. The background is painted black to avoid distractions. The painting will be coated with the appropriate gel texture to prepare for the next stage.

2 The painting has now progressed to the point where the highlights characteristic of this petal area need to be painted. An old round brush with a badly splayed tip is lightly dipped in white paint and used to stipple the textured highlights.

3 The same brush is cleaned and then dipped in the darker shadow mixture. The stippling of the darker colours increases the textural look and adds even more sparkle to the petal.

Painting with a smooth brush

Flat Taklon brushes have even and smooth bristles, making them an excellent choice for creating softly graduated blends. Keeping a variety of sizes on hand gives great flexibility when painting.

The appropriate brush can be chosen for any area of the painting. While a narrow or finely pointed brush is desirable for painting fine detail, the opposite is true for wide, soft blends of colour. A broader brush gives a smoother look to the paint. Smudging with a damp cloth or fingers are techniques that combine well with using smooth brushes.

1 The main blocks of colour have been loosely applied with broad smooth brushes. Shadow areas and the background are established. The soft look of this petal area already begins to show.

2 Gel is applied with another smooth flat brush, taking care to keep the texture on the petal smooth. The background gets a stronger and rougher texture. The gel looks milky here because it has not yet dried to its transparent state.

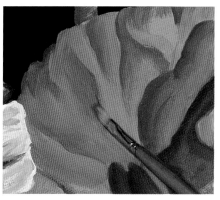

3 Different sizes of smooth flat brushes are being used to paint the petal. In the photograph, a small brush is shown being rotated as it is dragged across the canvas to create a graduated shadow.

Painting with a small round brush

A comfortable supply of properly chosen brushes is essential. Knowing the right brush for the desired effect becomes effortless, allowing you to concentrate on the qualities of the flower instead of the technique itself.

Round brushes are useful for the more precisely delineated portions of the flower. As a general rule, the smaller and more precise the area being painted, the smaller and more precise the brush should be. Small round brushes are particularly useful for painting the final highlights in a painting.

1 The painting is shown with the first underpainting completed. The general shapes and placement of the forms with their shadows is loosely indicated.

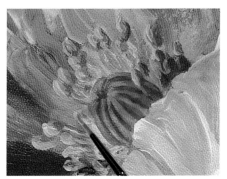

2 Gel has been applied and allowed to dry. Rich colour is created with the use of layers of paint. As the forms are being developed in this stage, a round brush becomes the brush of choice for painting the stamens.

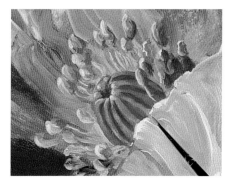

3 The smaller, irregular highlights in pure Titanium White are applied with a small round brush, which allows great control over the final appearance of the highlights.

Painting a Flower
The complete process

Palette

Titanium White

Lemon Yellow

Yellow Ochre

Raw Umber

Perinone Orange

Quinacridone Magenta

Quinacridone Violet

Carbazole Violet

Perylene Maroon

Indanthrone Blue

Green Gold

Chromium Green Oxide

Peonies, with their brilliant colours, large heads and curving, fleshy petals, make a wonderful subject for close-up treatment. The petals are defined first, by painting the main blocks of dark and light, and details are added last.

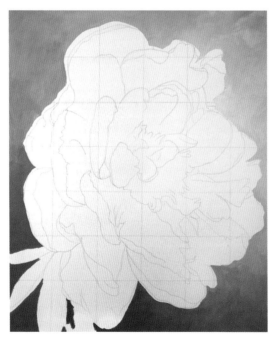

1 After priming the canvas and sketching the grid pattern, paint the background. Use Perinone Orange mixed with Carbazole Violet and varying amounts of Titanium White to make graduated greys. This mixture is opaque and easily covers the pencil lines.

2 Paint deep shadows in the petals with Quinacridone Violet. Use Quinacridone Magenta and Titanium White for brighter pinks. The Quinacridones are transparent colours, so painting the sketch with a thin coating of white before using the colours helps to hide the pencil lines.

Paint the shadows in the petals first to establish the form of the petal. Use the lighter mixtures to paint into the shadows to finish shaping the petal.

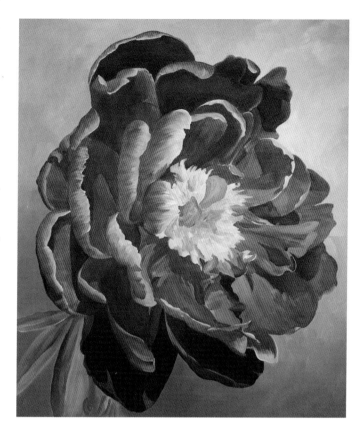 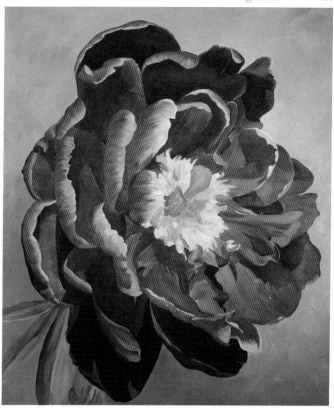

3 Mix Chromium Green Oxide, Raw Umber and Titanium White in varying mixtures to paint the leaves. Mix Lemon Yellow and Yellow Ochre for the centre stamens. Paint gel fairly smoothly on the petals, and more textured on the background. Allow to dry

4 Repaint the background over the newly created texture. Mix Indanthrone Blue and Raw Umber with the Carbazole Violet, Perinone Orange and Titanium White mixtures to give a slight bluish tint to the background. Make the lower left corner of the background the darkest part.

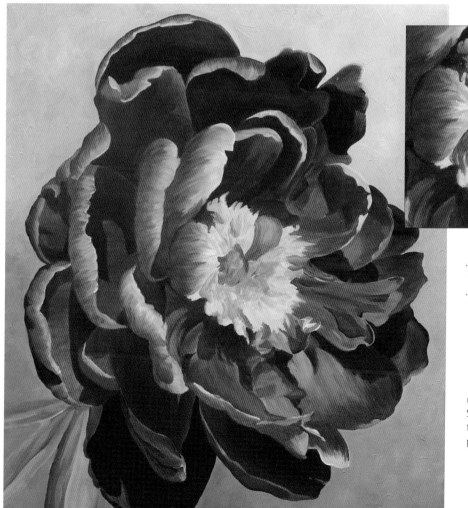

To paint the shadows in the centre, turn the flat brush sideways and use the edge for the radiating lines of shadows. Turning the brush from flat to sideways creates a stroke tapering to a narrow point.

5 Paint the petals with Quinacridone Magenta. Use the transparency of the paint to adjust the mid-tones of the petals to a brighter magenta. Smudge with a damp cloth or your finger to blend the transitions. Paint the background again, using paint layers for rich colour.

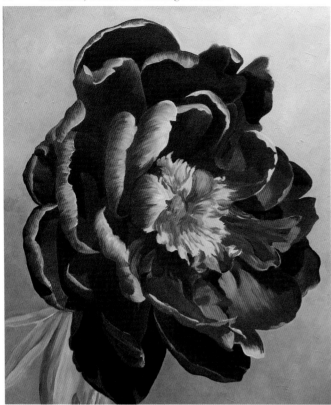

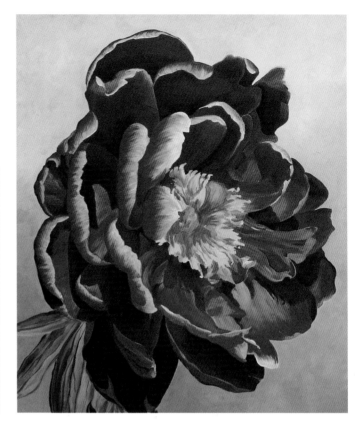

6 Paint Quinacridone Violet into the deep shadows. Add Quinacridone Magenta where needed for the brighter shadow areas. Velvety shadows create dimension and depth in the flower. Mix Yellow Ochre and Perinone Orange to establish shadows in the stamens.

7 Use the transparent Quinacridone Magenta to create a bright magenta glow in the flower, lightly smudging it across the petals. Add Titanium White for the lightest areas. Add Green Gold to the previous green mixture and paint the shadows. Use this mixture to paint the veins in the leaves also. Add the stem.

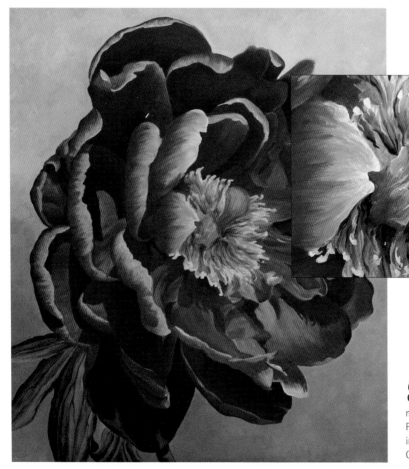

Use a small round brush to paint the more delicate Titanium White accents, both in the petals and in the stamens. This permits careful control of the final highlights, which really bring a painting to life.

8 Continue refining the leaves. Add Perylene Maroon to the stamen mixtures and add more detail to the shadows in the stamens. Place deep shadows in the centre area. Break into the outer edges of the stamen centre with Quinacridone Magenta and Violet as needed.

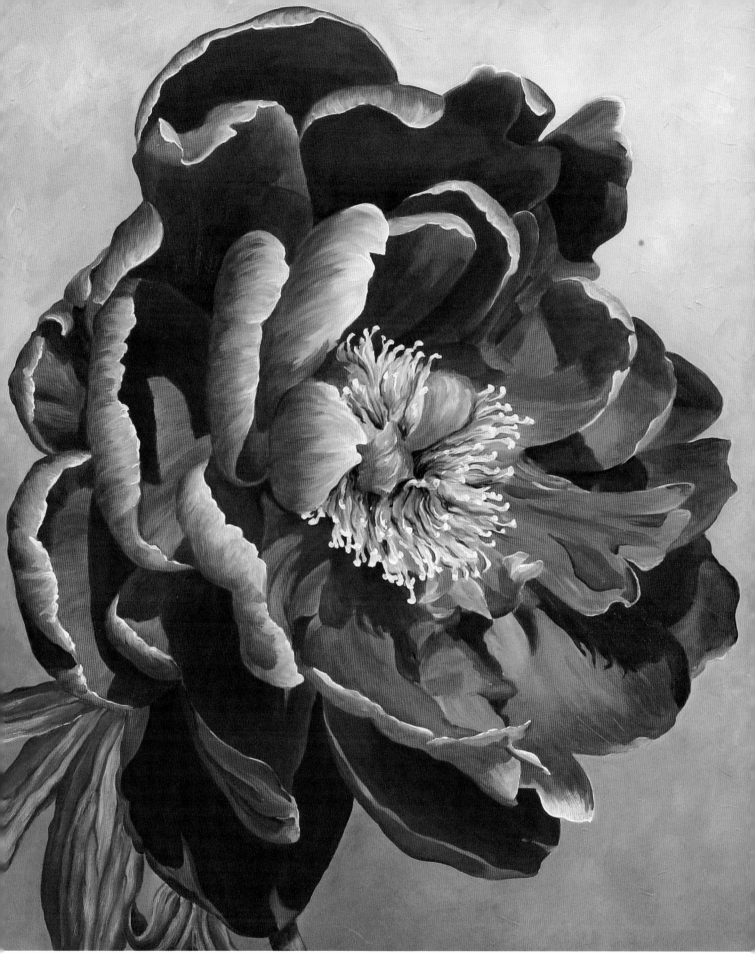

9 Mix Titanium White and a little Green Gold for leaf highlights. Use Quinacridone Magenta and Titanium White hightlights for the petals, followed by pure Titanium White accents. Combine Raw Umber and Perinone Orange for the darkest shadows in the stamens. Add Titanium White highlights to the stamens.

Exploring backgrounds

When planning a painting, it is helpful to consider what background treatment will enhance the flower. Dark backgrounds emphasize highlights and create maximum contrast for a dramatic effect. A lighter background will soften the contrast of a painting, but care must be taken so that the highlights on the petals are not lost.

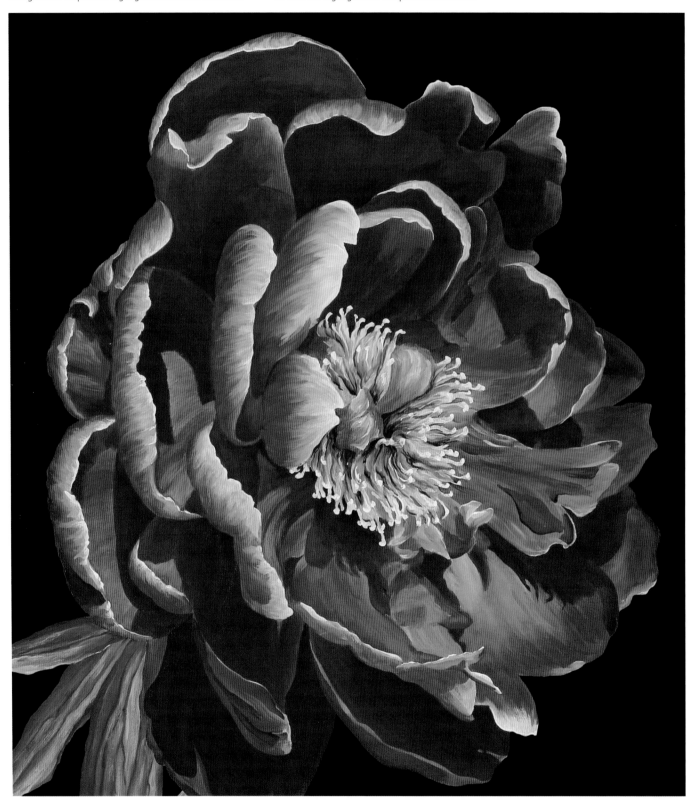

Fortunately, acrylics have none of the bleed-through effect characteristic of oils, so drastic colour changes are easily accomplished when desired. The peony shown here is particularly bold against the black background.

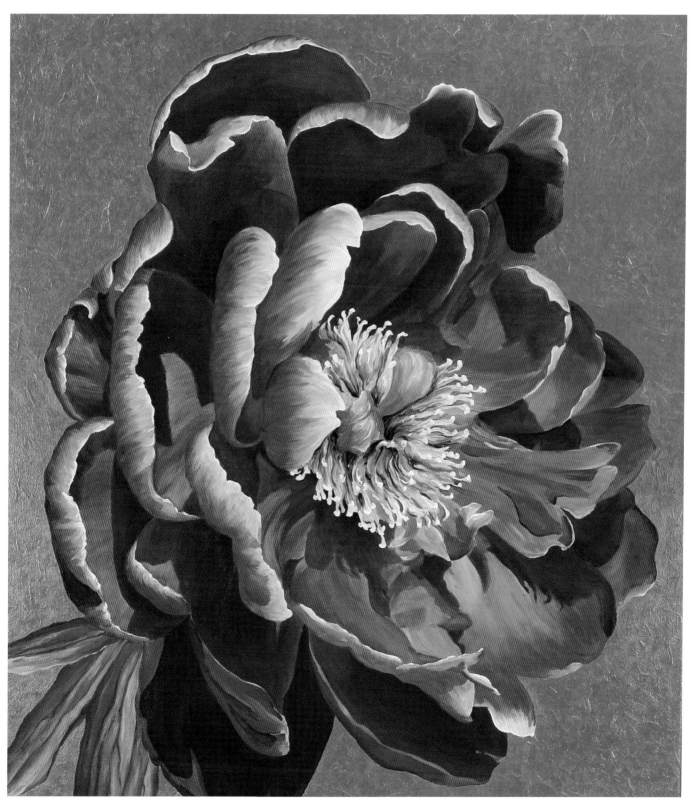

In this example, the same painting has had the background redone in a textured metallic gold for a wholly different effect. As an acrylic artist you have the freedom to change colours at any time that you decide it would be an improvement to do so.

Composition
for flower painting

Once you have mastered the medium of acrylic, explored the many different ways of working with this wonderfully versatile medium and practised painting flowers, you will need to think about the actual pictures you intend to make. Technical skills are vitally important, but they are only a means to an end – there is a language that has to be learned in order to express your own ideas about your chosen subject.

Format and composition

The first step in composing the picture is to decide on the format – vertical or horizontal rectangles are the usual choices, but some flower subjects might suit a squarer shape. If you are working from a photograph, try masking it in various ways to decide which shape works best. Then consider how you will place the subject on the page and how the shapes will relate to the outer edges of the canvas or paper. This is important, because too much space will isolate the subject, while too little will make it appear cramped. Don't forget you can crop, letting part of the flowers or leaves go out of the picture at various points.

Having made the first decision, consider how you will distribute the various elements. For a painting to succeed fully it must be composed in such a way that it presents a balanced and harmonious whole, with no jarring notes, but with areas of interest throughout the picture area. There are no hard and fast rules about composition, but it is as well to remember that over-symmetry should be avoided, because this creates a bland, dull effect that fails to hold the viewer's interest. The basic 'building blocks' of composition are shapes, colours and values (or tones), all of which can be used to set up contrasts or echoes as the subject demands. In a floral group, for example, a straight-sided vase might be chosen to contrast with a rough circle or oval produced by the massed flowers, and in a painting of a single, pale-coloured flower, a dark background might be chosen to bring in an eye-catching contrast of values.

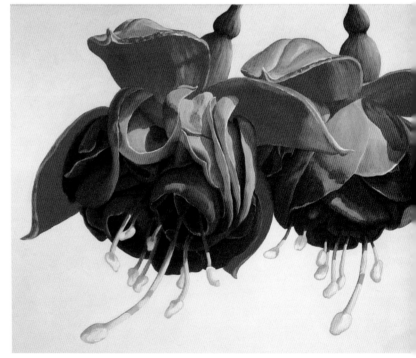

▲ **Placing the subject**
Gifts of the Morning, **by Lexi Sundell**
The flowers have been very carefully placed within the rectangle, which is a slightly squarer shape than the standard canvases or boards, and the composition is beautifully balanced. There is strong compositional rhythm based on a series of curves, and the cropping at the right side helps to lead the viewer into the picture, as the eye naturally follows this initial curve to continue through all the other ones.

Cropping

Letting parts of the image 'bust the frame' not only helps the composition in many cases, but also makes the flowers appear more alive, because it suggests they have a life outside the confines of the frame, rather than being isolated within it. Cropping needs to be handled carefully, and to anchor the image it is best to avoid cropping at both top and bottom.

Those who work on paper or board rather than stretched canvas can crop after the painting is complete, or even at a halfway stage, so if the painting seems not to be working, try arranging some strips of paper or board around the edges to see whether cropping would improve it.

▲ *Cropping the vase gives more emphasis to the flowers, but here the crop is too abrupt.*

▲ *The vase can be omitted altogether so that the flowers fill the whole of the picture area.*

◄ *An uneasy impression is created by the flowers touching the top margin. Let some go out of the frame.*

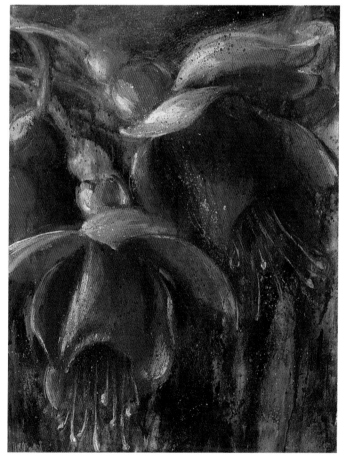

▲ **Focusing in** *Fuchsias,* **by Jennifer Bowman**
In this dramatic study, the artist has cropped at both sides in order to focus closely on the flower-heads, and the stamens of the main flower rest lightly on the bottom of the rectangle, providing an anchor for the image. The curving stems at top right lead the eye into the picture, where they find an echo in the curves of the main flower.

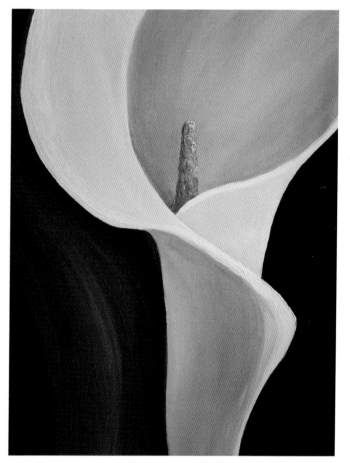

▲ **Vertical emphasis** *Calla Curves,* **by Christine Derrick**
The upright rectangle chosen for this semi-abstract treatment makes the most of the upward thrust of the petals, and the cropping at the bottom gives a sense of the shapes being pushed up from below.

Repeating shapes and colours

Although the interplay of light and dark values plays a vital role in a picture's composition, and without this the painting will seem bland and dull, you may not always want strong contrasts of shapes or colours. A gentler, more harmonious effect can be created by repeating, or echoing, shapes, especially in the case of curves and circles, on which many flower shapes are based. Roses could be placed in a rounded vase, or several similar-shaped flowers could be arranged together within the picture area. Echoing colours also creates harmony, but has an even more important function in that it unifies the composition by 'tying' each area of the picture together. Hints of the flower colours brought into a background, for example, create a relationship between the two instead of making the flower or group look like a cutout—this can be effective, but may not always be what you want.

Colour contrasts and harmonies

When planning a colour scheme for your painting, decide whether you want a dramatic, striking effect or a quiet, gentle one. The starting point will naturally be the colours of the flowers themselves, but whether you are painting a single bloom or a floral group, you can also decide what the other colors should be. Harmonious colours are those that are close to one another on the colour wheel (see page 18), while contrasting colours are those that fall opposite. To create harmony you might restrict the colours to a range of blues and greens, or reds and yellows, and for a more dynamic scheme you could contrast reds with blues or greens, or yellows with purple or mauve. The last two are complementary colours (see page 18), which create the strongest contrasts of all. Many floral subjects contain their own built-in complementaries – red flowers with green leaves – so all you need do is exploit them – or play them down if you don't want strong contrasts.

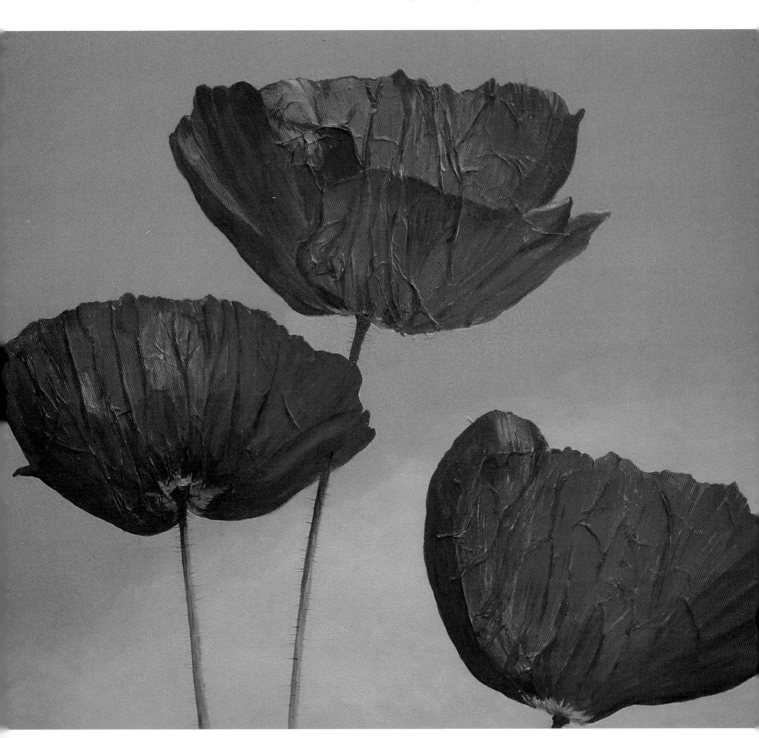

▲ **Artistic licence** *Yellow Rose*, **by Hanne Lore Koehler**

Neither pure black nor pure white are seen in nature, but the artist is free to depart from reality if it makes a better picture, and the black background is perfect for this subject. Not only does it provide a powerful tonal contrast that throws the flower-head into relief, it also makes the most of the negative shapes, which play an important part in the composition.

Negative shapes

The spaces between objects are termed negative space, or negative shapes, the positive ones being the objects themselves.

As can be seen from this schematic representation, the painting of the poppies opposite shows a deceptively simple arrangement of positive and negative shapes, creating a well balanced and pleasing composition.

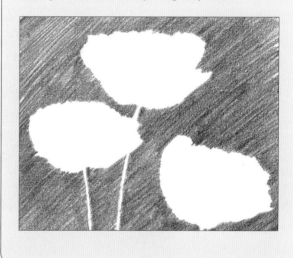

▶ **Colour harmony** *Purple and Blue*, **by Parastoo Ganjei**

For this gentle and harmonious flower piece the artist has chosen a limited colour scheme, using the same greens for the jug and the leaves, with a quiet blue brought into the background. The composition is further unified by the way she has echoed the rounded shapes of the blooms and leaves in the jug.

◀ **Placing the shapes** *Sommer Mohn*, **by Rebecca Henkel**

This composition is based on the repetition of three main shapes, which are placed in such a way that together they form a rough triangle. This compositional device, sometimes called 'the unseen triangle', has been exploited by artists for centuries. Notice that the tone of the background has been lightened towards the bottom of the image, making a subtle curve that opposes and echoes those of the flowers.

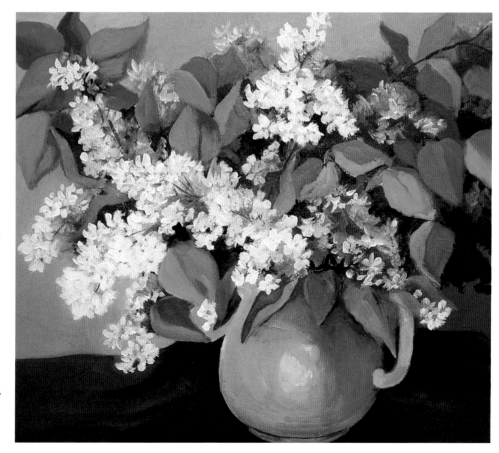

Editing nature

Whether you are painting single specimens, or flowers in landscape, you will nearly always have to leave out some of what you see, especially in the latter case, otherwise your picture will become cluttered and thus lack impact. Artists often say that what you leave out is as important as what you put in, so when you start a painting, think carefully about omitting or simplifying any element that does not help the composition. In the case of floral groups, you will have done much of the composing when you arranged the group, but even so you may find as you start to work that some further editing needs to be done, and when working outdoors, in a garden for example, you will certainly need to be selective. So decide on the flower or group of flowers that most interests you, and emphasize it in any way you can.

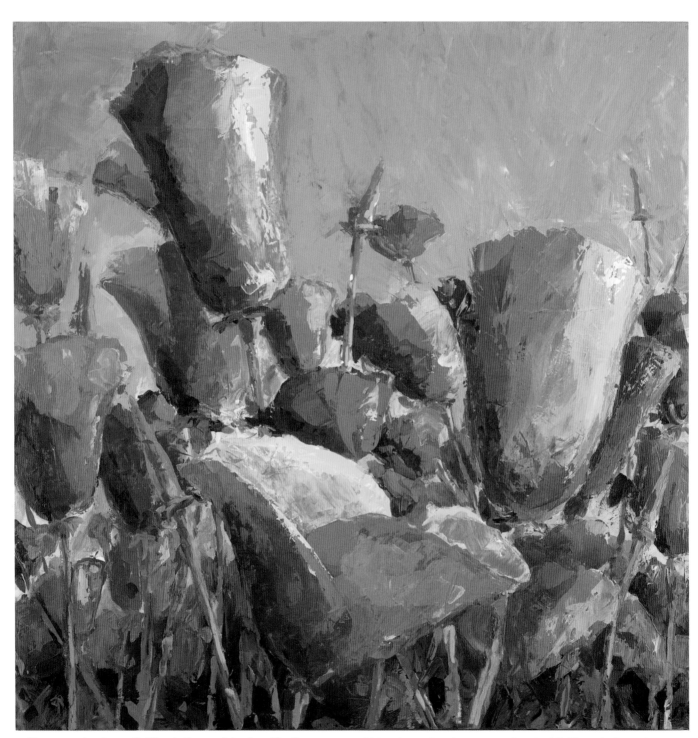

▲ **Shapes and colours** *California Squared*, **by Jennifer Bowman**
The artist's main interest here is in the bold shapes made by the flowers, and she has treated them with the minimum of detail, using thick paint so that they appear almost solid. The painting gains additional impact from the use of near-complementary colours, with the yellows and oranges set against a mauve-grey background.

Tonal interchange

The pattern of values (tones), with a continuous shift from dark against light to light against dark, is of great importance; without this the painting will look insipid and dull. It can be difficult to observe values, because our eye always responds to colour first, so it can be helpful to make small sketches before you paint in order to plan out the light, dark and middle values. Or if you are working from a photograph, make a monochrome photocopy, which will enable you to see whether you need to exaggerate the lights and darks.

In spite of good colour contrasts, the flowers have become rather lost against a similar-toned background.

The black-and-white photograph shows this failing even more clearly.

In this drawing, the background has been darkened on the right and lightened on the left, introducing more tonal interest.

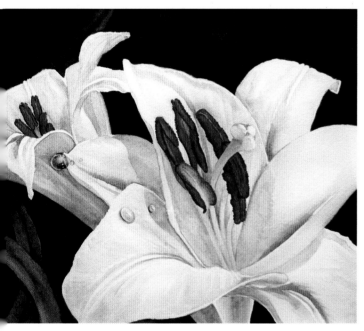

▲ **Complementary colours** *Lily White*, **by Hanne Lore Koehler**
This study makes spectacular use of the shapes of petals and stamens, and is given extra impact by the subtle use of complementary colours. All three pairs have been used, with mauves and blues brought in to the flowers to complement the yellow and oranges, and small touches of green at centre and right to complement the strong reds of the stamens.

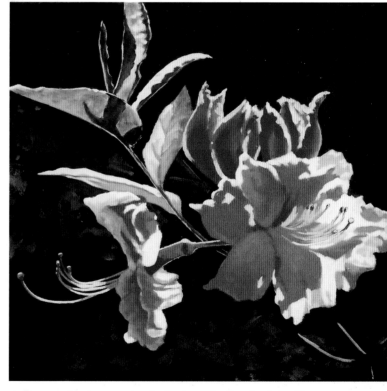

▲ **Tone and colour contrasts** *Azalea Gibralter*, **by John Stoa**
The powerful contrasts of tone and colour could not fail to catch the eye, and the dark background gives emphasis to the fragility and papery texture of the flowers.

Using a viewfinder

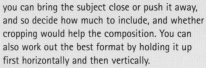

Very few artists are without one of these simple devices. A viewfinder consists of nothing more than a piece of card with a rectangular aperture in the middle, and can be made in minutes. By holding the viewfinder up at various distances from your eye, you can bring the subject close or push it away, and so decide how much to include, and whether cropping would help the composition. You can also work out the best format by holding it up first horizontally and then vertically.

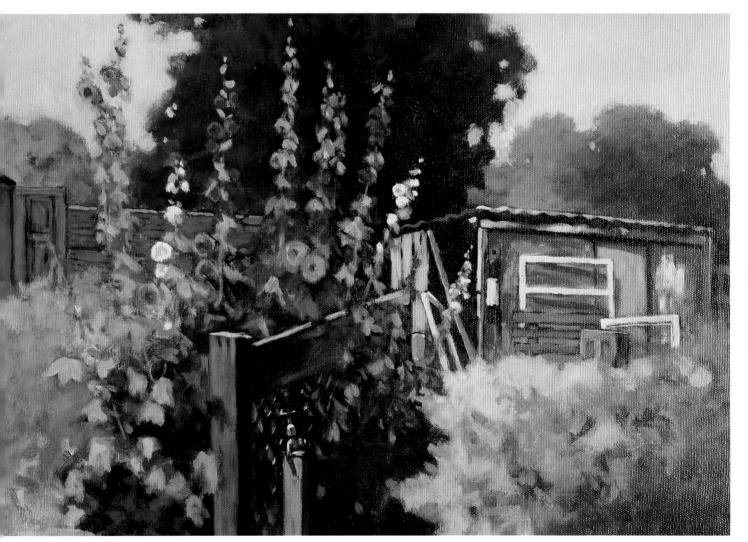

▲ **The focal point** *Hollyhocks,* **by John Stoa**

In this paintings, the main centre of interest, or focal point, is the group of hollyhocks, and the artist leads the eye towards it, first by the two opposing diagonals of the fence and shed roof, and second

through the dark tones behind and below the flowers. The foliage and foreground grasses have been treated very broadly so that they do not claim too much attention.

Leading the eye

The best way to lead the viewer's eye to the centre of interest is to set up visual 'signposts'. A diagonal line in the foreground of a floral group or landscape, perhaps the edge of a table, or a fence or path, is a compositional device often used, because the eye naturally follows diagonals. In the case of a single flower, a curving stem leading up to the main bloom is equally effective, because curves help to create a compositional rhythm, which draws the eye in much the same way as musical rhythm appeals to the ear. In paintings of single flowers, or one or two formally arranged blooms, the shapes themselves can be enhanced by strong contrasts of tone or colour, so don't be afraid of very light or very dark backgrounds, even though they may not be true to life. Remember always that as an artist you are interpreting the subject, not copying it.

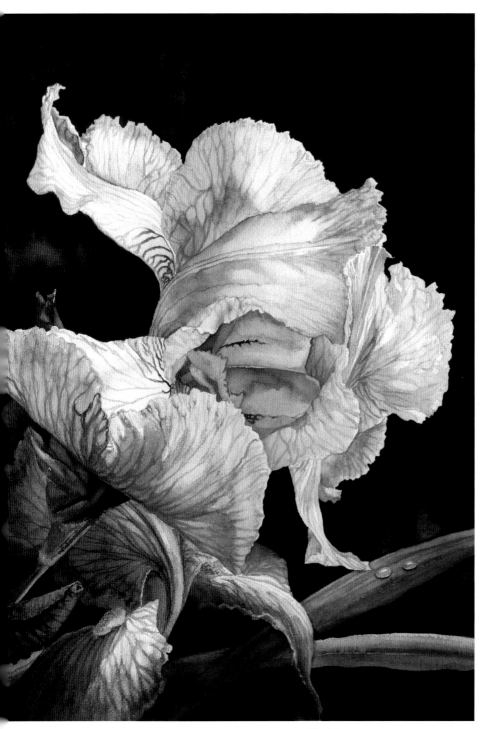

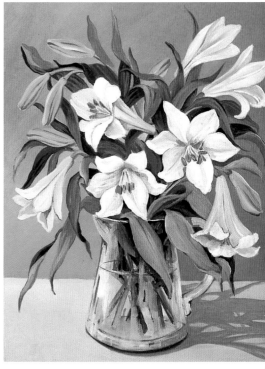

▲ **Judicious exaggeration** *White Lilies*, **by Parastoo Ganjei**
Floral still lifes can sometimes look rather dull and static, so it is important to think of ways of introducing a sense of rhythm and movement. In this lively painting, the artist has exploited and slightly exaggerated the curls and curves of the leaves and stems so that the flowers almost appear to be dancing.

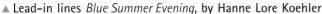

▲ **Lead-in lines** *Blue Summer Evening*, **by Hanne Lore Koehler**
The diagonal formed by the bottom of the central petal, together with the curves at the bottom, lead the eye into the picture, where it is caught by the lovely frilled curves at the top of the flower. These are emphasized by the strong tonal contrasts, with near-whites set against a rich, deep blue background.

Rules for capturing luminosity

Flowers naturally lend themselves to the creation of luminous, glowing paintings. Light shining through translucent petals or reflecting delicately within the flower creates a magical glow. Dawn light accentuates deep shadow and radiant highlights in the freshly opened flowers. Attention to light and colour allows you to capture this luminosity.

1 Establish your light source

A direct and even light looks rather flat and unexciting, so use a strongly angled light source for maximum interest. Look for shadow patterns that enhance the form of the flower. Rotate the flower and tilt it in the light until you see the best view to paint.

2 Use strong backlighting

As an alternative to angled lighting, look at the flower with a light behind it to determine if the backlit effect is what you prefer to paint. Rotate and tilt the flower to find the most attractive composition.

3 Maintain the direction of light

As you paint, maintain the established direction of light throughout the painting. Especially when first learning to paint, it can be too easy to forget the direction of light while working out the intricacies of colour mixes and painting techniques.

4 Balance light and dark areas

Keep light and dark values balanced. The background should support the values used in the painting – dark contrasts well with light flowers, and vice versa. If you are having difficulty with tonal values and can't identify the problem, take a black-and-white snapshot of the painting. This will instantly show up any problem areas.

5 Emphasize high contrasts

A deeply shadowed area surrounding a brilliantly lit area creates a luminous glow. Trying to create luminosity by using only lighter values simply results in a washed-out look. Using too many shadows without enough lighted areas results in a dark, heavy look. Make sure you have enough shadow areas and also enough brightly lit areas to combine in a luminous glow.

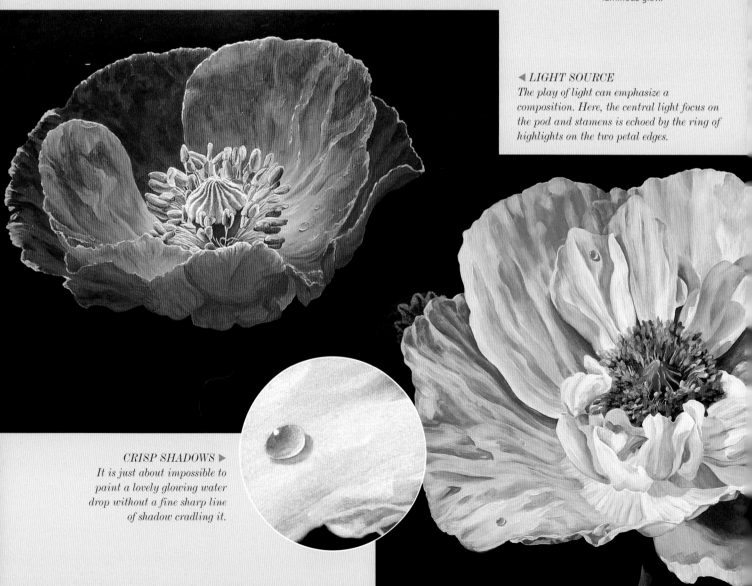

◀ *LIGHT SOURCE*
The play of light can emphasize a composition. Here, the central light focus on the pod and stamens is echoed by the ring of highlights on the two petal edges.

CRISP SHADOWS ▶
It is just about impossible to paint a lovely glowing water drop without a fine sharp line of shadow cradling it.

6 Keep the colour blends smooth

Use smooth blends of colour for softness. Even though the painting needs strong contrasts to be luminous, flower petals should appear soft, not harsh and coarse.

7 Juxtapose warm and cool

Using warm and cool colours next to one another creates another form of visual contrast. White petals can have yellow tinted light areas and blue tinted shadow areas, for example.

8 Show the reflected light

Notice where a leaf or bud catches a reflected glow of light from a red petal. The leaf or bud is green, but has a soft reddish blush when catching the reflected light. Be alert and observe any areas in the flower that reflect one colour onto another. These subtleties distinctively add to the luminosity of the flower.

9 Use intense shadows

When nearing completion, bring the deepest shadows to their maximum intensity. Look at the overall balance of shadows in the painting and make sure some intensely dark areas are emphasized, even if they are small.

10 Use brilliant highlights

These can be tiny bright white accents strategically placed to show the light falling across the flower. Look at the water drop, opposite: a tiny round highlight with a slightly softer arc of light on the opposite side of the drop shows the refraction of light through the liquid in a luminous glow. Highlights always show the movement of light.

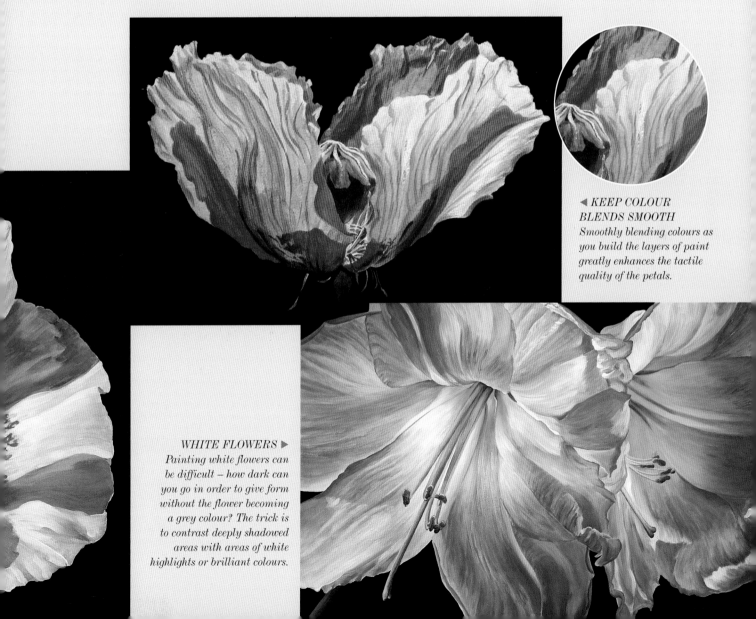

◀ *KEEP COLOUR BLENDS SMOOTH*
Smoothly blending colours as you build the layers of paint greatly enhances the tactile quality of the petals.

WHITE FLOWERS ▶
Painting white flowers can be difficult – how dark can you go in order to give form without the flower becoming a grey colour? The trick is to contrast deeply shadowed areas with areas of white highlights or brilliant colours.

Rules for creating brilliance

The myriad colours of flowers enchant the viewer with their brilliant hues. Capturing this magical brilliance in paintings requires attention to the nature of colours and how they work together. Shapes and contrasts also play into this dynamic. The astute student learns how to create brilliance using a variety of approaches.

1 Use complementary colours

Complementary colours are those pairs of colours that are opposite each other on the colour wheel. They provide far more visual contrast than adjacent colours on the colour wheel. The primary colours are red, yellow and blue. The complement of a primary colour is the mixture of the other two primaries, for example, the complement of red is green, a combination of blue and yellow.

2 Keep colours pure and bright

When using complementary colours, for example, blue and orange as the complementary pair, do not mix the orange into the blue paint on the palette. This will neutralize the blue, making it more subdued. This might be useful while painting a shadow, but it is worth noting it drastically reduces the brilliance perceived by the eye.

3 Limit the colours

Use no more than two main pairs of complementary colours. If all primary colours are used with their complements, the eye will begin to perceive white instead of brilliant colour. If two primary colours and their complements are used, a blended complementary pair can be added. For example, the pairs of red with green, and blue with orange could also have a pair of red-orange with the complement of blue-green.

4 Contrast large and small shapes

Equal sized blocks of colour can be boring and static. Placing a small, intense yellow accent into a large mass of its complementary colour purple is lively and arresting to the eye. Contrasts are what make brilliance work, so variations in sizes of colour areas provide one more way to maximize brilliance.

5 Emphasize brights against neutrals

Offset pure bright colour with neutrals to give 'pop'. A neutral colour does not compete with bright colour for attention. Instead, the bright colour almost leaps off the canvas when placed against a light neutral grey. If the complement of the bright colour is also used, the eye will register even more brilliance.

◀ *LIMITED COLOUR SCHEME*
The use of the yellow-mauve complementary pair gives this painting an extraordinary brilliance. The colour scheme is deliberately limited, to unify the image.

SUBTLE COMPLEMENTARY COLOURS ▶
This painting exploits the red-green complementary pair, but the red is used quite sparingly, restricted to the veining on the petals.

6 **Juxtapose both shapes and colours**
Contrast large and small shapes in bright and neutral colours. Using different sizes of colour areas creates more visual interest in the painting. This will increase the effectiveness of the neutrals by emphasizing the bright colours in a more visually commanding way.

7 **Use light and dark contrasts**
Paint values with contrasts in light and dark. Once again, contrasts are the most effective tool in creating brilliance. Beginning artists sometimes try to create a brilliant look by using all one value of pure bright colours. The viewer's eye starts to glaze as a result. Instead, paint a pure bright petal emerging from a dark shadow, which will greatly increase the effectiveness of the painting.

8 **Use values to focus the viewer's eye**
A painting with an even set of values across the whole surface of the image is boring and allows the eye to wander. Use contrasts in values as a compositional tool to place the viewer's attention on the focal point of the painting. A powerful composition executed with the use of contrasting values aids in the perception of brilliance rather than the perception of colour chaos and clutter.

9 **Paint black in the deepest shadows**
Even small touches of black in the shadows will magnify the contrasts in values, increasing the perception of brilliance in the painting. The value range of the painting should make this look natural, rather than jarring and out of place.

10 **Pure whites for highlights only**
These sparkling accents will greatly enhance the brilliance of the finished painting. Avoid painting a white background because it will badly dilute the effectiveness of white highlights and render them virtually useless. For maximum brilliance, use contrasts to maximum effect.

SHADOWS AND HIGHLIGHTS ▲
It is best to use fairly thin paint for the shadows, building up to thicker applications for the highlights. Here the darker areas have been applied as overlaid glazes so that they retain much of the brilliance of the flower's local colour.

▼ *DARK BACKGROUNDS*
Mid-toned flowers such as these may need strong tonal contrasts to bring out the highlights, and here the lighter petals are thrown into relief by the dark background. Notice how the leaves on the right almost merge into the background, while those on the left are much more distinct.

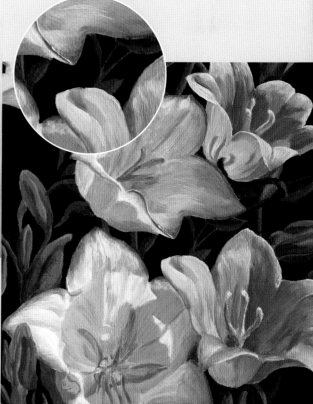

Troubleshooting

Sooner or later every painter faces the dreaded event, a painting with a problem, a painting that is not working. Fortunately, when faced with these techniques, nagging difficulties can be identified and resolved in the work. Rather than being disasters, such challenging paintings only strengthen the painter's skills.

1 Avoiding backache
Adjust the height on the easel. It is important to keep a comfortable posture so that you are not distracted by pain as you work on your painting. Also, keep the palette at a comfortable working height.

2 No more muddy colours
Sometimes simple solutions are the best. If the paint is muddied from a lot of colour mixing on the palette and picking up the desired colour with a brush is a struggle, it is time to eliminate the problem. Paint can eventually become gummy or mouldy, which is also undesirable. With a fresh palette you can concentrate on the painting itself, instead of the struggle with the paint.

3 Finding alternative colours
If Perinone Orange is not available, Cadmium Orange will work as a substitute. A small amount of red may need to be added. If mixing with a yellow, less yellow may be required. Yellow Ochre may be used in place of Nickel Azo Yellow, with some variation in results.

4 Avoid amateurish colour mixes
Mixing Burnt Sienna and Titanium White produces a highly unpleasant chalky pink, which is the hallmark of the amateur. Notice that no Burnt Sienna is included in the recommended palette at all. Other colours work much more effectively and give a more satisfactory painting experience.

5 Overcoming compositional problems
Take a black-and-white photograph of the painting. All manner of composition and value problems immediately become apparent when the distracting colour hues are removed. A bland and uninteresting block of fairly similar greys indicates that more contrast is needed. Sometimes one element has too much contrast in value, which is also easy to recognize.

◄ *BLACK-AND-WHITE*
This black-and-white painting shows good tonal contrast in the flower itself, but the background would need to be darkened at the top to emphasize the light petals.

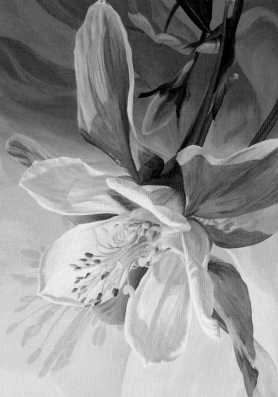

UPSIDE DOWN ▶
Turning a painting upside down may initially look strange, but it does allow you to look at it with a fresh eye, precisely because it becomes unfamiliar. Another way to re-evaluate the composition is to look at the painting in a mirror.

6 Looking with fresh eyes

Another method of seeing the painting with a fresh eye is by turning it upside down or sideways. A well-balanced composition should work from any orientation of the painting. Other problems can also be quickly identified by shifting the orientation.

7 Regaining perspective

After intense painting it is not always possible to view the work objectively. Returning after some rest from the project can make any problem and its solution immediately apparent. A shortcut in this process is to have someone else look at the painting. This will only help if the chosen person is knowledgeable and able to speak clearly about the painting, without offending.

8 Use the right level of detail

Some paintings require a great deal of detail to convey the intent of the painter. Others do not need so much detailing to create the desired effect. Painting detail solely for the sake of painting detail can derail a painting so the intended point is lost. Step back and evaluate the level of detail in the painting to be sure it works.

9 Fixing mistakes

This can allow a fresh start on a difficult section. Acrylics allow you to quickly and easily cover colours that have strayed too far from the intended vision. Use this quality to good advantage when necessary.

10 Paint the best area white

Sometimes an artist paints a few brushstrokes that are utterly gorgeous. This, surprisingly, can wreck a painting. The process may derail into painting around the wonderful brushstrokes, distorting the result. If you are struggling to work around that special spot, get rid of it. The painting can then be successfully completed, which erases the pain of repainting the best area.

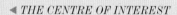

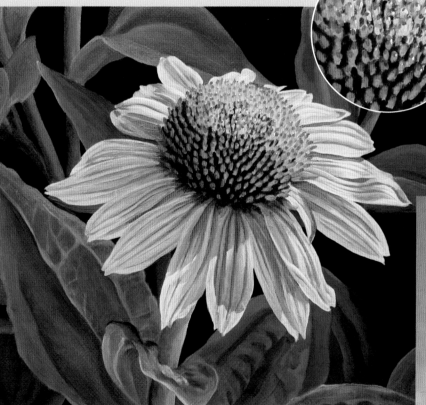

◀ *THE CENTRE OF INTEREST*
This painting of an echinacea has as the focal point of interest the complex centre disc of the flower. This intricate structure really does require considerable detail to convey it to the viewer. To render it loosely would diminish the impact of this lovely centre, and thereby also diminish the painting.

LEVEL OF DETAIL ▶
However, this sunflower has an equally intricate centre disc that has not been painted with the same degree of precision. The point of interest in this painting is the drama of a glorious sunflower against the sky. Painting more detail in the centre would not enhance that drama.

Alcea
Hollyhock 46

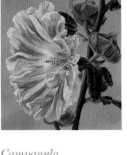

Anemone coronaria
Poppy Anemone 48

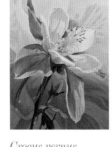

Aquilegia
Columbine 50

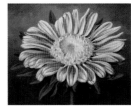

Aster
Aster 52

Begonia
Begonia 54

Campanula
Bellflower 56

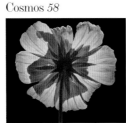

Cosmos
Cosmos 58

Crocus vernus
Spring Crocus 60

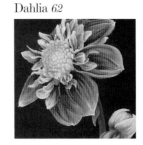

Dahlia variabilis
Dahlia 62

Delphinium
Delphinium 64

Directory

Dianthus
Pinks 66

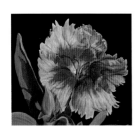

Digitalis
Foxglove 68

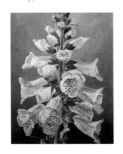

Echinacea
Coneflower 70

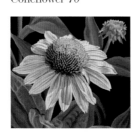

Eschscholzia californica
California Poppy 72

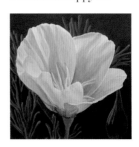

Fuchsia
Ladies' Eardrops 74

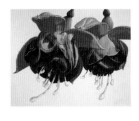

Gardenia
Gardenia 76

Gazania
Gazania 78

Gerbera
Gerbera 80

Helianthus
Sunflower 82

Hibiscus
Rose Mallow 84

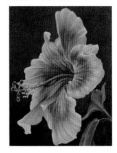

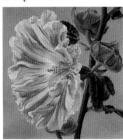

Hippeastrum
Amaryllis 86

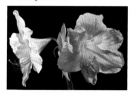

Ipomoea violacea
Morning Glory 88

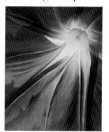

Iris
Bearded Iris 90

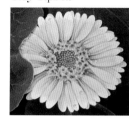

Layia platyglossa
Tidy Tips 92

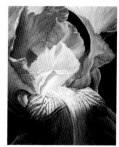

Linum
Flax 94

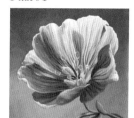

Malus
Apple Blossom 96

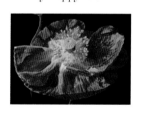

Nymphaea
Water Lily 98

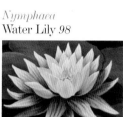

Opuntia
Prickly Pear Cactus 100

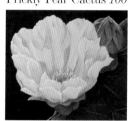

Osteospermum
Osteospermum 102

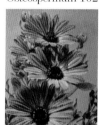

Papaver nudicaule
Iceland Poppy 104

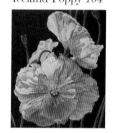

of Flowers

Papaver rhoeas
Shirley Poppy 106

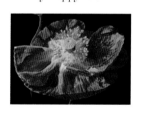

Papaver somniferum
Opium Poppy 108

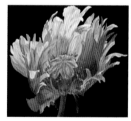

Pelargonium
Geranium 110

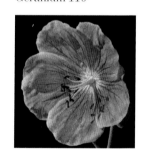

Portulaca
Moss Rose 112

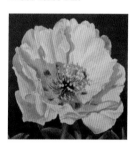

Rosa
Rose 114

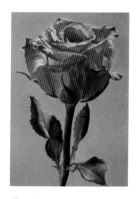

Tropaeolum
Nasturtium 116

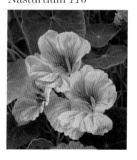

Tulipa
Tulip 118

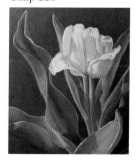

Viola tricolor
Wild Pansy 120

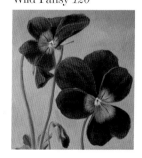

Zantedeschia
Calla Lily 122

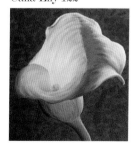

Zinnia
Zinnia 124

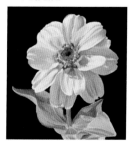

Alcea Hollyhock

Hollyhocks have dramatic deeply lobed leaves and large flowers that open on stalks several feet tall. The single or double blooms appear in many different colours ranging from reds, pinks and purples, to yellows, whites and even black. Hollyhock blossoms have a distinctive central column of stamens that twine around the pistil. The ruffled petals add further to the interest of the flower. Experiment with different lighting conditions to select the best view to paint.

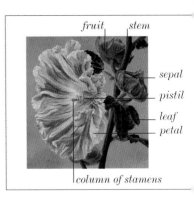

fruit *stem*
sepal
pistil
leaf
petal
column of stamens

Palette

Titanium White	
Yellow Ochre	
Raw Umber	
Perinone Orange	
Quinacridone Red	
Carbazole Violet	
Cerulean Blue	
Rich Green Gold	
Green Gold	
Permanent Green	
Chromium Green Oxide	
Mars Black	

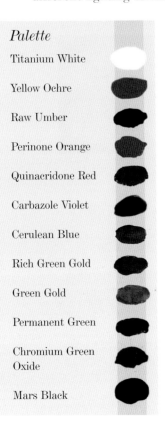

sequence start to finish

Underpainting

1 Use a pencil to sketch the flower, leaves, fruits and stems. Mix Cerulean Blue and Titanium White, and paint the sky. Use Chromium Green Oxide, a little Raw Umber and Titanium White in various mixtures to paint the leaves, fruits and stems. Add Green Gold and Permanent Green to the mix for part of the sepals and lighter stems.

2 Use Rich Green Gold, Chromium Green Oxide and Titanium White to paint the centre of the flower. Mix Carbazole Violet, Perinone Orange and Titanium White, and paint the petals and centre column. Establish the shadows in this process.

Using gel

3 Use a hog-bristle brush to coat the painting with gel (see Using Gel on p. 22). Follow the forms of the leaves, stems, fruits and petals with the brushstrokes. The petals need a grooved texture radiating from the centre of the flower. Allow to dry.

Building rich colour

4 Repaint the sky. Mix Chromium Green Oxide, Permanent Green, Green Gold, a little Raw Umber and Titanium White to paint the lighter parts of the leaves, fruits, stems and centre of the flower. Continue refining

the details with shadows painted with Chromium Green Oxide, Raw Umber and a tiny amount of Mars Black.

5 Use Quinacridone Red and Titanium White to paint the petals, lightly smudging it into the previous layer. Mix Yellow Ochre, Raw Umber and Titanium White for the column of stamens and pistil.

Refining detail

6 Continue working with the previous mixtures in the leaves, fruits, stems and centre of the flower. Softly blend the transitions in the areas where softness is needed. Add distinct shadows and glowing highlights in the backlit leaf and sepals. Look at the whole form, and balance the shadows and lighter areas.

7 Paint the petals in layers of the Carbazole Violet, Perinone Orange and Titanium White mixture, alternated with the Quinacridone Red and Titanium White mixture. Create the natural-looking striations of the pink breaking through the greys in the petals. Continue painting more detail in the central column of stamens and pistil with Yellow Ochre, Raw Umber and Titanium White.

8 Add strong darks into the green areas of the painting using Chromium Green Oxide, Raw Umber and a little Mars Black. Paint soft highlights with Green Gold mixed with Titanium White. Lightly drag a brush with Titanium White across the broader highlights in the petals, blending with your finger or a wet paper towel.

9 Use a small round brush to paint Titanium White highlights on the leaves, stems, fruits and petals. Leave skipped and broken sections of line on the edges to give a natural look.

Finishing

10 Lightly drag a brush with Titanium White across the broader highlights in the petals. Use a small round brush to paint Titanium White on the highlighted parts of the bud and petals, and stamens in the upper flower. Leave skipped and broken sections of line on the edges to give a natural look.

See also

Drawing, pages 14–17
Using Gel, page 22

special detail painting a striated colour in a petal

◀ *Use Carbazole Violet, Perinone Orange and Titanium White to paint the petal, establishing the shadows. Add more Titanium White in the lighter areas.*

◀ *After coating with gel, Paint Quinacridone Red and Titanium White over the petal, blending into the previous layer.*

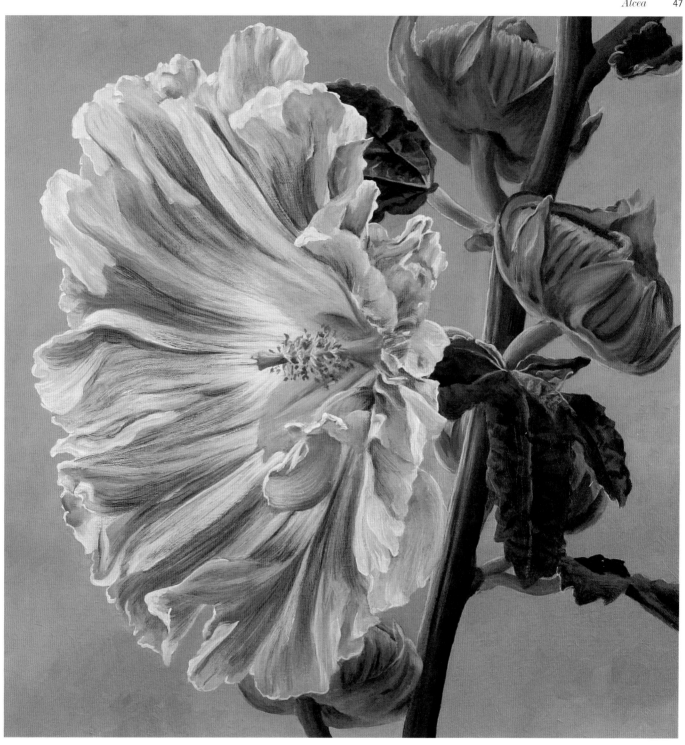

◄ *Alternate layers of the previous mixtures, creating radiating striations of colour in the petal. Make some streaks of Quinacridone Red that are darker, catching some of the gel texture with the brush.*

◄ *Lightly drag a brush with Titanium White over the highlights, blending into the lighter area. With a small round brush paint Titanium White highlights.*

Anemone coronaria Poppy Anemone

These tuberous flowers from the buttercup family are a welcome sight in the spring, although they can be a challenge to grow in colder climates. The heavily divided leaf bracts make a gentle backdrop for the bold flower that rises up on a sturdy stalk. Often called windflowers, anemones bloom in reds, blues and whites. The gently curved layers of petals capture shadows and reflected light in fascinating ways. Observe the variations in appearance from tilting the flower to capture the light at different angles before you paint this flower.

Palette

Titanium White

Raw Sienna

Raw Umber

Ultramarine Violet

Indanthrone Blue

Ultramarine Blue

Rich Green Gold

Chromium Green Oxide

Mars Black

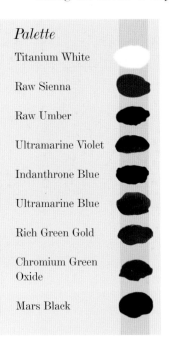

flower centre stamen

leaf bract styles petal

sequence start to finish

Underpainting

1 Sketch the flower, observing the layers of petals and the reflected light within them. Paint the background Mars Black for maximum contrast. Use Chromium Green Oxide mixed with Raw Umber and a little Titanium White to paint the stem and leaf bract, emphasizing the shadow areas.

2 Use Indanthrone Blue mixed with Titanium White to paint the flower petals, establishing shadows with mixtures containing less Titanium White. Paint the centre of the flower pure Indanthrone Blue.

Using gel

3 Use a hog-bristle brush to texture the painting with gel (see Using Gel on p. 22), creating a nice background texture, and painting the petals in the direction of the linear forms within them. Allow to dry.

Increasing brilliance

4 Paint the background black to cover the milky quality of the gel texture. Mix Green Gold with Chromium Green Oxide, Raw Umber and a small amount of Titanium White to add more definition to lighter areas of the stem and leaf bract.

5 Use varying mixtures of Indanthrone Blue, Ultramarine Blue and Titanium White to paint the petals. Apply more of the Ultramarine Blue in the brighter areas of the petals, and apply very little Ultramarine Blue in the deeper shadow areas. Paint the white highlighted petal areas sweeping into the centre of the flower, using soft blends to give shape to the petals.

Refining the painting

6 Mix Rich Green Gold with Chromium Green Oxide, Raw Umber and a little Titanium White to blend the deeper shadow areas with the highlighted areas of the stem and leaf bract. Do not use maximum contrast in the stem and leaf bract as they are in shadow.

7 Softly paint the veins in the petals with Indanthrone Blue mixed with Ultramarine Blue and Titanium White, harmonizing the veins with the colour blends so they are not harsh, dark streaks. Add a minute amount of Titanium White to a lot of Indanthrone Blue to paint some subtle highlights in the centre of the flower.

8 Mix Raw Umber with Raw Sienna and Mars Black, and paint the stamens. Use a small amount of Titanium White with this mixture to paint the lighter areas of the stamens. Mix Indanthrone Blue with Ultramarine Violet and Titanium White to paint the

styles. Notice that the stamens and styles are added after the petals are already well painted. This eliminates the blotchy effect caused by trying to paint pieces of the petals between the stamens. Paint the shadows of the stamens with Indanthrone Blue mixed with Titanium White.

Finishing

9 Use a small round brush to complete the subtle colour blends of Indanthrone Blue mixed with Titanium White and a little Ultramarine Blue in the shadows of the petals to show the reflected light. Use a small round brush to paint Titanium White highlights. On the outer edges of the petals, use thicker and thinner lines, leaving breaks and skips in the lines to create a natural look.

See also

Drawing, pages 14–17
Using Gel, page 22

special detail reflected light blends in shadows

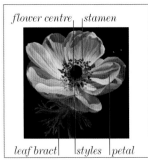

◀ *Block in the petals with the underpainting colours. Notice the shadow of the upper petal falling on the lower petal in the illustration. The shadow is darkest near the centre, has a brighter area of reflected light in the middle and goes darker again towards the outer part of the petal. Paint gel with a hog-bristle brush to texture the petals.*

◀ *Soften the blends in the petals to give them a more natural look. This can be done by gently smudging the paint with a finger or a damp paper towel. Use Ultramarine Blue in the paint mixture to add brilliance. Continue to add more detail in the shadows.*

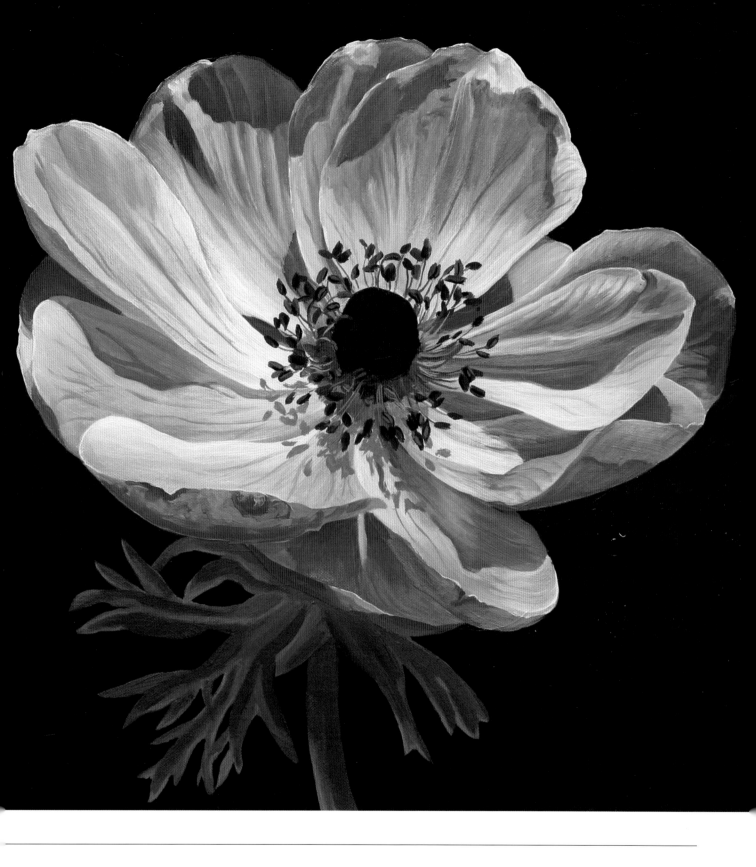

◀ Paint the stamens with the appropriate colours and then paint the shadows of the stamens on the blended petal shapes. Use Indanthrone Blue and Titanium White without Ultramarine Blue for those shadows.

◀ Highlight the stamens and paint the styles with the appropriate paint mixtures. Add Titanium White highlights on the brightest areas of the petals to create maximum brilliance in this flower.

Aquilegia Columbine

Columbines have exquisitely delicate forms that float airily above the foliage. The upper part of the petals becomes a white cup supporting the bushy shower of stamens in the centre. This particular flower is shown with early dawn light slanting across it, creating interesting shadows. In the background is an expanded painting of the middle section of the flower painted in soft greys, to accentuate the floating look of the flower.

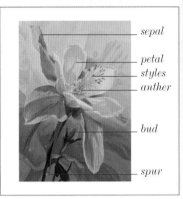

— sepal
— petal
— styles
— anther
— bud
— spur

Palette

Titanium White	
Nickel Titanate Yellow	
Nickel Azo Yellow	
Cadmium Yellow Medium	
Raw Sienna	
Raw Umber	
Perinone Orange	
Cerulean Blue	
Indanthrone Blue	
Ultramarine Blue	
Rich Green Gold	
Green Gold	
Chromium Green Oxide	

sequence start to finish

Underpainting

1 Sketch the flower, foliage and background in pencil. Paint the background with varying mixtures of Indanthrone Blue, Perinone Orange and Titanium White.

2 Use Chromium Green Oxide, Raw Umber and Titanium White for the leaves, bud and stems. Mix Ultramarine Blue, Cerulean Blue and Titanium White, and paint the spurs and sepals, establishing the shadows. Add a lot of Titanium White to this mixture and paint the white parts of the petals, making soft pale shadows.

Using gel

3 Using a hog-bristle brush, paint the gel onto the painting (see Using Gel on p. 22), following the shapes and forms of the foliage and flower, as well as the forms in the background. Allow the gel to dry.

Building form

4 Paint the background again with the grey mixture. Balance the values as you paint this area (see Values on p. 19). Mix Chromium Green Oxide, Titanium White and a little of the grey mixture, and paint the lighter areas of the leaves, bud and stems.

Building richness

5 Mix a little Indanthrone Blue with Ultramarine Blue and a tiny amount of Titanium White, and paint the deepest shadow areas in the blue parts of the flower. Softly smudge them into the lower layer of paint.

6 Continue adding detail to the petals and sepals with the mixtures in the previous step. Paint the anthers with Nickel Titanate Yellow, Cadmium Yellow Medium and Titanium White.

7 The upper anthers, which are darker, should be painted in Cadmium Yellow Medium and Raw Sienna. Use Rich Green Gold with a little of the grey mixture and Titanium White added to paint the styles.

Adding shadows

8 Use Ultramarine Blue and Titanium White to paint the lighter areas of shadow in the blue parts of the flower.

9 Use a mixture of Chromium Green Oxide, Green Gold and Raw Umber to paint the brighter greens in the leaves, bud and stems. Blend the mixture into the lower layers of the paint to create a natural appearance. Paint Nickel Azo Yellow, Raw Umber

and Titanium White on the small terminations of the spurs. Use the same mixture to paint small pale splotches at the tips of the sepals.

Adding highlights

10 Deepen the shadows in the lighter anthers with Cadmium Yellow Medium and Raw Sienna using a small round brush. Paint tiny shadows in the darker anthers with Raw Umber. Refine the details in the styles with Rich Green Gold, Titanium White and a little of the grey mixture.

Finishing

11 Paint the highlights in the white part of the petals with Titanium White. Drag the brush softly to create a sparkling look. With a small round brush, paint the Titanium White highlights on the edges of the sepals, petals and a few anthers, allowing skips and breaks, and unevenness in the strokes.

See also

Drawing, pages 14–17
Values, page 19
Using Gel, page 22

special detail painting rounded anthers and curving styles

▲ *Use Nickel Titanate Yellow, Cadmium Yellow Medium and Titanium White for the anthers. Use a touch of Raw Umber in the shadows. Use Rich Green Gold and a little of the grey mixture for the styles.*

▲ *Deepen the shadows in the anthers with Cadmium Yellow Medium and Raw Sienna. Add Raw Umber and some of the darker grey mixture to paint the dark shadows of the styles.*

▲ *Paint Cadmium Yellow into the anthers and to blend the shadows into the highlights. Mix Rich Green Gold with the previous green mixture and add some vibrant areas to the styles.*

▲ *Complete the shadow blends in the anthers with Cadmium Yellow Medium and Raw Sienna. Using a small round brush, add Titanium White highlights.*

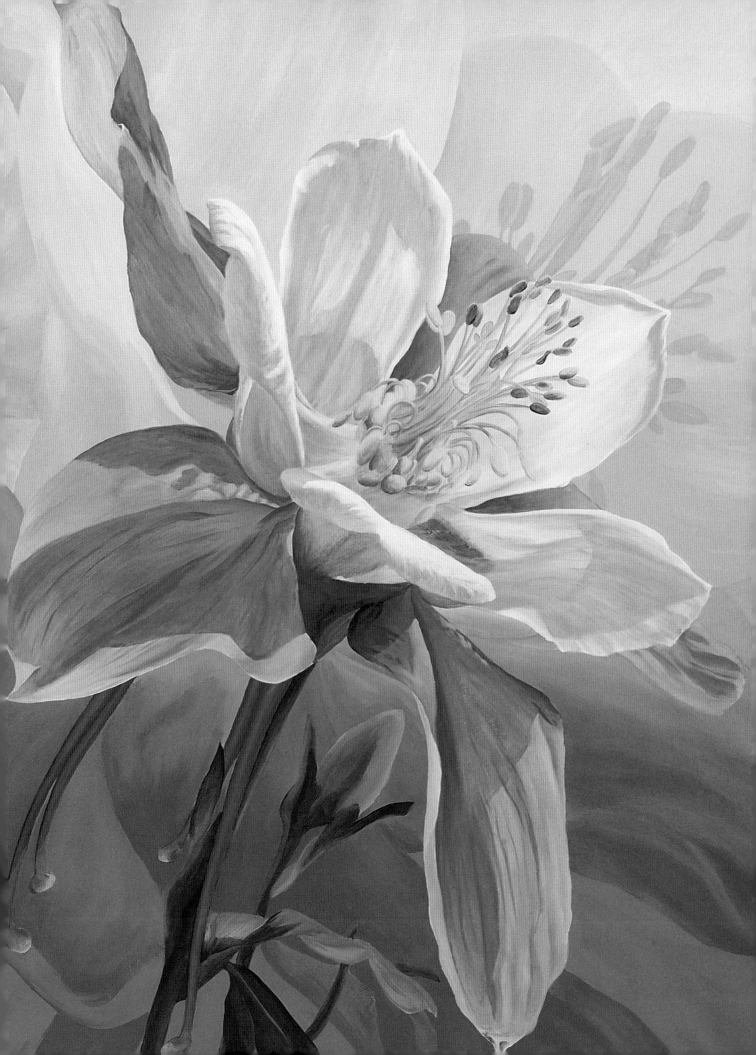

Aster Aster

Asters have slender pointed leaves and work well for edging, borders and rock gardens. The flowers appear in a range of white, lavender, blue, pink and violet colours, but not yellow or orange. Each blossom is comprised of rows of ray florets surrounding a mass of disc florets in the centre. Florists often use asters in bouquets due to the wide variety of colours and attractive appearance of the blooms. Likewise, the artist can find much for inspiration in these beauties.

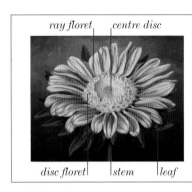

ray floret centre disc

disc floret stem leaf

Palette

Titanium White

Cadmium Yellow Medium

Yellow Ochre

Raw Umber

Perinone Orange

Quinacridone Red

Quinacridone Magenta

Permanent Green

Chromium Green Oxide

Mars Black

sequence start to finish

Underpainting

1 Use a pencil to sketch the ray florets, centre disc, leaves and stem. Paint the background with varying mixtures of Raw Umber, Yellow Ochre and a tiny amount of Titanium White. Mix Chromium Green Oxide, Permanent Green, Raw Umber and Titanium White, and paint the leaves and stem, emphasizing the shadows and highlights.

2 Paint the centre disc using varying combinations of Yellow Ochre, Cadmium Yellow Medium and Titanium White, establishing the shadow and disc florets. Use Quinacridone Red, Quinacridone Magenta and Titanium White for the ray florets, establishing the shadows as you paint them.

Using gel

3 Use a hog-bristle brush to coat the painting with gel (see Using Gel on p. 22). Follow the forms of the leaves, stem, centre disc and ray florets with the brushstrokes. Make an attractive texture in the background. Allow to dry.

Defining form

4 Repaint the background. Continue using the previous green mixtures for the leaves and stem. Mix Chromium Green Oxide, Raw Umber and a little Titanium White, and paint the leaves and stem, blending into the previous layer. Keep the leaves muted as they are mostly in shadow.

5 Paint the centre disc with more of the Yellow Ochre, Cadmium Yellow Medium and Titanium White combination. Create a soft-looking texture in the disc. Mix Quinacridone Red, Quinacridone Magenta, Yellow Ochre and Titanium White, and paint the ray florets. Define the shadows with more of the Quinacridone Red and Quinacridone Magenta.

Adding intensity

6 Define shadows in the leaves strongly, using Chromium Green Oxide, Raw Umber and a tiny amount of Mars Black. Use Chromium Green Oxide, Raw Umber and Titanium White to paint the lighter areas, blending carefully. Paint the shadows in the centre disc with Cadmium Yellow Medium, Yellow Ochre and a little Raw Umber. Mix Perinone Orange and Quinacridone Red, and sparingly paint a few deeper accents in the disc.

7 For the ray florets, mix Quinacridone Red, Quinacridone Magenta, Yellow Ochre and plenty of Titanium White, and paint the brighter highlights. Deepen the shadows with Quinacridone Red and Quinacridone Magenta. Use Mars Black to paint a few distinct shadows along the lower and right edges of the centre disc where the ray florets emerge.

Finishing

8 Because the leaves, stems and bud are in shadow, use Titanium White highlights only on the centre disc and ray florets. Use a small round brush and paint the highlights on a few tips of the disc florets. Paint the highlights in the ray florets, blending into the broader areas as needed.

See also

Drawing, pages 14–17
Using Gel, page 22

special detail painting layers of leaves and shadows

◀ *Use Chromium Green Oxide, Permanent Green, Raw Umber and Titanium White to paint the leaves, indicating shadows and highlighted areas. Observe where the shadows of leaves fall on other leaves.*

◀ *Paint a mixture of Chromium Green Oxide, Raw Umber and a little Titanium White into the leaves, blending into the lower layer.*

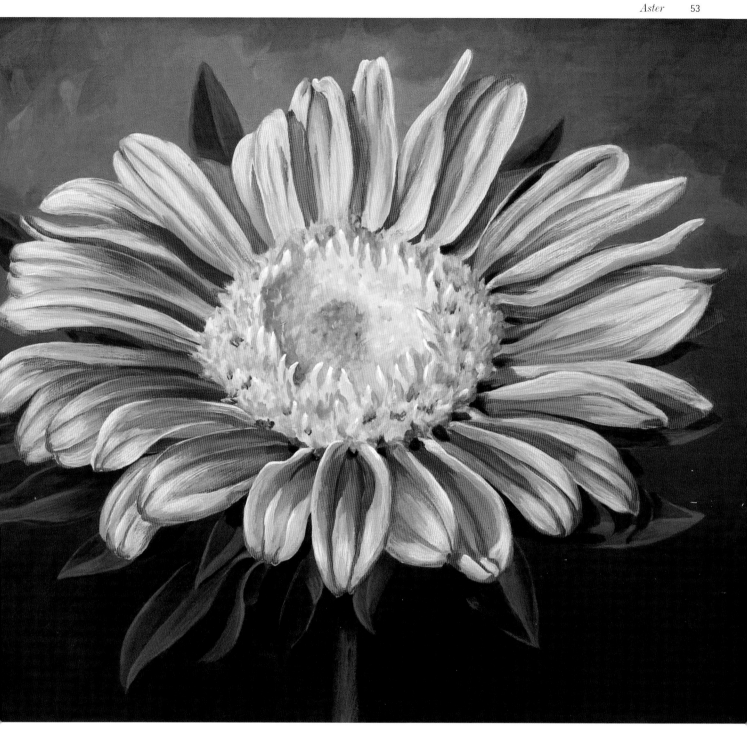

◄ *Define the shadows distinctly, which begins to create dimension in the leaves. Blend the lighter areas so they are muted.*

◄ *Mix Chromium Oxide Green with a little Raw Umber and Titanium White to paint the lighter areas, completing the dimensional look.*

Begonia Begonia

Begonias display a wide-ranging variety of leaves and flowers, both in colour and form. Some blooms are small, others large, and some are pendulous, while others stand more upright. These tropical flowers entice the artist with their sensual beauty. This one has dramatic red ruffled edges on the petals, enhanced by richly variegated leaves.

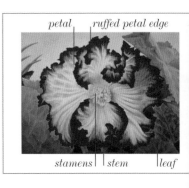

petal ruffed petal edge

stamens | stem | leaf

Palette

- Titanium White
- Lemon Yellow
- Yellow Ochre
- Raw Sienna
- Raw Umber
- Perinone Orange
- Anthraquinoid Red
- Permanent Red
- Carbazole Violet
- Rich Green Gold
- Green Gold
- Permanent Green Light
- Chromium Green Oxide
- Mars Black

sequence start to finish

Underpainting

1 Sketch the flower and leaves in pencil, observing the folds of the ruffles in both petals and leaves. Mix Carbazole Violet with Perinone Orange and Titanium White to make a light, clean grey and paint the background. Use a mixture of Chromium Green Oxide with a small amount of Raw Umber and Titanium White to establish the main forms of the leaves, beginning to indicate the shadows.

2 Paint the deepest shadows under the flower with Raw Umber. Paint the petals with Permanent Red mixed with Raw Umber and Titanium White. Keep the colours fairly light in this first layer of paint, but do start establishing the darker areas. Use Lemon Yellow and Titanium White to paint the stamens.

Using gel

3 Using a hog-bristle brush, paint gel following the forms of the leaves and petals (see Using Gel on p. 22). Create an interesting texture in the background.

Defining forms

4 Repaint the background texture to cover the milky look of the gel. Add Green Gold and Rich Green Gold in varying amounts to the green mixture used in the underpainting. Paint the leaves again, using more Rich Green

Gold in the darker shadow areas. Use Chromium Green Oxide, Raw Umber and a little Mars Black to make a deep, dark colour for the shadow areas under the flower.

5 Paint Permanent Red on the outer edges of the flower petals. Mix with Titanium White and a little Raw Umber to blend it into the lighter part of the petals. Use more Titanium White and less Raw Umber in the lighter areas of the petals. Use more Raw Umber in the mixture where the petals hold more shadows. Paint the centre of the flower with its stamens in a mixture of Lemon Yellow and Raw Sienna, making the shadows with more Raw Sienna.

Adding intensity

6 Deepen the shadows in the leaves with a mixture of Rich Green Gold, Chromium Green Oxide and Raw Umber. Use a little Titanium White when needed to create graduated colour. Paint the veins of the leaves with Chromium Green Oxide, Green Gold and Titanium White. In the upper right leaf, add a little Permanent Green Light to this mixture for the brighter greens in the leaf.

7 The underside folds of this leaf get Rich Green Gold in the mixture instead of Permanent Green Light in order to show the contrast of the leaf underside. Add Anthraquinoid Red to

the mixture and lightly smudge over the redder areas of the leaves. Begin using a small round brush to paint the edges of the leaves that turn red.

8 Use Titanium White, Permanent Red and Raw Umber mixtures to create the strongly veined look in the petals. Deepen some of the shadows in the centre with Raw Umber, Raw Sienna, Yellow Ochre and a small amount of Perinone Orange. Make a mixture of Lemon Yellow, Raw Sienna and a tiny amount of Perinone Orange and Titanium White, and smudge softly in the centre of the flower around the stamens to create a glow.

Finishing

9 Balance the shadows and highlights as necessary and make sure the colours blend well. Use a small amount of Titanium White on the centre stamens for highlights

See also

Drawing, pages 14–17
Using Gel, page 22

special detail working with permanent red and raw umber mixtures

◀ *Underpaint the petal with Permanent Red mixed with Titanium White. Begin to establish shadow areas with the darker shades of the mixture, but keep it fairly light.*

◀ *Paint Permanent Red around the outer edges of the petals. Mix Raw Umber with the Permanent Red and Titanium White mixture, and paint the deeper shadows. Add slightly more Titanium White for mid-range tones and paint those areas.*

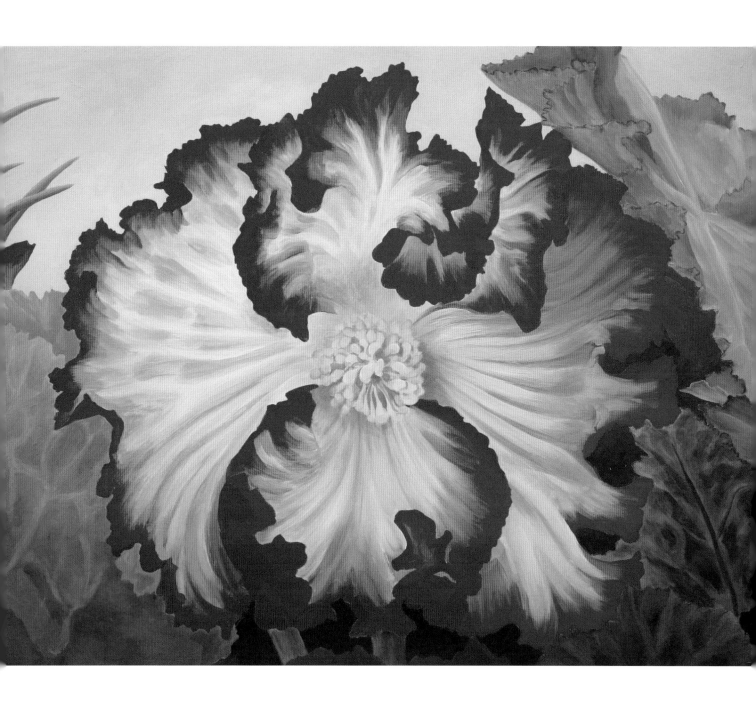

◁ *Blend the Permanent Red petal edges into the lighter area of the petal with the Permanent Red, Raw Umber and Titanium White mixtures. Soften the blends going into the shadows, smudging the paint with your finger or a damp paper towel.*

◁ *Add Titanium White highlights. Mix Permanent Red with Titanium White and a small amount of Raw Umber to paint the softer highlights in the shadows of the petal. Notice the rich colour variations Permanent Red and Raw Umber can make when combined in differing amounts with Titanium White.*

Campanula Bellflower

Peach-leaved bellflowers are beautiful garden perennials. They bloom primarily in blues and whites with delightful bell-shaped flowers ascending tall stalks. The triple-branched style is a striking accent in the blossoms. For the artist, the flowers look like cups of light, radiant and delicate in the early morning. Painting a grouping of the flowers allows an interesting composition, including multiple views showing different lighting effects on the same basic shape of flower.

Palette

Titanium White

Lemon Yellow

Nickel Titanate Yellow

Cadmium Yellow Medium

Raw Sienna

Raw Umber

Perinone Orange

Cerulean Blue

Indanthrone Blue

Ultramarine Blue

Green Gold

Permanent Green Light

Chromium Green Oxide

Mars Black

sequence start to finish

Underpainting

1 Use a pencil to sketch the flowers and foliage. Paint the background Mars Black for maximum contrast. Mix Indanthrone Blue, Perinone Orange and Titanium White to make a soft blue-grey, and paint the pale flowers. Use Ultramarine Blue, Cerulean Blue and Titanium White for the blue flowers, establishing the shadows.

2 Mix Chromium Green Oxide, Raw Umber and Titanium White, and paint the stems, leaves and buds. For the styles, use Cadmium Yellow Medium, Raw Sienna and Titanium White.

Using gel

3 With a hog-bristle brush, paint the gel on the flowers and foliage, following the forms with the brushstrokes (see Using Gel on p. 22). Use the gel to texture the background. Allow to dry.

Creating form

4 Paint the background again. Paint the pale flowers with Indanthrone Blue, Perinone Orange and Titanium White, making soft blends and adding shadow detail. Use Ultramarine Blue, Cerulean Blue and Titanium White again for the blue flowers, making deeper Ultramarine Blue shadows. Blend this same mixture on the edges of the pale flowers.

5 Paint Cadmium Yellow Medium, Raw Sienna, a tiny amount of Raw Umber and Titanium White on the styles, blending the shadows. Continue refining the foliage with Chromium Green Oxide, Permanent Green Light, Raw Umber and Titanium White in varying mixtures. Use Chromium Green Oxide, Raw Umber and a little Titanium White for the dark shadows.

Increasing intensity

6 Continue working with the previous mixtures, adding detail and increasing contrast. Paint the pale flowers with Indanthrone Blue, Perinone Orange and Titanium White, carefully defining the shadows and the highlighted areas. Blend the Ultramarine Blue, Cerulean Blue and Titanium White mixtures into the blue flowers, keeping a soft look while increasing the shadows. In the lighter parts of the blue flowers, add more Titanium White to give a glow.

7 Use Cadmium Yellow Medium, Raw Sienna and Raw Umber for the strong shadows on the styles. Use Nickel Titanate Yellow for the highlights on the styles.

8 Refine the shadow detail in the foliage, styles and stamens with Chromium Green Oxide, Permanent Green Light and Raw Umber. Mix Chromium Green Oxide, Green Gold and a little Titanium White, and paint soft highlights in the foliage, particularly in the buds.

special detail painting a dimensional glowing flower

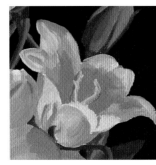

▲ *Paint Ultramarine Blue, Cerulean Blue and Titanium White on the petals, establishing the shadows. Use Cadmium Yellow Medium, Raw Sienna and Titanium White for the style.*

▲ *Continue using the previous mixture in the petals to blend into deeper Ultramarine Blue shadows. Add detail. Add a tiny amount of Raw Umber to the mixture for the style.*

▲ *Add more detail to the petals using the previous mixtures. Add more Titanium White in the brighter area to show the glow. Deepen the shadow in the style.*

bud

petal

sepal

stem

style

stamen

Finishing

9 Use a small round brush, to paint Lemon Yellow, Green Gold and Titanium White highlights in the foliage.

10 Lightly drag a brush loaded with Titanium White across the highlights in the pale flowers, blending into the previous layer.

11 Using a small round brush, paint small Titanium White highlights where needed on the petals and styles, leaving skipped and broken lines for a natural look.

See also

Drawing, pages 14–17
Using Gel, page 22

▲ *With a small round brush, paint Titanium White highlights on the edges of the petal and scattered on parts of the style.*

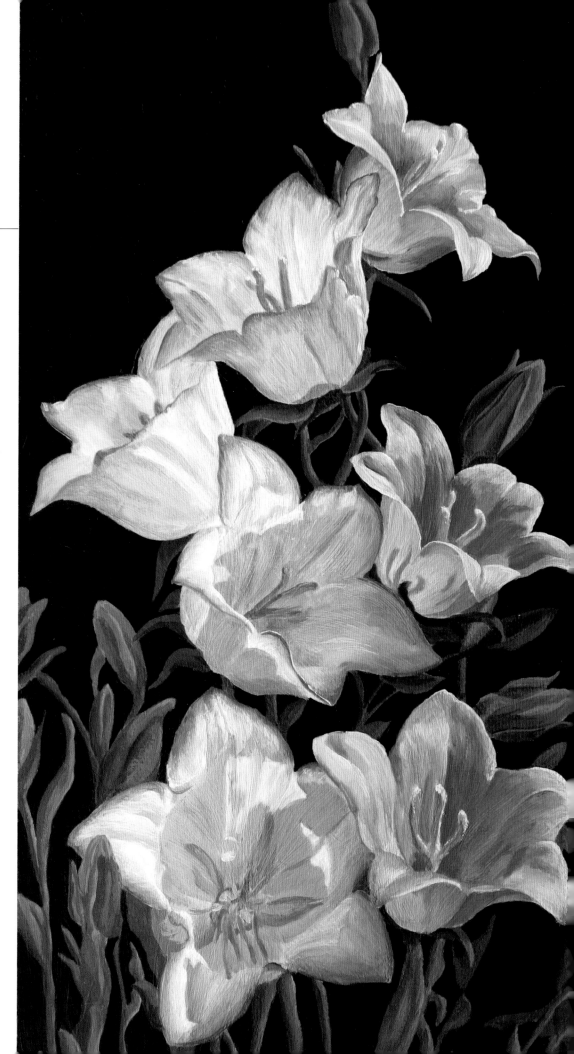

Cosmos Cosmos

Cosmos are annuals closely related to the dahlia and are tall enough to be used as lovely background border plants. Since the leaves are quite threadlike, the plant foliage has a lacy look. Flowers usually are white, pink, red or purple, but can also be found in yellow and orange colours. The flowers can be single or double, and in some varieties the petals are curled into tubes. Tolerant of poor soil, cosmos blooms happily in the heat of summer. The gardener is well advised to tour the flower beds at dawn to see how the light falls across these blooms. This particular flower was powerfully backlit one morning and that moment created this painting.

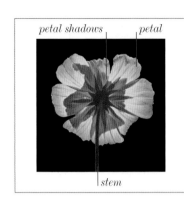

petal shadows petal

stem

Palette

Titanium White

Cadmium Yellow Medium

Yellow Ochre

Raw Sienna

Raw Umber

Perinone Orange

Anthraquinoid Red

Chromium Green Oxide

Mars Black

sequence start to finish

Underpainting

1 Sketch the flower petals with their shadows, stem and sepals in pencil. Paint the background Mars Black to emphasize the strong backlighting. Combine Chromium Green Oxide with Raw Umber and Mars Black to make a deep green for the stem and sepals.

2 Paint the shadows of the petals next with Raw Sienna and a little Yellow Ochre and Cadmium Yellow Medium. For lighter areas of the petals, use Yellow Ochre or Cadmium Yellow Medium with Titanium White. Paint the darker red accents with Perinone Orange mixed with Raw Umber and a little Raw Sienna.

Using gel

3 Paint the entire canvas with gel, using a hog-bristle brush (see Using Gel on p. 22). Follow the forms of the petals, stem and sepals with the brushstrokes. Allow to dry.

Developing form and colour

4 Repaint the background black. Paint varying mixtures of Chromium Green Oxide, Raw Umber and Mars Black on the stem and sepals. Keep highlighted areas rather dark as

these are all shadowed. Do make sure that the stem is a little lighter where it enters the back of the flower.

5 Mix Cadmium Yellow Medium and Raw Sienna, and paint the shadows in the petals, blending the colours by smudging with a finger or wet paper towel as needed. Add Raw Umber to the mixture for the darkest shadows. Mix Cadmium Yellow Medium and Titanium White, and begin emphasizing the lighter glow in the petals next to the central shadows. This will create a glowing look. Add Perinone Orange mixed with Anthraquinoid Red and paint the darker red accents again, smudging to blend these areas, allowing some of the lower layer of colour to show.

Refining the shapes

6 Use a mixture of Cadmium Yellow Medium, Yellow Ochre and Raw Sienna to adjust the central shadow areas of the petals. These shadows are fairly dark at their outer edges and become lighter towards the centre next to the sepals. Use this paint mixture to paint that lighter look, softly blending the colour outwards into the darker shadow areas.

7 Continue working with the mixtures from the previous step to build rich colour in the lighter areas of the petals. Balance the deep shadows and highlighted areas to create a glowing look to the flower. With a small round brush, add lighter edges on the sides of the stem, especially below the flower with a mixture of Chromium Green Oxide, Raw Umber and a small amount of Titanium White.

Finishing

8 Use a small round brush loaded with Titanium White to paint the tiny highlights unevenly on the outer edges of the petals, leaving broken places in the lines with thicker and thinner strokes to create natural highlights. Paint a few whiter highlights at the outer shadow edges where the glow begins. Add a very few highlights near the centre of the flower to complete the glow.

See also

Drawing, pages 14–17
Using Gel, page 22

special detail creating a glowing backlit petal

◀ *Block in the petal shadows with a mixture of Raw Sienna, a little Yellow Ochre and Cadmium Yellow Medium. For the lighter areas, use a mixture of Yellow Ochre and Titanium White. Use these mixtures with varying amounts of the colours for different areas of the flower.*

◀ *Using Cadmium Yellow Medium and Raw Sienna, paint the shadows, mixing the colours carefully to blend with the previous layer of paint. Smudge with a finger or damp paper towel as needed. Add Raw Umber to the mixture and paint the darkest shadows.*

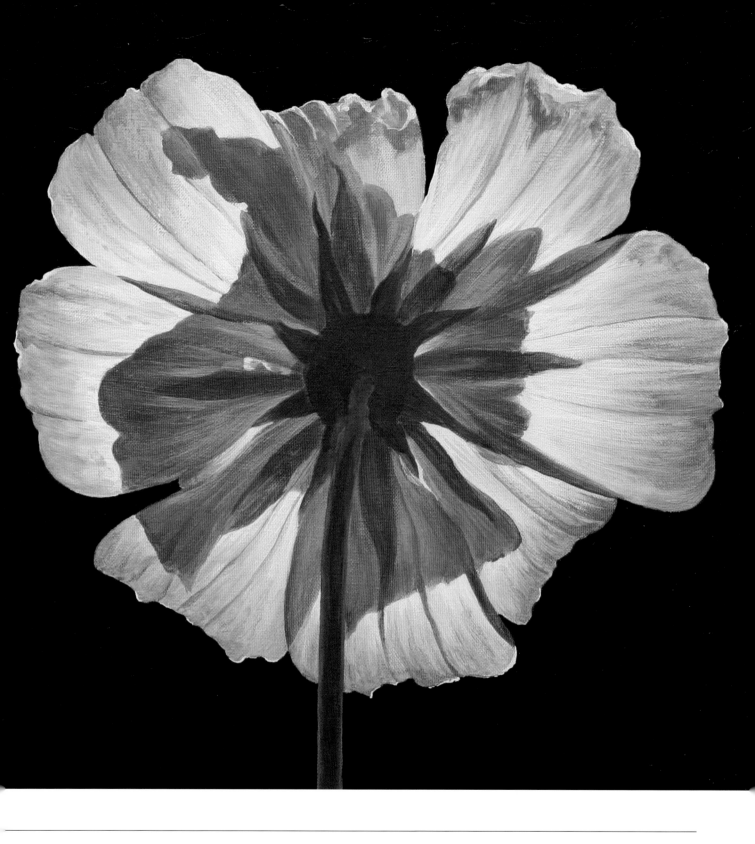

◄ Mix Cadmium Yellow Medium and Titanium White, and paint the glowing lighter areas of the petal. Add a few highlights at the outer edge. Soften some of the shadows with Cadmium Yellow Medium and Raw Sienna.

◄ Balance the shadows and highlights with the previous paint mixtures as needed to create a glowing look. Add Titanium White highlights at the outer edge with a small round brush.

Crocus vernus Spring Crocus

Crocus blossoms herald spring with a colourful splash, sometimes even in snow. You should observe the play of light across the blooms and find the time when the shadows of the central stigma are most interesting. The contrast of these brilliant blossoms with the leftover autumn leaf litter makes an interesting statement of the seasons.

petal stigma

enisform leaf

Palette

| Titanium White |
| Lemon Yellow |
| Cadmium Yellow Medium |
| Yellow Ochre |
| Raw Sienna |
| Raw Umber |
| Perinone Orange |
| Quinacridone Magenta |
| Quinacridone Violet |
| Ultramarine Violet |
| Carbazole Violet |
| Rich Green Gold |
| Green Gold |
| Permanent Green Light |
| Chromium Green Oxide |
| Mars Black |

sequence start to finish

Underpainting

1 Sketch the flowers, leaves and background in pencil. Mix Raw Umber, Titanium White and a little Mars Black, and paint the background, establishing shadows. Combine Chromium Green Oxide, Rich Green Gold and Raw Umber with a small amount of Titanium White and paint the leaves.

2 Paint the petals next with Ultramarine Violet mixed with Quinacridone Violet and Titanium White. Lightly block in the stigma with a combination of Yellow Ochre, Cadmium Yellow Medium and Titanium White.

Using gel

3 Take a palette knife and create a textured gel surface on the background (see Using Gel on p. 22). With a hog-bristle brush, paint the flowers with gel, taking care to follow the forms of the petals and sepals with the brushstrokes.

Defining form and colour

4 Paint varying mixtures of Raw Umber, Yellow Ochre, Mars Black and Titanium White to create the background forms. Observe and maintain the balance of light and dark areas as you work. Create a mixture of Chromium Green Oxide, Rich Green Gold, Raw Umber and a little Mars Black, and use this to darken the shadows in the leaves.

5 Mix Chromium Green Oxide, Green Gold, Permanent Green Light and a little Titanium White to paint the brighter greens in the leaves, blending by smudging as needed. Add more Titanium White and begin to establish the centre white stripes in the leaves. Notice that none of them look totally white because of the angled lighting.

6 Mix Carbazole Violet and Titanium White, and lightly paint the shadows in the petals, blending the colours by smudging with a finger or wet paper towel. Add the shadow of the central stigma at this time. Mix Cadmium Yellow Medium and Titanium White, and begin refining the stigma by blending it so the lower layer of paint breaks through.

Building rich colours

7 Mix Raw Sienna with Yellow Ochre, Raw Umber and Titanium White in differing amounts, and paint some of the background leaves, twigs and rocks, adding colour variation to the background. Lightly smudge some of this mixture in lighter areas of the soil in the lower right-hand corner. Mix Titanium White and Mars Black to make a medium grey and add to a combination of Chromium Green Oxide and Raw Umber. Smudge this mixture into the duller green shadow areas.

8 Mix Quinacridone Magenta with a little Carbazole Violet and Titanium White. Paint some of the brighter purples in the petals with this mixture. Softly blend into the lower layers of paint. Mix Perinone Orange, Cadmium Yellow Medium and Titanium White, and paint the upper parts of the stigma. Add Cadmium Yellow Medium, Yellow Ochre and a little Raw Sienna, and paint the darker area of the bottom of the stigma.

Finishing

9 Paint the Lemon Yellow highlights on the stigma with a small round brush. Use Titanium White to paint highlights towards the centre of the flower.

See also

Drawing, pages 14–17
Using Gel, page 22

special detail adding the shadow of a stigma

◄ *Paint the petals with a mixture of Ultramarine Violet, Quinacridone Violet and Titanium White. Establish the stigma with Yellow Ochre, Cadmium Yellow Medium and Titanium White.*

◄ *Using Carbazole Violet and Titanium White, paint the shadows, mixing the colours carefully to blend with the previous layer of paint. Smudge with a finger or damp paper towel as needed. Make the darker areas of the stigma shadow quite distinct.*

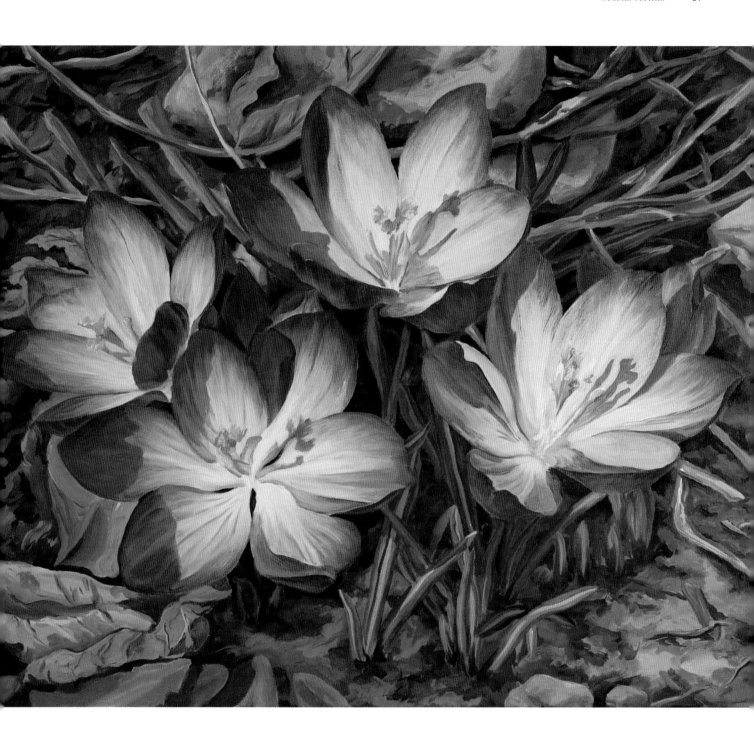

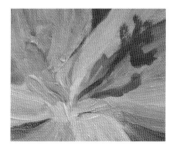

◀ Darken the shadows with more Carbazole Violet and Titanium White. Use Quinacridone Magenta, Carbazole Violet and Titanium White to add rich colour to the petals. Continue refining the stigma according to the painting sequence instructions.

◀ Complete the stigma according to the painting sequence instructions. Paint Titanium White highlights in the centre of the flower, creating contrast and softening the shadow of the stigma for a natural look.

Dahlia variabilis Dahlia

Dahlias are a diverse group of flowers, displaying a huge range of colours and forms. Each petal of a dahlia is actually a complete flower, with its own stamen and pistil. The central disc, in those flowers that have a central disc, is composed of many partly formed florets that also contain stamens and pistils. This dahlia also has petaloids around the centre, which add to the interest of the flower. The play of light on these forms creates a strong sense of space that is delightful to paint.

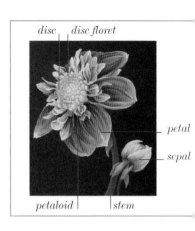

disc disc floret

petal

sepal

petaloid stem

Palette

Titanium White

Lemon Yellow

Nickel Titanate Yellow

Cadmium Yellow Medium

Yellow Ochre

Raw Sienna

Raw Umber

Permanent Red

Quinacridone Magenta

Quinacridone Violet

Green Gold

Chromium Green Oxide

Mars Black

sequence start to finish

Underpainting

1 Sketch the flower, bud, stem and leaves in pencil. Notice the layers of petals and petaloids in the flower and how they occupy space. Mix Chromium Green Oxide, Raw Umber and a little Mars Black, and paint a deep olive green for the background. Add a little Titanium White and paint the stems and shadows in the leaf and bud. Mix Green Gold and Chromium Green Oxide with Titanium White, and use this to paint the lighter areas of the sepals on the bud.

2 Mix a little Permanent Red with Quinacridone Magenta and Titanium White to paint the petals and petaloids of the flower, establishing the shadows. Use Lemon Yellow, Yellow Ochre and Titanium White mixtures to paint the disc of the flower.

Using gel

3 Use a hog-bristle brush to paint gel on the background, creating a nice texture (see Using Gel on p. 22). Paint gel following the forms of the flower, bud and stems. Allow this to dry completely before continuing.

Increasing contrast

4 Repaint the background texture to cover the milky look of the gel. Paint the stems with a Chromium Green Oxide, Raw Umber and Mars Black mixture. Add a small amount of Titanium White to the mix and paint the lighter edges of the stems. Use Nickel Titanate Yellow, Lemon Yellow, Green Gold, and Titanium White in varying mixtures for the lighter areas of the sepals on the bud.

5 Use Quinacridone Magenta and Titanium White to add intensity to the shadows and mid-ranges on the petals and petaloids. Use a small amount of Quinacridone Violet mixed with Quinacridone Magenta in the deepest shadows. Paint the shadows in the disc with Raw Sienna mixed with Cadmium Yellow Medium. Paint the highlights in the disc with Lemon Yellow mixed with Titanium White.

Softening colour transitions

6 Blend the colour transitions in all the petals and petaloids carefully, smudging fresh paint with a finger or wet paper towel. The shadows should have gradations of colour that create a sense of softness while keeping a strong overall contrast. Use Cadmium

Yellow Medium and Yellow Ochre to lightly smudge the shadowed half of the disc. Wipe off excess paint with a paper towel.

7 Make smooth gradations of colours in the sepals of the bud. The sepals should range from a pale Nickel Titanate Yellow at the highlighted edges to a stronger yellow, blending into yellow-green and deepening into the darkest greens at the base. Use all of the mixtures of greens and yellows in previous steps to refine these transitions, smudging as needed.

Finishing

8 Using a small round brush, paint the highlights in Titanium White. Notice how working with the white highlights on the petals, petaloids and bud in particular creates a strong sense of dimension and space. Paint Titanium White highlights on the brightly lit disc florets, but not on the shadowed ones.

See also

Drawing, pages 14–17
Using Gel, page 22

special detail using shadows and highlights to create space

◀ *Paint the petals and petaloids in a mixture of Permanent Red, Quinacridone Magenta and Titanium White. Use more Titanium White in the mixture in the lighter areas.*

◀ *Paint Quinacridone Magenta mixed with varying amounts of Titanium White to enhance and deepen the shadows. Paint a tiny amount of Quinacridone Magenta and Quinacridone Violet into the deepest shadows.*

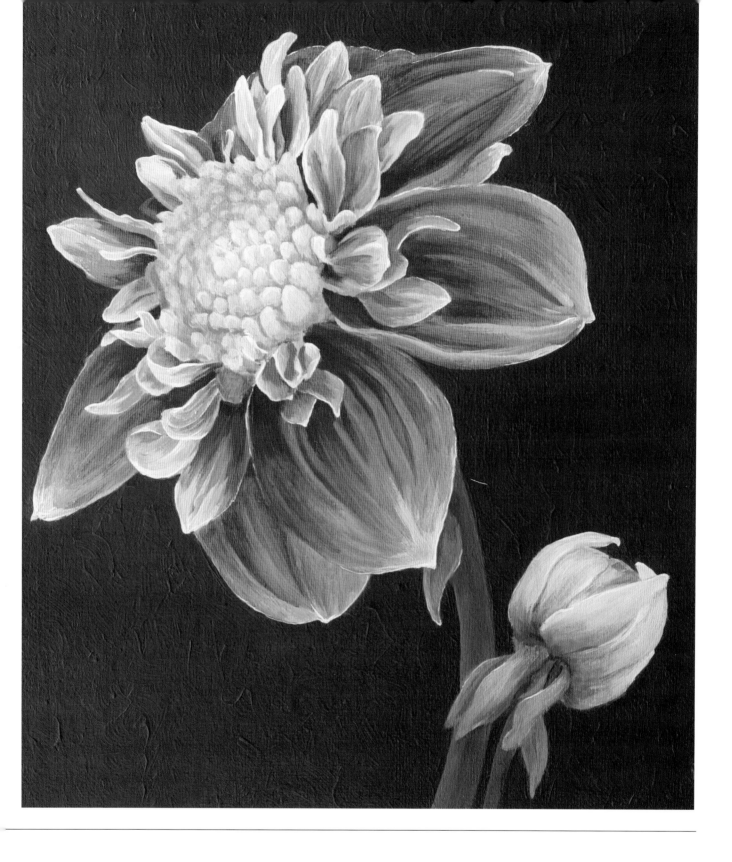

◄ Continue using the colour mixtures from the previous step to soften the colour transitions, smudging and blending to make the petals and petaloids look soft.

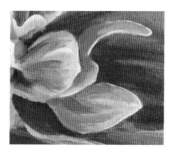

◄ Add Titanium White highlights to lift the brightly lit areas of the petaloids out of the shadows, creating a sense of occupying space.

Delphinium Delphinium

Delphiniums are grand perennials that grow tall stalks holding many florets spiralling upward. Oddly enough, the parts that look like petals actually are the sepals, and the small shapes in the centre are the true petals. Here, only two florets are shown, to better enjoy the sparkling texture and rich colours of the sepals. The eye is continually drawn to contrasts in colour, in light and shadow, and between smooth and textured surfaces.

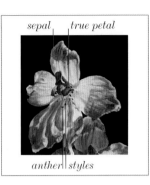

sepal true petal

anther styles

Palette

Titanium White

Lemon Yellow

Cadmium Yellow Medium

Raw Sienna

Raw Umber

Ultramarine Violet

Carbazole Violet

Cerulean Blue

Indanthrone Blue

Green Gold

Permanent Green Light

Chromium Green Oxide

Mars Black

sequence start to finish

Underpainting

1 Use a pencil to sketch the florets and stems. Paint the background Mars Black for maximum contrast. Mix Indanthrone Blue with Titanium White and block in the sepals, establishing the shadows, but fairly lightly.

2 Mix Carbazole Violet with Titanium White and paint the beginning forms of the violet areas in this colour. Paint the true petals with Indanthrone Blue mixed with Carbazole Violet and a tiny amount of Titanium White. Paint the stems with Chromium Green Oxide mixed with Permanent Green Light and Titanium White.

Using gel

3 Apply gel to the background with a hog-bristle brush (see Using Gel on p. 22). Paint the gel on the sepals heavily, dragging the brush to create strong grooves in the texture, extending from the centre of the floret outward towards the tips of the sepals, following the forms of the sepals. Allow to dry.

Building colour

4 Paint the background Mars Black over the texture. Begin to work with the texture on the sepals by painting the bluer areas loosely with a varying mixture of Indanthrone Blue, Cerulean Blue and Titanium White. Drag the brush slightly, to catch the texture with the paint. Mix Ultramarine Violet with Titanium White and repeat on the more violet areas of the sepals.

5 Paint the true petals with Carbazole Violet and a tiny amount of Titanium White. Paint the centre areas of these petals with Cadmium Yellow Medium, Lemon Yellow and Raw Sienna, softly smudged into place. Mix a tiny amount of Raw Umber with the Chromium Green Oxide, Permanent Green Light and Titanium White mixture, and paint the darker shadows in the stems. Paint the lighter areas of the stems with more Titanium White and no Raw Umber in the mixture.

Adding depth and detail

6 Continue painting the sepals with overlapping layers of the blue and violet paint mixtures. Create strong shadow areas contrasted with lighter areas, and continue working with the gel texture to add interest to the paint surface.

7 Paint the anthers Mars Black highlighted with a small amount of Raw Umber. Paint the styles with varying mixtures of Indanthrone Blue mixed with Titanium White. Blend the shadows and highlights of the stems by smudging a mixture of Permanent Green Light and Chromium Green Oxide down the middle, using your finger or a damp paper towel to blend the colour smoothly.

Finishing

8 Smudge a mixture of Green Gold, Chromium Green Oxide and Titanium White into the base of the sepals near the centre of the floret to create a soft glow. Use it near the tips of the sepals beside the dark splotch at those tips. Drag a brush carrying Titanium White lightly across the texture in the sepals where white highlights are needed. Using a small round brush, paint highlights in Titanium White where needed on the edges of the sepals.

See also

Drawing, pages 14–17
Using Gel, page 22

special detail creating sparkling texture

▲ *Paint the sepals in mixtures of Indanthrone Blue and Titanium White in varying intensities. Add areas of Carbazole Violet mixed with Titanium White. Add texture with gel and allow to dry.*

▲ *Use Indanthrone Blue, Cerulean Blue and Titanium White in varying mixtures to paint the shadow areas of the sepals. Repeat with Titanium White mixed with Ultramarine Violet in the more violet areas.*

▲ *With the same colour mixtures, add depth and richness to the layers of colour. Work with the texture by painting the top parts of the texture while dragging the brush lightly to skip the deeper areas.*

▲ *Smudge a little mix of Green Gold, Chromium Green Oxide and Titanium White at the tip of the sepal. Drag Titanium White across the textured ridges to form highlights across broad areas for the final sparkles.*

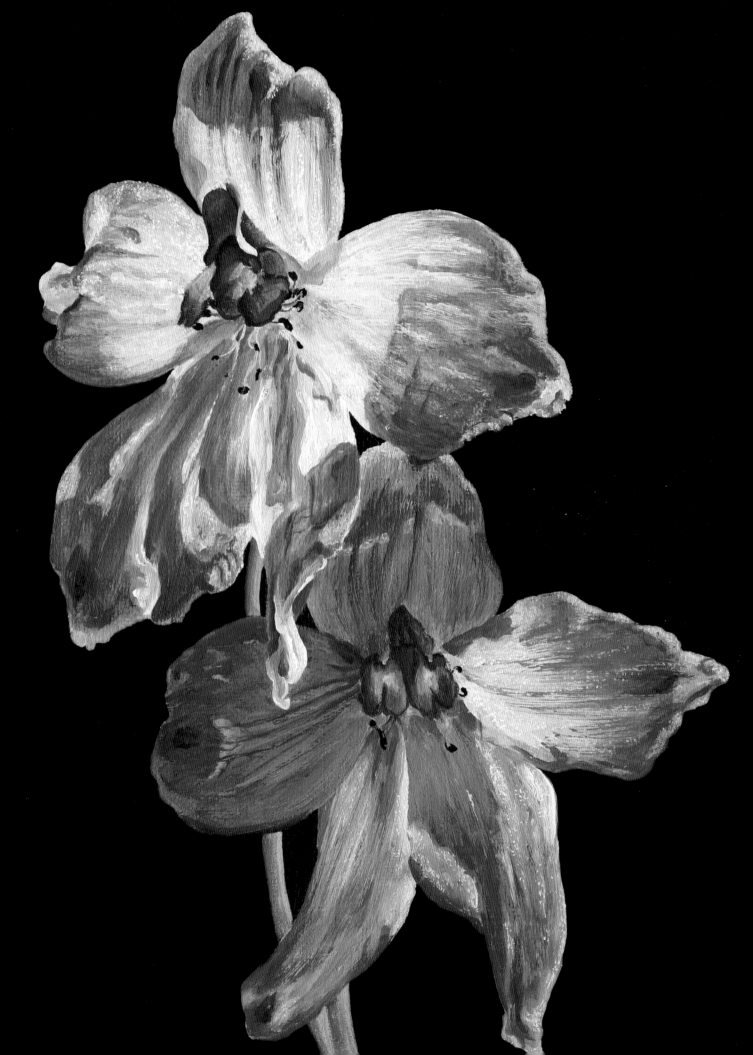

Dianthus Pinks

Dianthus are commonly called pinks not because of their colour but because the edges of their petals look as though they have been cut with pinking shears. The colour pink ended up taking its name from the flower itself. Due to the easy hybridizing this plant offers, the flowers are now available in a rainbow of colours. With interesting curls and rolls in the petals highlighted by slanting light, the artist sees a magnificent opportunity for painting. The lance-shaped leaves and closed bud add even more interest with their curving shapes and shadows. The entire composition works well.

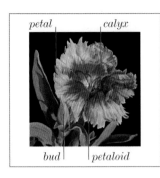

petal calyx

bud petaloid

Palette

Titanium White

Lemon Yellow

Raw Umber

Quinacridone Coral

Anthraquinoid Red

Permanent Red

Quinacridone Magenta

Quinacridone Pink

Quinacridone Red

Quinacridone Violet

Chromium Green Oxide

Mars Black

sequence start to finish

Underpainting

1 Sketch the flower, leaves and bud in pencil. Paint the background Mars Black. Mix Chromium Green Oxide, Raw Umber and Titanium White with a small amount of Mars Black, and paint the shadows in the leaves. Use more Titanium White in this mixture for the lighter areas of the leaves.

2 Paint the petals with a combination of Quinacridone Red, Quinacridone Pink and Titanium White, establishing shadows and darker areas. Add a little Quinacridone Violet to the previous mixture and paint the shadows in the calyx and the shadow of the calyx. Use some of the green mixture from the leaves to paint the deep centre of the flower, smudging it gently on the bottom of the calyx.

Using gel

3 Paint the canvas with gel using a hog-bristle brush (see Using Gel on p. 22). Follow the forms of the petals, leaves and bud with the brushstrokes. Create an interesting texture in the background. Allow to dry.

Increasing rich colour

4 Use Chromium Green Oxide, Raw Umber and Titanium White with a small amount of Mars Black for leaves. Continue refining the shapes. Be sure to vary the blends in the shadows to show the reflected light.

5 Mix Permanent Red, Quinacridone Red and a tiny amount of Titanium White, and paint the reddish centre of the flower. Use Anthraquinoid Red and Permanent Red to paint the darker shadows in the petals.

6 Mix Quinacridone Red and Titanium White and paint the lighter outer areas of the petals, working with the curving forms and vein of the petals. Use Quinacridone Magenta and Titanium White for the upper right two petals, which are more shadowed. Add a little Quinacridone Violet in the deeper shadows. Paint a tiny amount of pure Mars Black in deep centre of the flower around the base of the calyx.

Refining the blends

7 Work with all the previous mixtures to soften the blends of the colour transitions. These petals need to look soft to the touch and harsh colour transitions ruin that look. Pay particular

attention to the transition from the red centre to the pink outer parts of the petals. Paint a Quinacridone Red and Titanium White mixture to create highlighted areas on the red centre area of the petals.

Finishing

8 Use Quinacridone Coral to paint the red centre area of the petals as well as some of the more intense shadow areas in the outer parts of the petals. Use your finger or a damp paper towel to smudge this transparent layer. Use a small round brush to paint the Lemon Yellow highlights on the stigma. Use Titanium White to paint tiny highlights with strokes varying in thickness and with skips and breaks on the outer edges of the petals, calyx, leaves and buds. Add a few highlights in the lighter areas of the petals.

See also

Drawing, pages 14–17
Using Gel, page 22

special detail creating depth in the flower centre

◂ *Paint the petals with a mixture of Quinacridone Red, Quinacridone Pink and Titanium White. Add Quinacridone Violet and paint the deeper shadows, including the shadow of the calyx. Use Chromium Green Oxide, Raw Umber, Titanium White and a little Mars Black to paint the green areas around the calyx.*

◂ *Mix Permanent Red, Quinacridone Red and Titanium White, and paint the redder areas of the petals. Use Anthraquinoid Red and Permanent Red to paint the deeper shadows. Use Mars Black to paint the deepest shadows at the base of the calyx. Paint Quinacridone Violet and Titanium White on the whiter part of the calyx.*

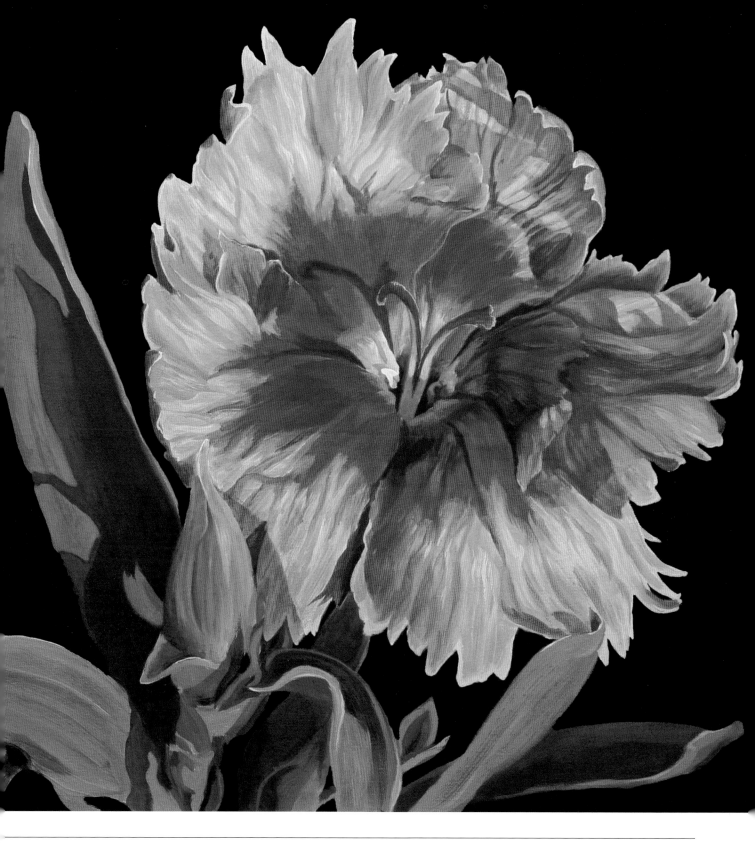

◄ Paint Quinacridone Red and Titanium White
to create highlights on the redder parts of the
petals. Use Quinacridone Magenta and
Titanium White to soften the lighter areas of
the petal. Smudge Titanium White to lighten
the whiter part of the calyx above the shadow
falling on it.

◄ With a small round brush,
add Titanium White highlights.
Notice how using them along the
edges of the calyx creates a great
sense of space.

Digitalis Foxglove

The foxglove is a biennial with tall spikes of ascending flowers. Each flower has petals that are completely fused into a tube. The entire plant is toxic, but the leaves are used to make digitalis, a heart stimulant. The name foxglove may be a corruption of 'folk's glove' – it was believed that the flowers were gloves for fairies. These wonderful flowers can reach 1–1.5 m feet high, making a dramatic accent in the garden or in a painting.

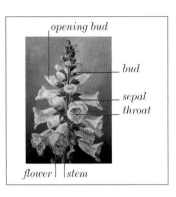

opening bud

bud

sepal
throat

flower *stem*

Palette

Titanium White

Cadmium Yellow
Medium

Yellow Ochre

Raw Umber

Anthraquinoid Red

Quinacridone
Magenta

Quinacridone Red

Carbazole Violet

Green Gold

Permanent Green
Light

Chromium Green
Oxide

Mars Black

sequence start to finish

Underpainting

1 Sketch the foxglove plant in pencil. Paint the background with varying mixtures of Chromium Green Oxide, Raw Umber, Yellow Ochre and Titanium White. Mix Chromium Green Oxide, Permanent Green Light, Raw Umber and Titanium White, and paint the leaves, sepals and stem, emphasizing the shadows and highlights.

2 Paint the opening buds Cadmium Yellow Medium, Yellow Ochre and Titanium White, again establishing the shadows and highlights. Use Quinacridone Red, Quinacridone Magenta and Titanium White for the flowers, adding more white for the highlights. Blend some of the opening bud mixtures into the middle transitional flowers.

Using gel

3 Use a hog-bristle brush to coat the painting with gel (see Using Gel on p. 22). Follow the forms of the flowers, buds, leaves, sepals and stem with the brushstrokes. Make an attractive texture in the background. Allow to dry.

Defining form

4 Repaint the background. Continue using the previous green mixtures for the leaves, sepals and stem, and make the shadows strongly defined. Mix a tiny amount of Carbazole Violet and a tiny amount of Mars Black with plenty of Titanium White, and paint the opening buds and flowers, blending into the previous layer. Paint more Cadmium Yellow Medium into parts of the opening buds. Use the previous mixtures to blend into the shadows, building rich colour. Mix Quinacridone Magenta with Anthraquinoid Red, and use a small round brush to paint the splotches in the throats of the flowers.

Refining detail

5 Mix Green Gold, Chromium Green Oxide, Raw Umber and Titanium White for the highlights in the buds, sepals, leaves and stem, blending carefully. Continue refining the flowers and opening buds with the previous mixtures. Mix Carbazole Violet, Mars Black, Quinacridone Red and lots of Titanium White to make a greyed white, and use a small round brush to paint the light areas around the Quinacridone Magenta and Anthraquinoid Red splotches.

6 Repaint the inner splotches with a small brush. Combine Quinacridone Magenta, Anthraquinoid Red and Raw Umber for the shadow splotches. Mix a tiny amount of the Carbazole Violet with Quinacridone Magenta and Anthraquinoid Red, and use this for the splotches on the outsides of the flowers and opening buds. The splotches on the outside of the petals should be muted compared to the splotches in the throats.

Finishing

7 With a small round brush, paint Titanium White areas around the brightly lit splotches in the throat of the flowers. Blend Titanium White highlights into the flowers and opening buds and then add sharp Titanium White accents on the edges in the light. Add more accents on the buds, leaves, sepals and stem as needed.

See also

Drawing, pages 14–17
Using Gel, page 22

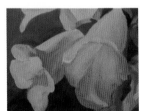

special detail painting tubular flowers

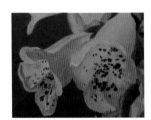

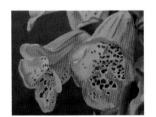

▲ *Loosely establish the shadows with Quinacridone Red, Quinacridone Magenta and Titanium White. Add more Titanium White for the highlighted areas.*

▲ *Blend a little Cadmium Yellow Medium and Titanium White into the base of the tubes and the lighter areas inside the tube. Add a few shadows in Carbazole Violet, Mars Black and Titanium White. Add splotches in Anthraquinoid Red and Quinacridone Magenta.*

▲ *Using the previous mixtures, refine the forms carefully. Paint Carbazole Violet, Mars Black, Quinacridone Red and lots of Titanium White as a greyed white around the shadowed splotches. Add Raw Umber to the mixture used previously for the splotches and repaint the shadowed inner splotches.*

▲ *Blend Titanium White into the lighter areas of the tubes. Paint white areas around the brightly lit splotches. Add tiny white edges where the light hits the flowers. Add Raw Umber to the mixture used previously for the splotches and repaint the shadowed inner splotches.*

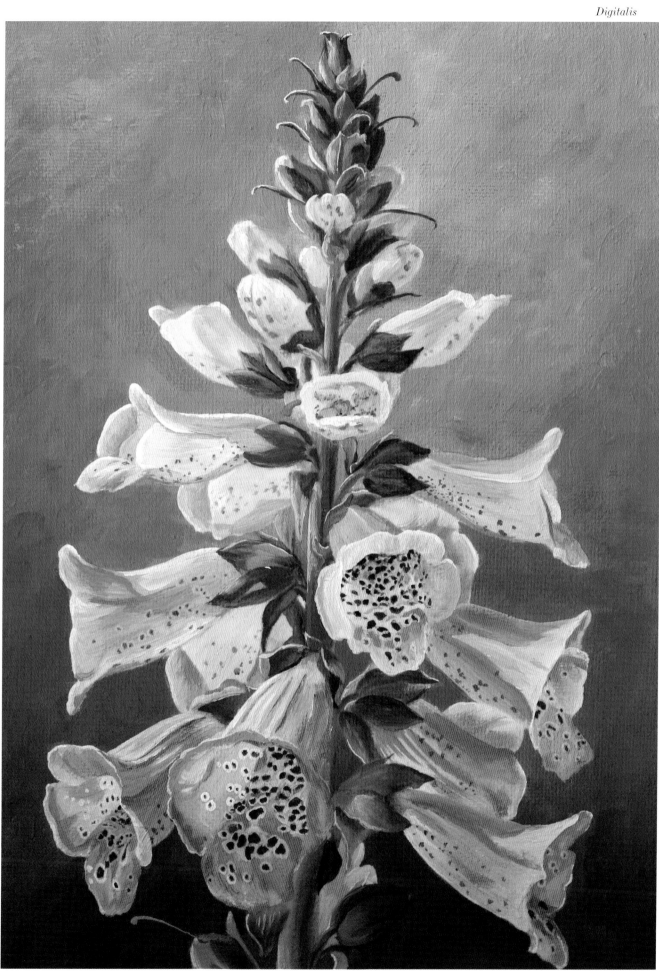

Echinacea Coneflower

Echinacea was used extensively by Native Americans for medicinal purposes. Europeans also used it as a medicine, and it has now become popular as a herbal remedy. Echinacea flowers are from the Composite family; this means that what appear to be petals are actually ray florets, each a complete flower. The striking centre cone is composed of disc florets. The buds are distinctive, with the centre cone appearing first and the ray florets growing outward from the centre cone. The plant has large bold leaves and, for the artist, lends itself to strong compositions.

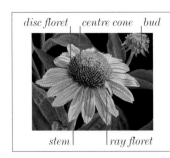
disc floret centre cone bud

stem | ray floret

Palette

Titanium White

Cadmium Yellow Medium

Yellow Ochre

Raw Umber

Perinone Orange

Quinacridone Magenta

Quinacridone Red

Carbazole Violet

Rich Green Gold

Green Gold

Permanent Green

Chromium Green Oxide

Mars Black

sequence start to finish

Underpainting

1 Sketch the ray florets, centre cone, bud, leaves and stems in pencil. Paint the background Mars Black. Mix Chromium Green Oxide, Raw Umber and Titanium White to paint the leaves and stems. Mix varying combinations of Chromium Green Oxide, Green Gold, Rich Green Gold, Raw Umber and Titanium White, and paint the bud and the more intensely green parts of the leaves and stems. Also paint the middle of the centre cone.

2 Use Quinacridone Red, Quinacridone Magenta and Titanium White for the ray florets. Mix Cadmium Yellow Medium and Perinone Orange, and paint the disc florets. Add Titanium White for the lighter areas. Paint Raw Umber into the deep shadows of the centre cone.

Using gel

3 Use a hog-bristle brush to coat the painting with gel (see Using Gel on p. 22). Follow the forms of the leaves, stems, bud, centre cone and ray florets with the brushstrokes. Allow to dry.

Building rich colour

4 Repaint the background. Continue using the previous green mixtures for the leaves, stems, bud and middle of the cone. Mix Chromium Green Oxide, Permanent Green, Raw Umber and a little Titanium White, and paint the richer greens.

5 Use Quinacridone Red, Quinacridone Magenta, a minute amount of Carbazole Violet and Titanium White for the shadows in the ray florets that have a bluish hint to them. Use a mixture of Quinacridone Red, Quinacridone Magenta, Yellow Ochre and Titanium White for the rest of the ray florets. Paint Raw Umber in the darkest shadows of the cone, smoothly blending them outward into the ray florets.

Increasing intensity

6 Continue working with the previous green mixtures to detail the leaves, stems and bud. Define the shadows strongly, using Chromium Green Oxide, Raw Umber and a tiny amount of Mars Black. Use Green Gold and Titanium White to paint the brighter highlights.

7 For the ray florets, paint Quinacridone Red, Quinacridone Magenta, Yellow Ochre and plenty of Titanium White into the brighter parts to show the light falling across them. Use Perinone Orange and Cadmium Yellow Medium with Titanium White to create the graduated colour in the disc florets, which are strongly orange at the tips, becoming paler towards the base. Add orange tips to the yellow-green middle disc florets.

Finishing

8 Because the leaves, stems and bud are already powerful in appearance, use Titanium White highlights only on the disc and ray florets. Use a small round brush and paint the highlights on a few tips of the disc florets. Then paint the highlights in the ray florets, blending as needed.

See also

Drawing, pages 14–17
Using Gel, page 22

special detail painting disc florets in the centre cone

◄ *Paint the middle of the cone with the mixture specified in the painting sequence. Paint the rest of the disc florets Cadmium Yellow Medium and Perinone Orange, with Titanium White added in the lighter parts. Use Raw Umber for the deep shadow.*

◄ *Continue working with the previous mixtures, refining the shapes of the disc florets. Create the graduated colour in them and add orange tips to the middle disc florets.*

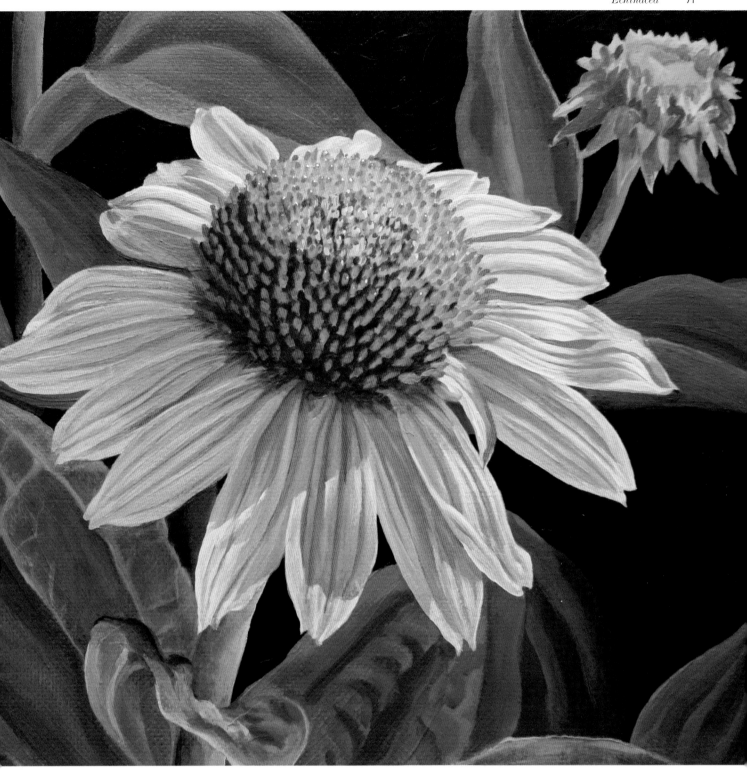

◄ *Add intensity by increasing the amount of Perinone Orange in the tips. Add Titanium White to the green mixture and highlight the middle disc florets. Paint Titanium White highlights sparingly on the tips of some of the disc florets. Smudge a little Raw Umber over the shadowed disc florets to make them recede into the shadows.*

Eschscholzia californica California Poppy

The golden California poppy is an easily grown annual, thriving in poor soil, drought and heat. The blossoms have four petals that open in a cup shape, with a pink tinted collar below the petals called a receptacle. When spring brings good rainfall, entire mountainsides in southwestern USA are covered with blankets of these splendid flowers. Plant breeders have developed new varieties that display shades of orange, pink and white, in addition to the original golden colour. In the garden, the artist becomes entranced by the rich glow that sunlight brings to these flowers.

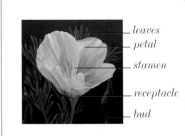

— leaves
— petal
— stamen
— receptacle
— bud

Palette

Titanium White

Lemon Yellow

Nickel Titanate Yellow

Nickel Azo Yellow

Cadmium Yellow Medium

Yellow Ochre

Raw Sienna

Raw Umber

Perinone Orange

Anthraquinoid Red

Green Gold

Permanent Green Light

Chromium Green Oxide

Mars Black

sequence start to finish

Underpainting

1 Using a pencil, sketch the flower, buds, leaves and stems. Paint the background with a mixture of Chromium Green Oxide, Raw Umber and a tiny amount of Mars Black. Add a little Titanium White to the mixture towards the top of the painting to give a graduated background.

2 Use a mixture of Green Gold, Permanent Green Light and Chromium Green Oxide with either Titanium White for lighter areas or Raw Umber for darker areas, and paint the leaves, stems and buds. Establish the shadows, noticing the direction of light as you paint. Mix Raw Sienna with Cadmium Yellow Medium for the shadow areas of the petals. For the lighter areas of the petals, use Lemon Yellow mixed with Titanium White and occasionally a little Cadmium Yellow Medium. Use these yellow mixtures for the stamens also.

Using gel

3 Texture the background with gel and a hog-bristle brush (see Using Gel on p. 22). Use the gel fairly smoothly on the leaves, buds, stems and petals. Allow to dry.

Developing form and colour

4 Paint the background again as before. Refine the shadows and highlights in the leaves and stems with the green mixtures from the underpainting. Add a tiny amount of Mars Black and Titanium White to these mixtures to slightly neutralize the greens in the buds, giving a softer look. Carefully blend the colours to create naturally rounded forms. Notice the bud on the right has a shadow on the lower portion, so paint the lighter areas in the shadow darker (see Values on p. 19) than the lighter areas where the sun touches it.

5 Paint the shadows in the petals and stamens with varying mixtures of Cadmium Yellow Medium, Lemon Yellow and Raw Sienna. Use Nickel Titanate Yellow mixed with Lemon Yellow or Titanium White for lighter areas. Gently blend the transitions of colour by smudging. Add a tiny amount of Perinone Orange to Cadmium Yellow Medium to accent the more brilliant areas of shadow. Use Yellow Ochre, Nickel Azo Yellow and Cadmium Yellow Medium for the duller shadow areas.

Finishing

6 Taking care to maintain the direction of light already established, use a small round brush to paint subtle highlights with Titanium White on the buds and a few of the leaves. Paint Anthraquinoid Red on the edge of the receptacle under the flower. Smudge it delicately into the shadow while keeping the outer edge quite distinct. Use Titanium White to create broad highlights in the petals. Use a small round brush to paint Titanium White highlights on the edges of the petals, leaving spaces and breaks in the strokes for a natural look.

See also

Drawing, pages 14–17
Values, page 19
Using Gel, page 22

special detail shadows in yellow

◄ *Paint the shadows in the petals with a mixture of Raw Sienna and Cadmium Yellow Medium. Use Lemon Yellow mixed with Titanium White and occasionally with a little Cadmium Yellow Medium for the lighter areas.*

◄ *Combine Cadmium Yellow Medium, Lemon Yellow and Raw Sienna to create rich shadow colours. Mixing black into yellow creates unpleasant colours, so avoid this for shadows. T paint duller shadows, mix Nickel A Yellow, Yellow Ochre and Cadmium Yellow Medium. Mix Nickel Titanat Yellow, Lemon Yellow and Titanium White for the lighter areas.*

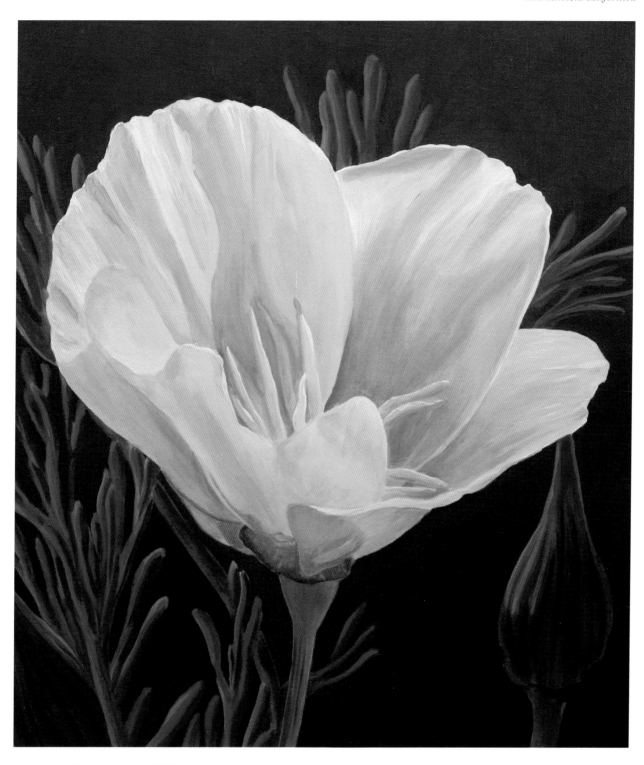

◄ *Continue using the colour mixtures from the previous step to soften the blends of colour. Smudge with your finger or a damp paper towel as needed.*

◄ *Add a tiny amount of Perinone Orange to Cadmium Yellow Medium to accent the more brilliant areas of shadow. Paint Anthraquinoid Red on the edge of the receptacle, blending it softly away from the edge. Add Titanium White highlights to complete the painting.*

Fuchsia Ladies' Eardrops

Fuchsias grow in glorious tangles of multicoloured flowers. The buds form in pairs and their opened flowers have interesting and unusual shapes. This particular variety has high lifted red-orange sepals and a deep purple corolla richly folded in shadowed whorls from which descend the long slender stamens. As this flower is so complex, it is best to paint it without including any distracting foliage.

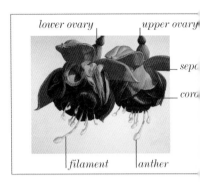

lower ovary upper ovary

sep

cora

filament anther

Palette

Titanium White

Cadmium Yellow Light

Cadmium Yellow Medium

Cadmium Orange

Quinacridone Coral

Quinacridone Red

Cadmium Red Medium

Permanent Carmine

Ultramarine Violet

Carbazole Violet

Mars Black

sequence start to finish

Underpainting

1 Outline the shapes in pencil. Paint the undersides of the sepals Cadmium Orange in the darker areas and a mixture of Cadmium Orange and Cadmium Yellow Medium in the lighter areas. For the tops of the sepals and lower ovaries use Permanent Carmine mixed with Titanium White.

2 Mix Quinacridone Red and Titanium White and paint the pink areas of the corollas. Mix Ultramarine Violet and Titanium White and paint the purple areas of the corollas and the upper ovaries. Establish the shadows during this process.

3 Paint the filaments with Quinacridone Red and Titanium White. Use Permanent Carmine in the filaments' shadowed areas.

Using gel

4 Take a palette knife and create a textured gel surface on the background (see Using Gel on p. 22). With a hog-bristle brush, paint the flowers with gel, taking care to follow the forms of the petals and sepals with the brushstrokes.

Building richness

5 Use a mixture of Cadmium Red Medium and Permanent Carmine to lightly paint the darker areas of the undersides of the sepals. Blend into the highlighted areas for a natural look. Use layers of this mixture and the Cadmium Orange and Cadmium Yellow Medium to create the glow. Repeat on the upper part of the right fuchsia corolla where the light reflects. Allow to dry. Dilute Quinacridone Coral with water and apply to the undersides of the sepals and the reflected area.

6 For the corollas, mix Quinacridone Red with Titanium White. Paint the edges of the petals in the corollas and the broader pink areas inside those petals. Add a small amount of Ultramarine Violet to the mix and paint the gradations where the pink blends into the purple. Work in layers to create soft blends of colour.

7 Paint Permanent Carmine mixed with Titanium White on the filaments. Paint the anthers in Cadmium Yellow Light and Cadmium Yellow Medium mixed with Titanium White as needed. Dilute Carbazole Violet with water and paint over the shadowed tops of the filaments and the shadowed anther in the right fuchsia corolla.

Adding shadows

8 Paint thin shadows on the left edges of the filaments, anthers and ovaries in the colour mixtures for those parts. Paint lighter edges on the right sides of those parts. Dilute a mixture of Quinacridone Red, Ultramarine Violet and Titanium White. Lightly paint this over the darker areas in the anthers, blending them softly.

9 Paint Carbazole Violet in the shadow areas of the corollas. Blend a mix of Carbazole Violet and Mars Black into the deepest areas.

Finishing

10 Use a small round brush with Titanium White to paint the petal and sepal edges where they catch the light. Work these highlights in an irregular manner, using thin broken lines to give a natural look.

See also

Drawing, pages 14–17
Using Gel, page 22

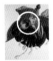

special detail creating soft blends of colour

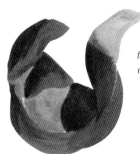

◀ *Block in the petal with the underpainting colours. Allow to dry. Smoothly apply gel with a hog-bristle brush.*

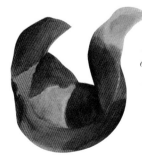

◀ *Soften the harsh edges of dark shadows by mixing Quinacridone Red and Titanium White and painting over the edge of the shadow. With a damp paper towel smudge the paint. Mix Ultramarine Violet with Titanium White and paint into the deeper pink areas.*

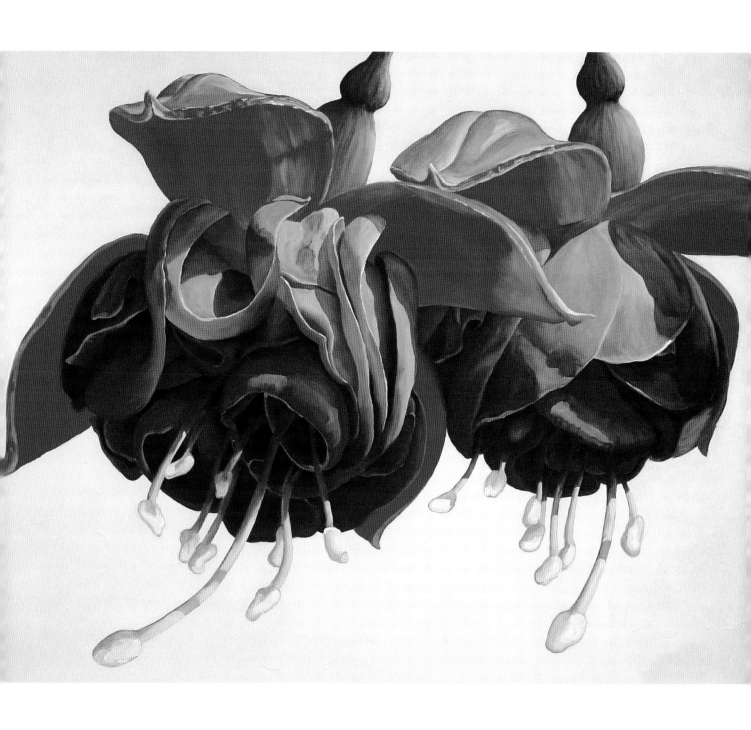

◀ *Continue working in layers to blend the colours, adding layers and gently blending to create smooth transitions of colour.*

◀ *Working in layers and softly smudging the paint, lighten a few areas that need it. Take a tiny round brush and delicately paint the highlighted edge of the petal.*

Gardenia Gardenia

Gardenias are native to China and are unable to survive cool climates. These evergreen bushes or small trees have glossy, deep green leaves that are leathery and strong. The plant is characterized by a naturally well-shaped form, bearing white or pale yellow flowers. Favoured by florists, richly fragrant gardenias are often used for corsages. The petals are waxy and deeply textured, turning a yellowish tint as they age. The flowers themselves somewhat resemble roses. When preparing to paint gardenias, it is helpful to use the light to illuminate the petals to show their texture and luminosity.

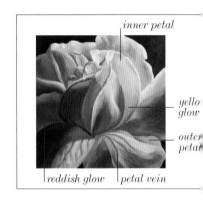

inner petal

yellow glow

outer petal

reddish glow *petal vein*

Palette

Titanium White	
Nickel Titanate Yellow	
Nickel Azo Yellow	
Cadmium Yellow Medium	
Yellow Ochre	
Raw Sienna	
Raw Umber	
Anthraquinoid Red	

sequence start to finish

Underpainting

1 Use a pencil to sketch the petals of the gardenia. Observe the luminous glow from the backlighting and the forms of the shadows. Paint the background a mixture of Raw Umber, Yellow Ochre and Titanium White.

2 Add more Titanium White to the background mix and paint the main shadows in the petals. Add more Titanium White to the mix and blend softly into the lighter areas. Accentuate the glowing yellow areas with more Yellow Ochre. Add Raw Sienna to a little Raw Umber and Titanium White for the glowing redder area on the left. With the original mixture for the background, paint a few dark accents along petal edges where distinct darker edges appear. Establish all the shadow placements as you work.

Using gel

3 Paint the background and petals with an interesting texture in gel using a hog-bristle brush (see Using Gel on p. 22). Carefully emphasize the shapes of the petals, following their forms with the brushstrokes. Allow this to dry before continuing.

Increasing intensity

4 Repaint the background with the previous mixture. Combine Nickel Titanate Yellow with varying mixtures of Yellow Ochre, Raw Umber and Titanium White. Paint the lighter areas of the petals in these mixtures, emphasizing more of the Yellow Ochre. Follow the shadows and blend carefully.

5 Establish the yellow glowing areas clearly. Delineate the veins in the outer petals with darker mixtures, emphasizing the Raw Umber. For the mid-range tones, blend the mixtures over each other until a nice gradient is created. In the glowing redder area, mix Raw Sienna, Nickel Azo Yellow, Raw Umber and a little Titanium White.

Adding richness

6 Continue painting the petals with the previous mixtures, building layers so that the petals begin to glow. Mix Cadmium Yellow Medium with a little Titanium White, and paint a vibrant emphasis in the yellow glowing areas. Add a tiny amount of Anthraquinoid Red to a mixture of Raw Sienna with a little Raw Umber. Use this to create the reddish shadowed

areas at the base of the central petals. Blend the reddish glowing area smoothly. Take extra care to blend all the petals softly.

Finishing

7 Use a small round brush to paint strokes of varying thicknesses of Titanium White along the edges of the highlighted areas. Leave broken areas and unevenness to create a natural look. Blend broader areas of Titanium White into the broader highlighted areas of the petals.

See also

Drawing, pages 14–17
Using Gel, page 22

special detail painting rich shadows

◀ *Paint the shadows with Yellow Ochre, Raw Umber and Titanium White. Paint the lighter areas with more Titanium White in the mixture. Add more Yellow Ochre to paint the yellow glowing area.*

◀ *Continue painting with the previous mixtures, creating richer colour.*

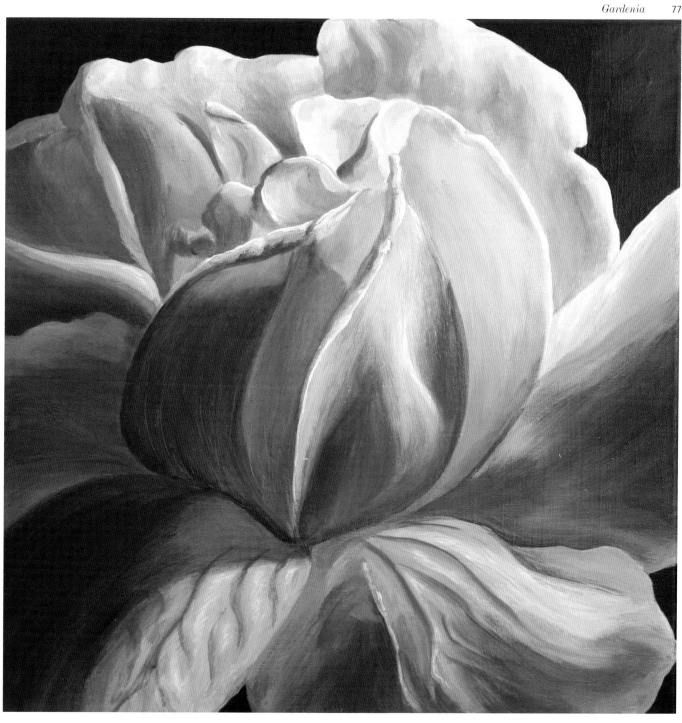

◀ *Mix a little Anthraquinoid Red with Raw Sienna and Raw Umber to paint the deep red shadow area. Continue developing the shadows with a little Raw Sienna added to the mixture.*

◀ *Use Cadmium Yellow Medium with a little Titanium White to paint the glowing yellow area. Add Titanium White highlights.*

Gazania Gazania

Gazanias thrive in hot, dry, windy locations and bloom in a wide range of colours, such as combinations of red, orange, yellow, pink, burgundy, copper and white. Native to South Africa, the plant is named after a fifteenth-century Greek scholar, Theodore de Gaza. Daisy-like in appearance, the blooms are composed of groupings of ray florets and disc florets, all individual flowers in their own right. The bloom has many sepals at the base and distinctive splotches at the bottom of each ray floret. These dramatic flowers can be painted from many points of view. Notice how the side view in this painting gives a dramatic shape accentuated by rich shadows.

Palette

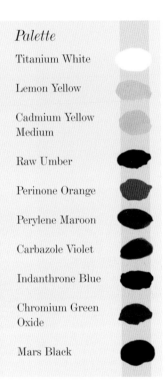

Titanium White

Lemon Yellow

Cadmium Yellow Medium

Raw Umber

Perinone Orange

Perylene Maroon

Carbazole Violet

Indanthrone Blue

Chromium Green Oxide

Mars Black

ray floret

stem | *splotch*

See also

Drawing, pages 14–17
Using Gel, page 22

sequence start to finish

Underpainting

1 Use a pencil to sketch the stem, sepals and ray florets. Observe the luminous glow from the backlighting. Paint the background a mixture of Indanthrone Blue, Perinone Orange and Titanium White, making a nice light variegated grey.

2 Mix Lemon Yellow and Titanium White, and paint the highlighted areas of the ray florets. Paint Perinone Orange mixed with Cadmium Yellow Medium in the shadows of the ray florets. Add more Cadmium Yellow Medium and paint the transitions from the darks to lights in the ray florets.

3 Mix Chromium Green Oxide and Raw Umber with a little Titanium White, and paint the stem and sepals, establishing the shadows. Use this mixture to indicate the splotches at the bottom of the ray florets.

Using gel

4 Paint the background with an interesting texture in gel, using a hog-bristle brush (see Using Gel on p. 22). Paint gel on the ray florets, stem and sepals, following their forms with the brushstrokes. Allow to dry.

Refining form

5 Repaint the background with the previous mixture. Combine Lemon Yellow with Perinone Orange to paint intermediate tones in the ray florets. Mix Lemon Yellow and Titanium White, and paint the highlighted areas.

6 Use a mix of Perinone Orange, Cadmium Yellow Medium, and a tiny amount of Raw Umber to define more distinctly the darker shadows. Paint Chromium Green Oxide, Raw Umber and a little Mars Black for the deepest shadows in the sepals and stem. Blend a mixture of Chromium Green Oxide, Raw Umber and Titanium White into the shadows to create the lighter areas. Do not paint strong highlights here as all the sepals are in shadow.

Adding intensity

7 Mix Perinone Orange with Cadmium Yellow Medium and paint the vibrant shadow areas in the ray florets, blending into the intermediate tones. Use the previous Chromium Green Oxide, Raw Umber and Mars Black mixture to paint the splotches.

Finishing

8 Use Perinone Orange and a very little Cadmium Yellow Medium, and paint distinct small accent areas of glow in the ray florets. For two or three of the darkest areas, mix a tiny amount of Carbazole Violet with Perylene Maroon, and blend a small amount into the Perinone Orange and Cadmium Yellow Medium mixture.

9 Use a small round brush to paint strokes of varying thicknesses of Cadmium Yellow Medium or Lemon Yellow along the edges of the highlighted areas. Then paint Titanium White on the highlighted edges of the ray florets using a smaller round brush.

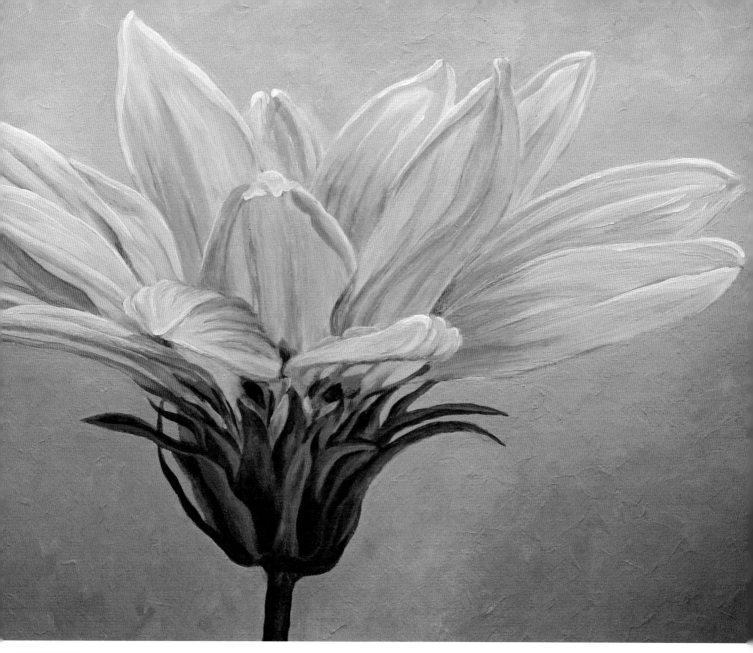

special detail painting a curved ray floret with glowing shadows

◄ *Paint highlights with Lemon Yellow and Titanium White. Paint the shadows with Perinone Orange and Cadmium Yellow Medium. Add more Cadmium Yellow Medium to this mix to paint the transitions between shadows and highlights.*

◄ *Paint a mix of Perinone Orange, Cadmium Yellow Medium and a tiny amount of Raw Umber into the shadows. Use Lemon Yellow with Perinone Orange for the intermediate tones. Mix Lemon Yellow and Titanium White for the highlights.*

◄ *Use a mixture of Perinone Orange and Cadmium Yellow Medium to paint the intensely glowing shadow areas, blending into the intermediate tones.*

◄ *Use Perinone Orange with a very little Cadmium Yellow Medium to paint small areas of the shadows. Add Titanium White highlights.*

Gerbera Gerbera

Each daisy-like bloom is composed of a myriad individual flowers and can be any of a wonderful array of colours – white, yellow, orange, red, violet, pink and salmon. The central disc sometimes is surrounded by whorls of female flowers that have tubular corollas. Beyond those, we find radiating petal forms that actually are ray florets, each one an entire flower in its own right. This combination of forms creates a beautifully beguiling flower, which can be a delight to paint. In this example, the disc is incredibly soft and cushiony, accented by tubular corollas casting dramatic shadows on the many radiating florets.

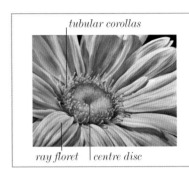

tubular corollas

ray floret | *centre disc*

Palette

Titanium White	
Cadmium Yellow Medium	
Yellow Ochre	
Raw Sienna	
Raw Umber	
Perinone Orange	
Ultramarine Blue	
Mars Black	

sequence start to finish

Underpainting

1 Sketch the lines of the bloom in pencil. Paint the small amount of background Mars Black. Mix Ultramarine Blue, Raw Umber, plenty of Titanium White and a tiny amount of Mars Black, and paint the ray florets, establishing the shadows in this process. Mix Cadmium Yellow Medium, Yellow Ochre and Titanium White and paint the disc. Add Raw Umber and brush the shadows in the disc.

Using gel

2 Apply gel with a hog-bristle brush (see Using Gel on p. 22). Paint the gel on the ray florets heavily, creating a radiating texture outward to the edge of the painting. Allow to dry.

Building form

3 Repaint the background. Use Ultramarine Blue and Titanium White to add depth to the shadows and to blend transitions in the ray florets. Deepen the shadows with Raw Umber added to this mixture. Add strong shadows around the disc.

4 Use lighter mixtures for the brighter parts of the ray florets. The disc should be painted with short strokes close to each other and with stippling to create a cushiony look. Soften the disc with a lighter mixture of Yellow Ochre, Cadmium Yellow Medium and Titanium White blended into the previous layer of paint. Mix Raw Sienna and Cadmium Yellow Medium and paint the mid-range tones in the disc.

Adding depth and detail

5 Continue painting the ray florets with overlapping layers of the previous paint mixtures. Create strong shadow areas contrasted with lighter areas and work with the gel texture to add interest to the paint surface. Mix a tiny amount of Perinone Orange into Cadmium Yellow Medium and paint the rich glow in the disc, using your finger or a damp paper towel to smudge the colour.

6 Paint the tubular corollas with varying mixtures of Ultramarine Blue, Raw Umber and Titanium White, taking care to blend the shadows and highlights so the tubular forms actually look round.

Finishing

7 Drag a brush carrying Titanium White lightly across the texture in the ray florets where white highlights are needed. With a small round brush loaded with Titanium White, paint small highlights on the edges of the ray florets where they catch the light. Do the same for the tubular corollas, giving them brilliant emphasis.

See also

Drawing, pages 14–17
Using Gel, page 22

special detail adding depth to an edge

◄ *Use Ultramarine Blue, Raw Umber, lots of Titanium White and a small amount of Mars Black for the ray florets, establishing the shadows. Mix Cadmium Yellow Medium, Yellow Ochre and Titanium White, and paint the disc with short brushstrokes. Add Raw Umber and paint the shadows.*

◄ *Deepen the shadows on the edge of the disc by using Raw Umber added to the yellow mixture. Mix Ultramarine Blue with Titanium White and paint into the ray florets, blending into the previous layer of paint.*

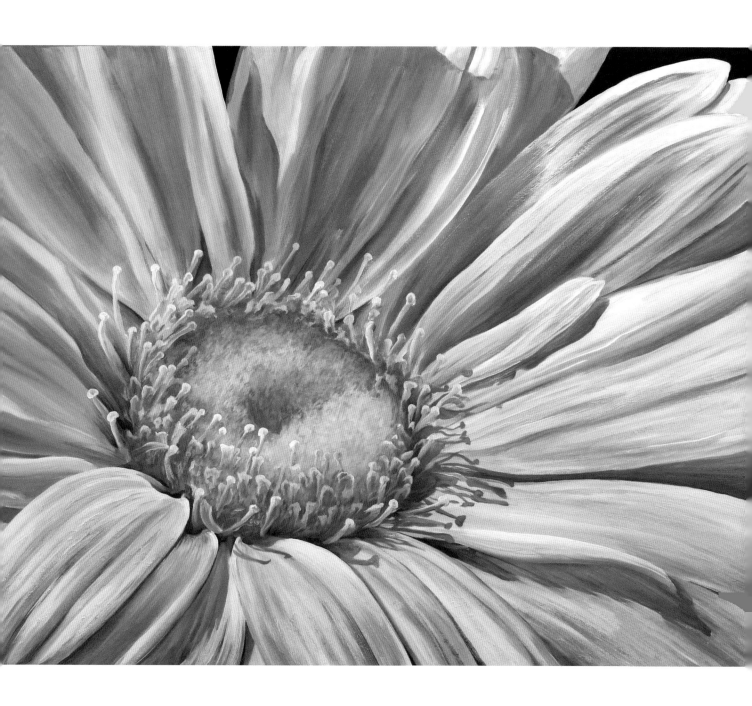

◄ *Refine the detail in the ray florets with the previous mixtures. Add Cadmium Yellow Medium and Raw Sienna to the disc. Paint the tubular corollas with Raw Umber, Titanium White and a tiny amount of Ultramarine Blue. Smudge the yellow mixture over part of the tubular corollas to show reflected light.*

◄ *Paint the shadows of the tubular corolla with the blue-grey mixture. Add a tiny amount of Perinone Orange and Cadmium Yellow Medium to the disc to create a vibrant glow. Paint small Titanium White highlights with a small round brush to accent the direction of light.*

Helianthus Sunflower

Aptly named, the sunflower has the phototropic ability to follow light, so the blooms always face the sun. Each sunflower head is composed of one to two thousand flowers tightly packed together. The outer flowers are ray florets with large golden corollas. The richly patterned central disc is formed by flowers with both stamens and pistils that produce seeds. With their strong, bold leaves, the blooms are dramatic against the sky.

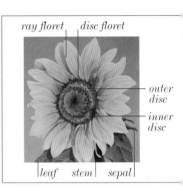

ray floret disc floret

outer disc

inner disc

leaf stem sepal

Palette

Titanium White

Lemon Yellow

Cadmium Yellow Medium

Yellow Ochre

Raw Sienna

Raw Umber

Perinone Orange

Anthraquinoid Red

Carbazole Violet

Cerulean Blue

Rich Green Gold

Green Gold

Permanent Green Light

Chromium Green Oxide

Mars Black

sequence start to finish

Underpainting

1 Sketch the sunflower, leaves and stem in pencil. Paint the background Cerulean Blue mixed with Titanium White to make the sky. Use Chromium Green Oxide and Raw Umber and a little Mars Black to make a grey-green for the shadows in the leaves, sepals and stem. Add a little Titanium White for the lighter areas.

2 Mix Cadmium Yellow Medium and Titanium White to paint the ray florets. Add Raw Sienna and use less Titanium White for the shadows. Use varying mixtures of Yellow Ochre, Raw Umber and Raw Sienna, and a small amount of Titanium White, for the outer disc. Paint the inner disc with a mixture of Titanium White, Green Gold and Raw Umber, establishing the shadows in the process.

Using gel

3 Paint gel on the painting with a hog-bristle brush (see Using Gel on p. 22). Use the brushstrokes to follow the forms of the leaves, stem and flower. Allow to dry.

Refining the forms

4 Repaint the sky. Mix Chromium Green Oxide, Green Gold and a tiny amount of Raw Umber with Titanium White, and paint the leaves, stem and sepals. Continue using Chromium Green Oxide and Raw Umber, sometimes with a tiny amount of Mars Black, for the shadows. Create strong definition in the shadows.

5 Mix Cadmium Yellow Medium, Raw Sienna and a tiny amount of Perinone Orange to paint stronger shadows in the ray florets. Using the original mixtures, add more detail to the centre disc. For the inner disc, add some highlights on the right half with Titanium White and a little Carbazole Violet.

Adding intensity

6 Mix Chromium Green Oxide, Green Gold, Permanent Green Light and a small amount of Raw Umber and Titanium White, and softly blend the colours in the leaves and stems, deepening the shadows to create more contrast.

7 Mix a little more Perinone Orange into the Cadmium Yellow Medium and Raw Sienna mixture, and paint this rich butterscotch colour in the petals. Carefully blend the colour transitions by smudging with your finger or a wet paper towel. Increase the intensity in the outer disc with some Anthraquinoid Red added to the mixture. Use Green Gold, Rich Green Gold, Raw Umber and Titanium White in varying mixtures to add emphasis to the inner disc.

Finishing

8 Mix Raw Umber with a tiny amount of Mars Black and paint assorted disc florets in the outer disc and shadows of them falling on the right side of the inner disc. With a small round brush, paint bright Lemon Yellow tops on these disc florets.

9 Use a small round brush to paint Titanium White on the highlighted parts of the leaves and ray florets. Leave skipped and broken sections of line on the edges to give a natural look.

See also

Drawing, pages 14–17
Using Gel, page 22

special detail painting a complex centre disc

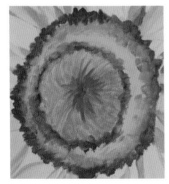

◄ *Mix Yellow Ochre, Raw Umber and Raw Sienna, and a small amount of Titanium White, to paint the outer disc. Use a mixture of Titanium White, Green Gold and Raw Umber for the inner disc.*

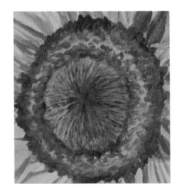

◄ *Add more detail to the outer disc with more Raw Sienna in the mixture. Continue using Titanium White, Green Gold and Raw Umber to detail the inner disc. Paint highlights on the right side with Carbazole Violet and Titanium White.*

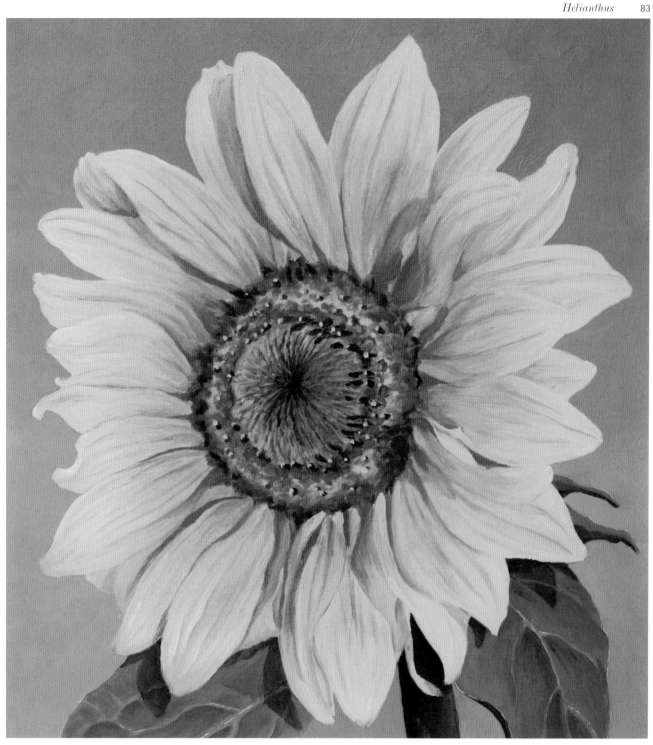

◂ *Add darker shadows radiating from the centre of the inner disc. Add intensity to the outer disc with Anthraquinoid Red added to the previous mixtures. Paint a scattering of disc florets in the outer disc with Raw Umber and a tiny amount of Mars Black, also adding their shadows on the right side of the inner disc.*

◂ *With a small round brush, paint bright Lemon Yellow tops on the disc florets.*

Hibiscus Rose Mallow

Originating in Asia and the Pacific islands, tropical hibiscus is now popular around the world, having been hybridized into dazzling colour combinations. Each blossom has five or ten petals with a distinctive central stamen tube with branching styles found in no other flower. The artist will have no difficulty in finding inspiration in these blooms.

style branch stamen tube

anther

stigma petal leaf

Palette

Titanium White

Lemon Yellow

Iridescent Antique Gold

Cadmium Yellow Medium

Raw Umber

Perinone Orange

Quinacridone Coral

Quinacridone Magenta

Quinacridone Red

Green Gold

Chromium Green Oxide

Mars Black

sequence start to finish

Underpainting

1 Sketch the flower, leaves and stems in pencil. Paint the background Raw Umber. Mix Green Gold, Chromium Green Oxide, Titanium White and a small amount of Raw Umber in varying mixtures and use this to paint the leaves and stems.

2 Mix Quinacridone Red and Quinacridone Magenta with Titanium White for the centre splash of pink in the petals of the flower, establishing the shadows. Paint the stamen tube, style branches and stigma with these combinations. Use Cadmium Yellow Medium, Perinone Orange and Titanium White to paint the outer parts of the petals, once again establishing the shadows as you work. Paint Lemon Yellow and Titanium White on the anthers.

Using gel

3 Use a hog-bristle brush to paint gel on the background, creating a strong texture (see Using Gel on p. 22). Paint the gel following the forms of the flower, leaves and stems. Allow to dry before continuing.

Building form

4 Paint the background texture with a mixture of Raw Umber, Titanium White and Mars Black, creating a gradation from light at the top to dark at the bottom. Using the previous mixture, refine the forms in the leaves and stems, using more Green Gold in the highlighted areas. Continue using Quinacridone Red, Quinacridone Magenta and Titanium White in centre splash of the flower.

5 Define the shadows and highlights with more Titanium White in the highlights and less in the shadows. Carefully blend the colours into the lower layer by smudging. Paint soft highlights around the stigma. Add a little Lemon Yellow and Titanium White to the pink mixture, and paint the highlight on the stamen tube. Paint Lemon Yellow and Titanium White highlights on the outer part of the petals, streaking into the centre splash.

Creating rich colour

6 Smudge a small amount of Iridescent Antique Gold on the background. Deepen the shadows in the petals with the previous mixtures used, painting in layers to streak the colours into each other to create a ribbed look in the petals. Allow to dry.

7 At the intersection of the inner splash and the outer part of the petals, lightly smudge Quinacridone Coral to blend the transition, giving a rich glow to the flower. Repaint the centres of the stigma. Define the shadows in the stamen tube and style branches. Paint a little Cadmium Yellow Medium on the anthers. Refine the leaves and stems with careful blends into the previous layer, using the previous green mixtures.

Finishing

8 Paint Lemon Yellow and Titanium White highlights on the outer petal areas. Blend Titanium White highlights into the fully lit ribs in the petals. With a small round brush paint Titanium White highlights on the edges of the flower and foliage.

See also

Drawing, pages 14–17
Using Gel, page 22

special detail painting richly blended colour transitions

▲ *Paint Quinacridone Red and Quinacridone Magenta with Titanium White into the centre splash of pink, establishing the shadows. For the outer part of the petals paint Cadmium Yellow Medium, Perinone Orange and Titanium White.*

▲ *Begin refining detail in the centre splash. Add more Cadmium Yellow Medium to the outer part of the petal.*

▲ *Deepen the shadows in the petal and add small, muted highlights. Over the intersection of the inner splash and outer part of the petal, smudge Quinacridone Coral. Paint the mixtures over each other until a nice gradation is achieved.*

▲ *Use Lemon Yellow and Titanium White to paint soft highlights on the outer petal edge. With a small round brush, add distinct Titanium White highlights.*

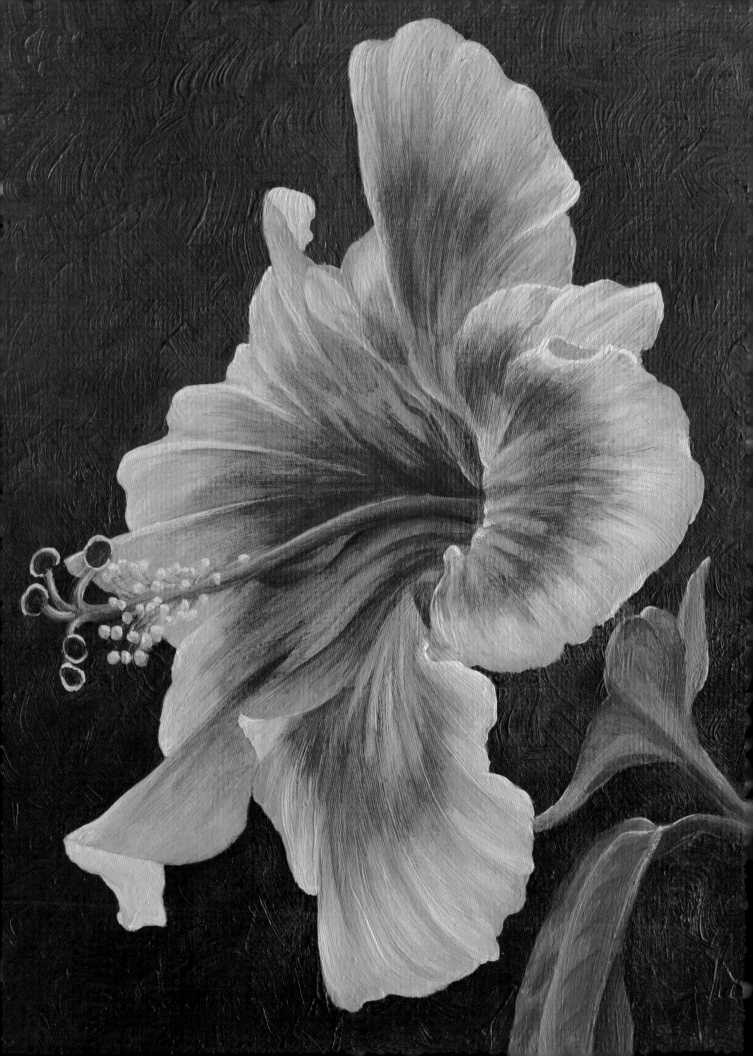

Hippeastrum Amaryllis

The amaryllis blooms in spectacular fashion from a large bulb, usually grown in a flowerpot on a windowsill. A tall stalk eventually emerges from slender long leaves and supports two to four large buds that burst open into huge flowers. These white ones show a glorious greenish yellow centre that provides a dramatic glow when backlit. Elegant long stamens add even more interest to these blooms. Occasionally, the richly textured petals show a few irregular edges, a type of fringing, which further intrigues the artist. These flowers invite the painter to abandon all other thought and celebrate the dance of light through the petals with layers of paint on canvas.

Palette

Titanium White

Lemon Yellow

Nickel Titanate Yellow

Yellow Ochre

Raw Umber

Ultramarine Blue

Green Gold

Chromium Green Oxide

Mars Black

See also

Drawing, pages 14–17
Using Gel, page 22

sequence start to finish

Underpainting

1 Sketch the flowers, stem and buds in pencil, observing the patterns of light and shadow. Paint the background Mars Black to emphasize the backlighting. Use Titanium White with small varying amounts of Mars Black and Ultramarine Blue to paint the petals and the styles, establishing shadows in the process.

2 Use Chromium Green Oxide mixed with Raw Umber, Titanium White and a small amount of Mars Black to paint the stem, buds and the base of the right flower. Mix Nickel Titanate Yellow with Green Gold and a small amount of Titanium White to paint the lighter areas of the stem, buds, base of the right flower and the dangling sepal. Paint Lemon Yellow mixed with Titanium White in the yellow glowing areas of the flowers.

Using gel

3 Using a hog-bristle brush, paint gel on the entire surface, creating textures that follow the forms of the flowers (see Using Gel on p. 22). Allow this to dry.

Developing form and colour

4 Repaint the background black. Paint the petals of the flower with a varying mixture of Titanium White, Raw Umber and a small amount of Ultramarine Blue, adding depth to the shadows.

5 Use more of the Raw Umber mixture for the styles and stamens of the right flower. For the left flower, use Raw Umber mixed with Yellow Ochre on the stamens. Add some of the grey mixture to Nickel Titanate Yellow and Yellow Ochre to paint the shadows

in the dangling sepal. Mix Chromium Green Oxide, Raw Umber, Mars Black and a tiny amount of Titanium White to establish the shadow areas of the stem and buds.

Refining the painting

6 Continue developing the soft blends of warm and cool greys in the petals, adding more Titanium White in the highlighted areas. Mix Lemon Yellow, Nickel Titanate Yellow and Titanium White, and paint some of the glowing yellow areas of the left flower. Add Green Gold and paint the deeper parts of the glow in the centre of the flower. Add Raw Umber to paint the shadows in the centre where the styles emerge.

7 Mix Lemon Yellow, Yellow Ochre and some of the grey mixture to paint the more subtle glowing areas of the right flower. Continue defining the forms of the stamens and styles in both flowers. Mix Lemon Yellow with a small amount of Green Gold and Titanium White to begin painting the highlighted areas of the buds.

Finishing

8 Paint distinct Titanium White highlights in the brightest areas of the flowers, working with the texture of the gel by dragging the brush across it. Use a small round brush to paint the tiny highlights unevenly on the edges of the petals, leaving broken places in the lines with thicker and thinner strokes to create natural highlights.

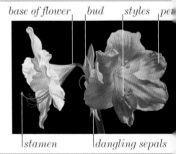

base of flower bud styles pe...

stamen dangling sepals

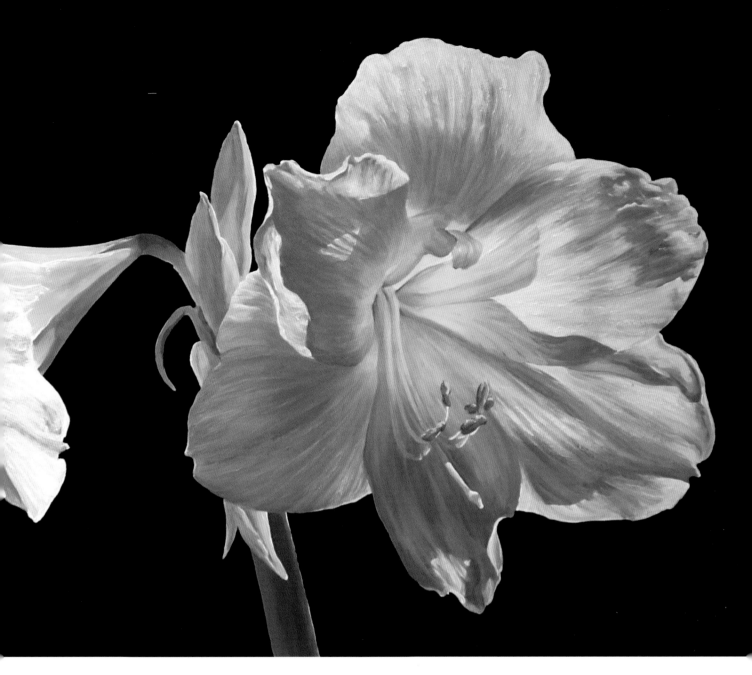

 special detail creating yellow-green glows

▲ *After painting the shadows with Mars Black, Titanium White and Ultramarine Blue mixed in varying degrees, mix Lemon Yellow with Titanium White to paint the glowing area. Lightly smudge the yellow mixture over the blue-grey underpainting.*

▲ *Continue working with the two paint mixtures, adding more middle-range values with the blue-grey mixture, and more highlights with the yellow mixture.*

▲ *Mix Raw Umber and Yellow Ochre to deepen the shadows where the styles emerge from the centre of the flower. Add lighter highlights in Titanium White with a little Mars Black.*

▲ *Mix Lemon Yellow and Nickel Titanate Yellow with a little Titanium White for the lighter yellow areas of the glow in the flower. Add Green Gold to the mix, and smudge the base of the styles and part of the petals from the centre. The paint should be thin enough for the darkness of the shadows already painted to show through.*

Ipomoea violacea Morning Glory

Originally a tropical vine with heart-shaped leaves, morning glories have large, trumpet-shaped blooms that open in the morning sun and are finished by evening. Gardeners grow the plants as annuals in a range of blues, pinks and whites. The deep, royal blue of this variety gradually turns violet as the flower ages, which can be visually arresting at the right stages of the transition. A five-pointed star in the centre is dramatically revealed by backlighting, which provides the basis for this painting.

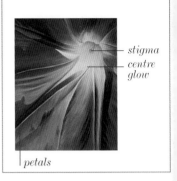

stigma
centre
glow

petals

Palette

Titanium White

Lemon Yellow

Cadmium Yellow
Medium

Raw Sienna

Perinone Orange

Carbazole Violet

Indanthrone Blue

Mars Black

See also

Drawing, pages 14–17
Using Gel, page 22

sequence start to finish

Underpainting

1 Use a pencil to sketch the lines of the petals and the stigma. Mix Indanthrone Blue with Titanium White and block in the petals, establishing the shadows in this process. Mix Carbazole Violet with Titanium White and paint the beginning forms of the violet areas in this colour.

2 Mix Lemon Yellow with Titanium White and paint the centre glow lightly. Indicate the stigma with a tiny amount of Mars Black mixed with Titanium White.

Using gel

3 Apply the gel with a hog-bristle brush (see Using Gel on p. 22). Paint the gel on the petals thickly, dragging the brush to create strong grooves in the texture, extending from the centre of the flower outward to the edge of the painting. Allow to dry.

Shaping the flower with blends

4 Use Indanthrone Blue and Titanium White to blend transitions in the petals. Deepen the shadows with darker blends and use lighter mixtures for the brighter parts of the flower. Mix Raw Sienna and Cadmium Yellow Medium, and paint the deeper part of the centre glow around the stigma. Smudge a little over the stigma to indicate the reflected light.

5 Use Indanthrone Blue mixed with Carbazole Violet and a tiny amount of Titanium White to refine the petal areas that are more violet. Use varying mixtures of these colours to create the shadows and the transitions into them. Drag the brush slightly to catch the texture with the paint.

6 Mix Carbazole Violet with Titanium White and repeat on the more violet areas of the petals. Begin to work with the highlights by painting a pale mixture of Indanthrone Blue and Titanium White in those areas.

Adding depth and detail

7 Continue painting the petals with overlapping layers of the blue and violet paint mixtures. Create strong shadow areas contrasted with lighter areas and continue working with the gel texture to add interest to the paint surface. Mix a tiny amount of Perinone Orange into Cadmium Yellow Medium and Titanium White, and paint the darkest area of the centre glow, using your finger or a damp paper towel to blend the colour smoothly. Make sure all the blends are smooth to create the glow in this flower.

Finishing

8 Smudge Titanium White into the highlights in the centre of the flower to create a powerful glow. With a small round brush loaded with Titanium White, follow the brightly lit seams down the petals. Drag a brush carrying Titanium White lightly across the texture in the petals where white highlights are needed.

special detail blending colour transitions

▲ *Paint the petals in a mixture of Indanthrone Blue and Titanium White. Use more Titanium White in the lighter areas. Add areas of Carbazole Violet mixed with Indanthrone Blue and Titanium White. Paint Lemon Yellow and Titanium White in the centre glow. Add a heavily streaked texture in gel and allow to dry.*

▲ *Use Indanthrone Blue and Titanium White in varying mixtures to blend lighter areas into the shadows. Smudge with your finger or a damp paper towel to soften the blend. Repeat with Ultramarine Violet mixed with Indanthrone Blue and Titanium White in the more violet areas.*

▲ *Paint Raw Sienna and Cadmium Yellow Medium into the darker part of the centre glow. Softly blend this into the lower layers of paint. Continue using the colour mixtures from the previous step to add depth and richness, carefully blending them into the lower layers.*

▲ *Smudge a little paint mixed from Perinone Orange, Cadmium Yellow Medium and Titanium White in the deepest parts of the glow around the sepal. Paint Titanium White highlights to complete the glowing look.*

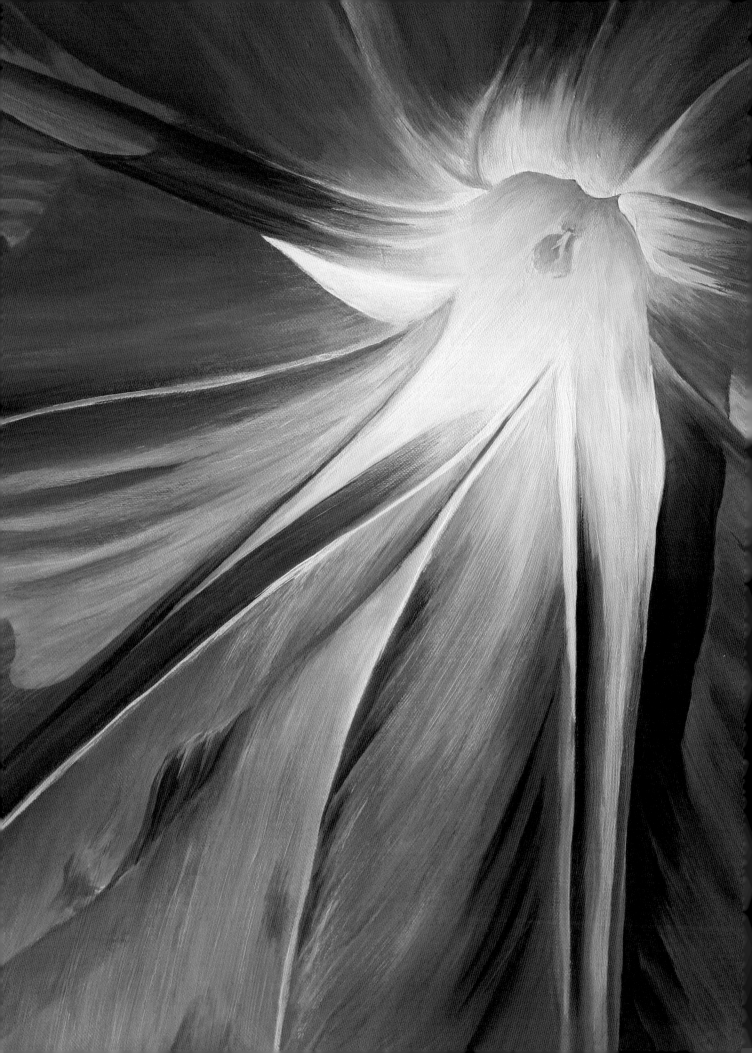

Iris Bearded Iris

Each bearded iris stands elegantly above the long slender leaves of the plant. The flower has three falls, those large petals curving downward graced by their bearded accents, and three tall standards, the majestically upright petals. The standards enclose the centre of the flower protectively, inviting you to look into its secret heart. The unusual structure of the iris presents challenges in composition for the painter, while simultaneously exciting the senses with a dizzying array of colour possibilities.

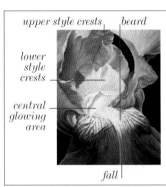

upper style crests beard
lower
style
crests
central
glowing
area
fall

Palette

Titanium White

Cadmium Yellow Light

Cadmium Yellow Medium

Cadmium Orange

Quinacridone Magenta

Quinacridone Pink

Quinacridone Violet

Ultramarine Violet

Carbazole Violet

Ultramarine Blue

Mars Black

sequence start to finish

Underpainting

1 Sketch the iris in pencil, taking note of the direction of light falling on the flower. Paint the small amount of background with Mars Black.

2 Mix Ultramarine Violet and Titanium White. Paint the petals of the iris, making the shadow areas darker than the highlighted areas, but not as dark as the final result will be. Mix a small amount of Cadmium Yellow Light with plenty of Titanium White and paint the beard and central glowing area.

Using gel

3 When dry, use a hog-bristle brush to apply gel, taking care to make the brushstrokes follow the form of the petals (see Using Gel on p. 22). Do not paint the gel too heavily.

Building depth

4 Use Carbazole Violet and a mixture of Carbazole Violet and Titanium White to paint the dark shadows. Blend them into the lighter areas. Use the texture of the gel underneath to create

the petal texture. Use Quinacridone Pink mixed with Titanium White on the highlighted areas of the petals. A very small amount of Ultramarine Violet and Titanium White can be added to create shadows in this area. Mix Quinacridone Violet and Titanium White to paint the two taller style crests in the top centre of the flower.

5 Now build layers of paint to create richness of colour. Emphasize Carbazole Violet in the darker areas and pinks and lavenders in the lighter areas. Use the edge of the brush to create the darker veins of colour in the standards.

Finishing

6 Use Quinacridone Magenta and a mix of Quinacridone Magenta and Titanium White to paint the dark veined patterns on the top of the fall. Paint Quinacridone Magenta in the deepest shadows of the middle of the fall and on the dark upper-left edge of the fall. Use a small amount in the shadow area of the left standard where it curls around the glowing centre area. Use layering of colours to create richness.

Mix a tiny amount of Ultramarine Blue with plenty of Carbazole Violet, and paint this into the deepest shadows of the bottom of the fall.

7 Use a small round brush to paint the beard with Cadmium Yellow Light and Cadmium Yellow Medium. Use Titanium White to give highlights to the centre. Add Cadmium Orange sparingly to create shadowed areas in the beard.

8 Take a round brush and use Titanium White on the petal edges where they catch the light.

See also

Drawing, pages 14–17
Using Gel, page 22

special detail painting a glowing centre

▲ *Underpaint with Cadmium Yellow Light mixed with Titanium White and Ultramarine Purple mixed with Titanium White. Use Carbazole Violet mixed with Titanium White for the darker shadows. Apply gel with a hog-bristle brush.*

▲ *Begin to intensify the shadow areas. A glow comes from contrasting values. In this example, the dark contrast comes from the petal wrapping around this smaller glowing inner part of the flower.*

▲ *Work in layers to blend the colours. The glowing centre of the iris needs several layers of paint gently smudged to keep them smoothly blended.*

▲ *Soften the graduation of tone in the little glowing area by continuing to work in layers until a smooth blend is achieved. Paint a blended white edge on the right of the glowing area for maximum contrast.*

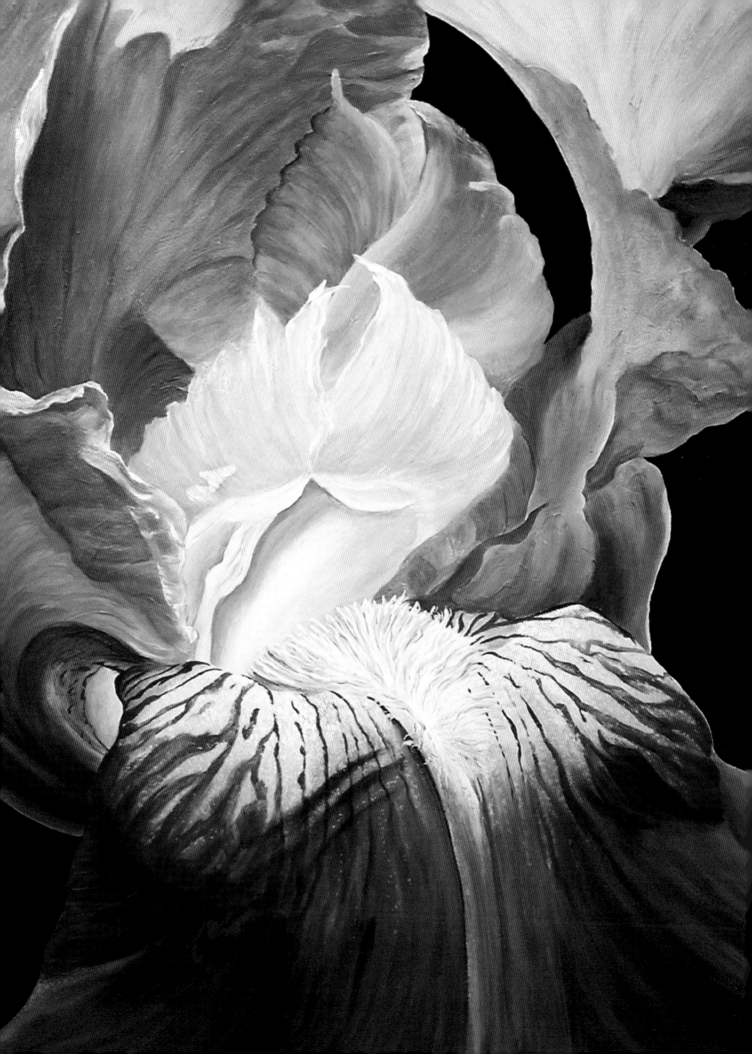

Layia platyglossa Tidy Tips

Tidy tips is a lovely Californian wildflower, a delightful yellow daisy with precise white outer tips. Drought resistant and highly prolific in self-seeding, this low-growing plant is a pleasing addition to many gardens. A member of the sunflower family, the bloom is composed of a multitude of individual flowers grouped together. In this particular painting, the blossom is found peeking from beneath a nasturtium leaf. The artist should always be alert for such little surprises that add visual interest to a painting. Water drops are the final accent to complete this composition.

water drop *outer disc floret*

in d fl

nasturtium leaf *stem*

Palette

| Titanium White |
| Lemon Yellow |
| Cadmium Yellow Medium |
| Yellow Ochre |
| Raw Sienna |
| Raw Umber |
| Perinone Orange |
| Anthraquinoid Red |
| Indanthrone Blue |
| Green Gold |
| Permanent Green |
| Chromium Green Oxide |
| Mars Black |

sequence start to finish

Underpainting

1 Sketch the daisy, nasturtium leaves and stems in pencil. Combine Chromium Green Oxide, Raw Umber and a little Titanium White in varying mixtures for the leaves and stems. Use Raw Umber with a very small amount of Chromium Green Oxide and Mars Black in the deep shadows. Mix Cadmium Yellow Medium and Titanium White for the ray florets. Paint the tips and water drops with Titanium White. Establish the shadows in the ray florets with Raw Sienna and Cadmium Yellow Medium, and a little Raw Umber.

2 Use Yellow Ochre and Titanium White for the lighter parts of the outer disc florets. Mix Raw Sienna and Anthraquinoid Red for ovoid shapes in the outer disc florets. Add Raw Umber accents to some of the deepest shadow areas in the outer disc florets. Mix Green Gold with a little Chromium Green Oxide and Titanium White for the inner disc florets. Raw Sienna and Raw Umber are used to paint the shadows around the inner disc florets, except in the very centre where Permanent Green is added.

Using gel

3 With a hog-bristle brush, paint gel on the daisy, stems and nasturtium leaves, following the forms with the brushstrokes (see Using Gel on p. 22) Allow to dry.

Refining blends

4 Repaint the stems and leaves with the previous mixtures. Indicate the veins in the leaves with the lighter green mixture. Use the yellow mixtures to blend the colour transitions in the ray florets. Add Lemon Yellow with a little Titanium White in the lighter areas.

5 Develop the shadows with more Raw Sienna and Cadmium Yellow Medium. Add a little Titanium White for the water-drop shadows. Use Lemon Yellow and Titanium White for the water-drop highlights. Paint the shadows in the white tips with Indanthrone Blue, Perinone Orange and Titanium White. Repaint the disc florets, adding Cadmium Yellow Medium to the outer disc florets. Paint the deepest shadows between the inner disc florets with Anthraquinoid Red and Raw Umber, blending into the green shadows in the centre.

Adding intensity

6 Refine the veins and paint a highlighted edge on the left nasturtium leaf in Green Gold and Titanium White. Finish defining the shadows in the ray florets and water drops with Raw Sienna and Cadmium Yellow Medium. Add Raw Umber in the deepest shadows of the ray florets. Paint Lemon Yellow and Titanium White highlights on the ray florets. Use the shadow mixture for the white tips to paint the water drops on the tips, blending into the previous yellow layer.

Finishing

7 Using a small round brush, paint Titanium White highlights on the water drops and the left nasturtium leaf edge.

See also

Drawing, pages 14–17
Using Gel, page 22

special detail painting water drops

◄ *Indicate the placement of the water drops in Titanium White.*

◄ *Paint shadows on the left side of the drops in Raw Sienna, Cadmium Yellow Medium and a little Titanium White. Paint the highlights in Lemon Yellow and Titanium White.*

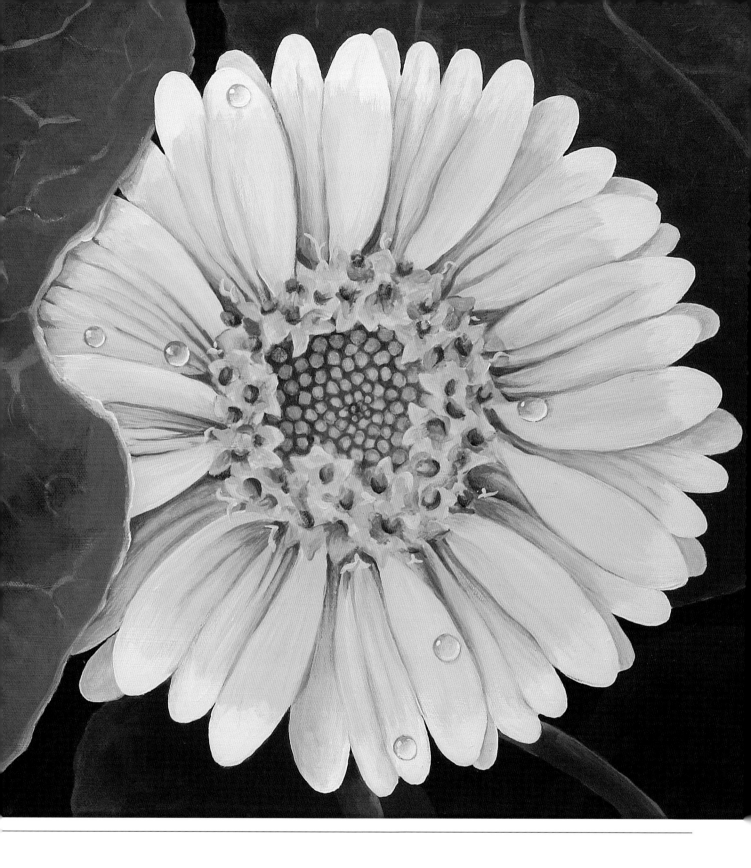

◄ *Deepen the shadows with Raw Sienna and Cadmium Yellow Medium. Notice the darker arc on the left edges. Define the highlights more carefully in Lemon Yellow and Titanium White.*

◄ *Carefully soften the shadows and highlights in the water drops by blending in layers until a glowing quality is achieved. Paint a tiny arc of Titanium White on the lower right edges and a highlighted spot on the left side of each water drop.*

Linum Flax

Flax has been used since ancient times to make linen cloth and for medicinal purposes. In addition, artists often choose linen canvases for their paintings. These plants are delicate and graceful, with arching stems, small leaves and buds. The flowers are a lovely blue with ten stamens and a pistil with five styles. The petals look almost transparent in the morning light, enticing the artist to paint them, perhaps even on a linen canvas.

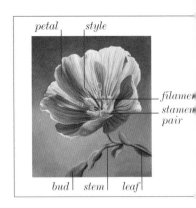

petal style

filament
stamen
pair

bud stem leaf

Palette

Titanium White

Lemon Yellow

Yellow Ochre

Raw Umber

Perinone Orange

Cerulean Blue

Indanthrone Blue

Ultramarine Blue

Green Gold

Permanent Green Light

Chromium Green Oxide

sequence start to finish

Underpainting

1 Use a pencil to sketch the flower and foliage. Mix Indanthrone Blue, Perinone Orange and Titanium White to make a soft blue-grey, and paint the background. Use Ultramarine Blue and Titanium White for the petals and filaments, establishing the shadows. Add plenty of Titanium White to the blue-grey background mixture and delineate the pairs of stamens.

2 Mix Chromium Green Oxide, Permanent Green Light, a little Raw Umber and Titanium White in various mixtures, and paint the stems, leaves and buds. Use a little of this mixture combined with the pale grey stamen mixture and paint the styles. For the centre of the flower, use a combination of Lemon Yellow, Green Gold and Titanium White.

Using gel

3 Apply gel to the background with a hog-bristle brush, creating a nice texture (see Using Gel on p. 22) Paint the gel on the petals while dragging the brush to create strong grooves in the texture, extending from the centre of the flower outward. Follow the forms of the foliage with the brushstrokes. Allow to dry.

Building colour

4 Paint the background again over the texture. Paint the petals and filaments with Indanthrone Blue, Cerulean Blue and Titanium White, making soft blends and adding detail. Mix Lemon Yellow, Green Gold, a tiny amount of Raw Umber and Titanium White for the centre of the flower and the styles. Increase the shadows in the stamens with the blue-grey mixture.

5 Mix Yellow Ochre with the Chromium Green Oxide, Permanent Green Light and Titanium White mixture, and paint the stems. Use Chromium Green Oxide, Raw Umber and a little Titanium White for the dark shadows in the buds. Paint the leaves and buds with Chromium Green Oxide, Green Gold and Titanium White, adding a little Raw Umber in places.

Increasing intensity

6 Continue working with the previous mixtures, adding detail and increasing the contrast. In the petals, drag the brush slightly to catch the texture. Create strong shadow areas contrasted with lighter areas and continue working with the gel texture to add interest to the paint surface.

7 Use strong Ultramarine Blue for the dark veins in the petals, fading them outward from the centre of the flower. Add Indanthrone Blue for the darkest veins near the centre and also on the filaments. Refine the shadows and detail in the foliage, styles and stamens.

Finishing

8 With a small round brush, paint Lemon Yellow, Green Gold and Titanium White highlights in the foliage. Use Lemon Yellow and Titanium White to accent the centre of the flower. Then paint highlights in Titanium White where needed on the petals, styles and stamens

See also

Drawing, pages 14–17
Using Gel, page 22

special detail painting a curved ruffle in a petal

◀ *Paint the petal with Ultramarine Blue and Titanium White, broadly establishing the shadows.*

◀ *Paint soft blends of Indanthrone Blue, Cerulean Blue and Titanium White to soften the petal. Start shaping the curved edge.*

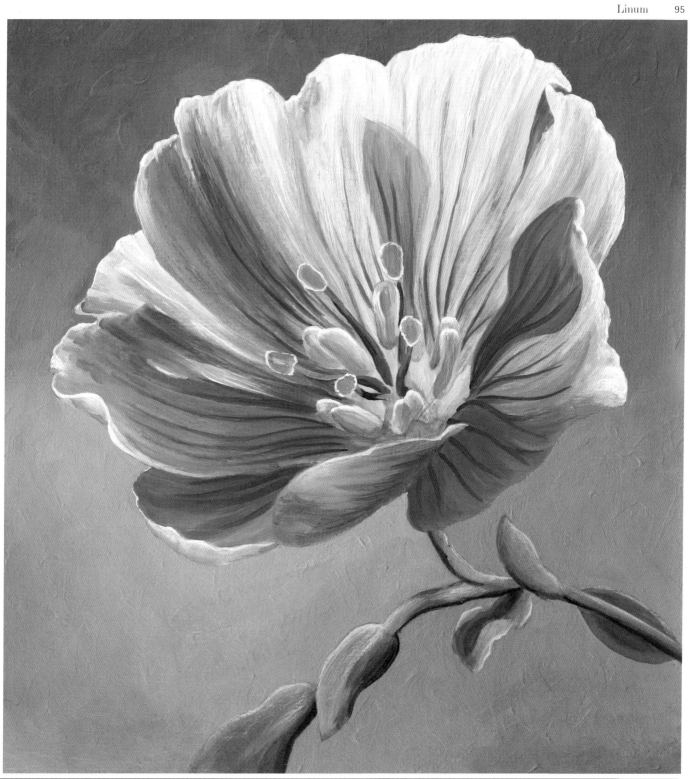

◄ *Add more detail, using the previous mixture. Notice how the shadow deepens where the petal rolls under.*

◄ *With a small round brush, paint a Titanium White highlight on the edge of the petal, showing the curving ruffle.*

Malus Apple Blossom

Even the most gnarled old apple trees celebrate spring with a mass of beautiful blossoms. The buds form in clusters from a twig on the tree, and each flower has five slightly cupped petals with a cluster of stamens in the centre attracting bees with their scent. Paint cannot capture their fragrance, but if painted well, the viewer will almost smell the flowers on the breeze when looking at the painting.

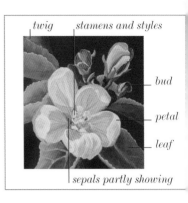

twig stamens and styles

bud

petal

leaf

sepals partly showing

Palette

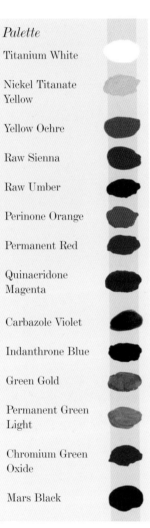

Titanium White

Nickel Titanate Yellow

Yellow Ochre

Raw Sienna

Raw Umber

Perinone Orange

Permanent Red

Quinacridone Magenta

Carbazole Violet

Indanthrone Blue

Green Gold

Permanent Green Light

Chromium Green Oxide

Mars Black

sequence start to finish

Underpainting

1 Sketch the flower, twig, buds and leaves in pencil. Paint the background a deep, dark, olive green mixed from Chromium Green Oxide, Raw Umber and a small amount of Mars Black. Paint the twig with a mixture of Raw Sienna, Raw Umber and Titanium White. Paint the buds with a mixture of Permanent Red and Titanium White. Use Green Gold, Chromium Green Oxide and a small amount of Raw Umber for the leaves.

2 Mix Carbazole Violet with Perinone Orange and Titanium White to create a light grey, slightly tinted pink for the petals. In the centre of the flower, use Chromium Green Oxide and Green Gold for the sepals. Paint the stamens and styles with Nickel Titanate Yellow and Titanium White.

Using gel

3 Using a hog-bristle brush, paint a fairly smooth gel texture, following the shapes and forms of the leaves, petals, and twig (see Using Gel on p. 22). The background can have a more definite texture. Allow the gel to dry.

Using rich colour

4 Mix Nickel Titanate Yellow with Green Gold to paint the glowing lighter areas of the leaves. Use Chromium Green Oxide mixed with Raw Umber and Green Gold for the deeper shadows of the leaves. Mix Quinacridone Magenta and Titanium White, and paint more detail in the buds.

5 For the petals, mix Indanthrone Blue with Perinone Orange and Titanium White to make a light grey tinted slightly blue. Overpaint the petals, allowing the pinker grey to show in places. Add some of the darker green from the leaves in the centre of the flower where the sepals show. Mix Yellow Ochre with the Nickel Titanate Yellow to paint shadows in the stamens. Add a slight blush of a pale mixture of Green Gold and Titanium White to part of the styles.

Detailing

6 Add more detail to the twig by mixing Raw Sienna, Raw Umber and Titanium White, and make the lighter areas more defined. Use Raw Umber with a small amount of Raw Sienna and Mars Black to paint the shadow areas of the knot on the twig. Allow the mid-range colour areas of the twig to have more Raw Sienna in the mixture. Use the Nickel Titanate Yellow and Green Gold mixture to paint the veins in the leaves. Add Permanent Green Light to Chromium Green Oxide to add a richer green in some areas of the leaves.

7 Paint the veins in the flower petals with Quinacridone Magenta and Titanium White, keeping them soft and not harsh. Paint more shadow details, alternating between the pink-grey and the blue-grey. Use Titanium White to create highlighted areas on the petals. Add more shadows and more definite edges to the stamens.

Finishing

8 Add a light Quinacridone Magenta and Titanium White blush to the petals, smudging it softly. With a small round brush, paint highlighted leaf edges with Nickel Titanate Yellow mixed with Titanium White. With a smaller round brush, paint the white highlights on the edges of the leaves and petals and buds, allowing skips and breaks and unevenness in the strokes. Add a few highlights on the stamens.

See also

Drawing, pages 14–17
Using Gel, page 22

special detail using warm and cool mixed greys

◀ *For the flower petal, use a grey mixed from Carbazole Violet, Perinone Orange and Titanium White. This should be a light grey with a distinctly pink tint to it. Mixing greys rather than painting with a neutral grey gives a more lively and luminous look to a painting. Paint with a fairly smooth gel texture.*

◀ *Mix another grey with Indanthrone Blue, Perinone Orange and Titanium White, creating a light grey with a blue tint. Paint over the petal, allowing a pink tinted glow to show from the first underpainting. Smudge it with your finger or a damp paper towel to give a soft look.*

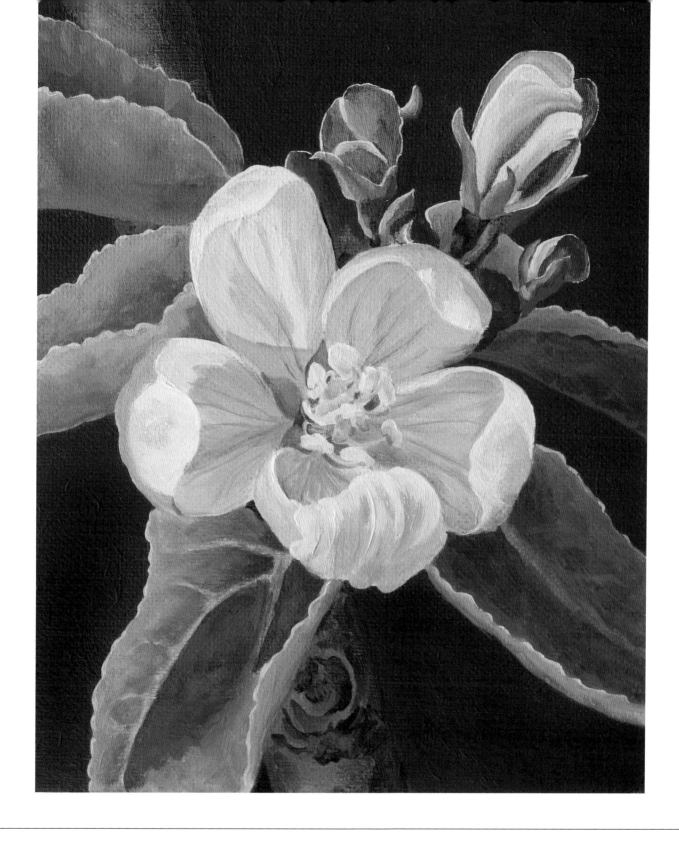

◄ Continue painting with both greys over each other to give a soft, luminous look to the petal. Add Quinacridone Magenta and Titanium White veins in the petals. Also smudge this mixture on parts of the petal to give a pink blush. Add brighter highlighted areas on the petals with Titanium White.

◄ Add a lighter blush with the Quinacridone Magenta and Titanium White mixture on part of the highlighted areas. With a small round brush paint Titanium White highlights, allowing the strokes to vary in width and break in places.

Nymphaea Water Lily

What can be more beautiful than an array of lily pads graced by blooming water lilies floating in a sky blue pond? The shapes are most interesting, the reflections in water alluring and the flowers spectacular with their many petals and colourful yellow stamens. These flowers can inspire the mystical in all of us. American Indians have a story of the water lily being a star that came to earth. Ancient Egyptians buried their dead with necklaces of water-lily petals. And the artist today can translate these magical visions into painted images that evoke all the mysteries of the past.

lily pad winged filament

sta
inr
pet

water outer petal

Palette

Titanium White

Cadmium Yellow Medium

Nickel Titanate Yellow

Yellow Ochre

Raw Sienna

Raw Umber

Perinone Orange

Quinacridone Magenta

Carbazole Violet

Indanthrone Blue

Ultramarine Blue

Green Gold

Chromium Green Oxide

sequence start to finish

Underpainting

1 Use a pencil to sketch the flower and lily pads. Mix Chromium Green Oxide, Raw Umber and Titanium White to paint the lily pads. Use Ultramarine Blue and Titanium White for the water. In the dark shadows of the water paint Ultramarine Blue and Indanthrone Blue.

2 For the petals start with a light pinkish grey made of Carbazole Violet, Perinone Orange and Titanium White. Begin painting the outer rows of petals in this mixture. Blend Quinacridone Magenta and Titanium White into this mixture and paint the purple part of the petals. Mix a little Raw Sienna and Yellow Ochre into this combination and begin the next row of petals. For the central petals mix Cadmium Yellow Medium and Titanium White. In the centre paint Cadmium Yellow Medium.

Using gel

3 Use a hog-bristle brush to paint on the gel (see Using Gel on p. 22). The brushstrokes should follow the form of the petals, add a texture to the lily pads and be placed in horizontal streaks on the water.

Building form

4 Paint the water with the previous mixtures used, emphasizing the shadows more distinctly. Mix Chromium Green Oxide, Green Gold, Raw Umber and Titanium White, and use this to paint the lily pads, smoothly blending into the lower layer of paint. Establish the shadows under the petals on the bottom right lily pad.

5 Paint varying mixtures of Carbazole Violet, Quinacridone Magenta and Titanium White into the outer petals. Paint the inner petals with a mixture of Nickel Titanate Yellow, Cadmium Yellow Medium and a little Titanium White. Blend some of the outer petal mixtures into some of the inner petals so the colour transition looks natural. Smudge the mixtures with your finger or a damp paper towel as needed. With Perinone Orange and Cadmium Yellow Medium, paint the winged filaments and stamens in the centre.

Refining detail

6 Paint a varying mixture of Raw Umber, Ultramarine Blue and a tiny amount of Titanium White over the water, gently blending into the previous

layers. Create rich colour in the lily pads with the green mixtures already used. Paint Green Gold, Chromium Green Oxide and a little Titanium White into the lighter areas. Using the mixtures from previous steps, continue to refine the colour transitions in all the petals. Mix a small amount of Carbazole Violet with Quinacridone Magenta and add intense shadows in the petals. Continue to refine the details in the winged filaments and stamens in the centre.

Finishing

7 With a small round brush, paint the highlights on the petals and stamens with Titanium White. Use varying width strokes and broken areas to create a natural look.

See also

Drawing, pages 14–17
Using Gel, page 22

special detail painting a glowing shadow area

◀ *Mix Cadmium Yellow Medium and Titanium White and paint the centre area.*

◀ *Use Perinone Orange and Cadmium Yellow Medium to paint the winged filaments and stamens.*

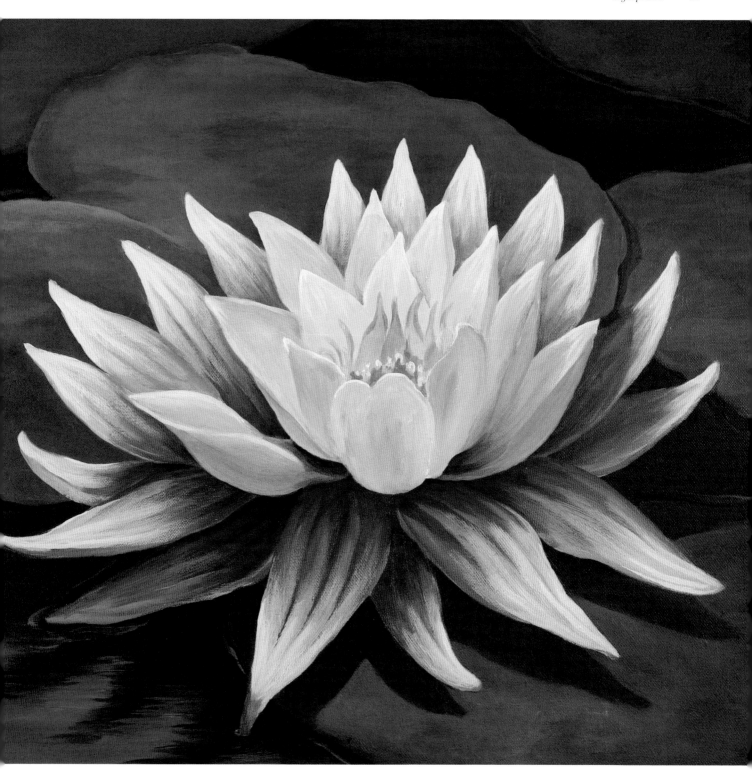

◄ *Refine the shapes of the winged filaments and stamens with the previous mixture.*

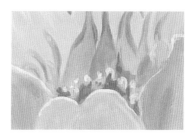

◄ *Use the small round brush to paint Titanium White highlights on the stamens and petal edges.*

Opuntia Prickly Pear Cactus

Prickly pear cactus has modified itself to withstand heat and drought, storing water in the distinctive oval pads. All parts of the plant are edible and are used for medicinal purposes. The spines are a formidable deterrent to casual handling, but the blooms are spectacular. The sepals and petals have merged, and are called tepals. Flowers appear on the upper edges of the pads and each one develops a sweet and delicious fruit. The unusual forms of this cactus lend themselves to interesting compositions in painting.

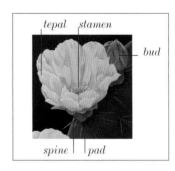

Palette

Titanium White

Lemon Yellow

Cadmium Yellow Medium

Yellow Ochre

Raw Umber

Green Gold

Chromium Green Oxide

Mars Black

sequence start to finish

Underpainting

1 Use a pencil to sketch the flowers, bud, pad and spines. Paint the background with a mixture of Chromium Green Oxide, Raw Umber and a little Mars Black. Use Chromium Green Oxide, Raw Umber and Titanium White to paint the pad.

2 Use varying mixtures of Green Gold, Chromium Green Oxide, Raw Umber and Titanium White for the bud and lower tepals of the flower. Paint the flowers Lemon Yellow mixed with Titanium White. Add Cadmium Yellow Medium for the darker areas. Mix Yellow Ochre, Raw Umber, Titanium White and a tiny amount of the background mixture to paint the spines.

Using gel

3 Use a hog-bristle brush to coat the painting with gel (see Using Gel on p. 22). Follow the forms of the tepals, bud and spines with the brushstrokes. Allow to dry.

Creating form

4 Repaint the background. Mix Chromium Green Oxide, Raw Umber and a little Titanium White, and paint the pad. Add a little Mars Black to the mixture for the deep shadows under the flower and bud. Carefully add a softly blended highlight with more Titanium White in the mix on the outer edge of the pad.

5 Continue refining the tepals and bud with the previous mixtures, strongly establishing shadows and highlights. Mix a small amount of the pad mixture with Raw Umber and paint the small mounds where the spines emerge from the side of the pad. Continue to shape the spines, increasing the darker tones where the shadows are deepest.

Refining the shapes

6 Mix Green Gold with varying mixtures of Lemon Yellow, Cadmium Yellow Medium and sometimes a little Titanium White. Introduce this into the shadows in the flowers, softly blending into the lower layers. Add a little Chromium Green

Oxide for the deepest shadows in the centre of the main flower. Deepen all the yellows in the tepals for rich colour. Paint the stamens in Green Gold, Lemon Yellow and Titanium White.

7 Make the shadows and edges in the bud strong and distinct, and deepen the shadows under the flower and bud. Add subtle highlights in Chromium Green Oxide and Raw Umber to the mounds where the spines emerge. Create deeper shadows with Raw Umber and lighter areas with Titanium White in the spines.

Finishing

8 Softly smudge Titanium White across the broader highlights in the tepals. Use a small round brush to paint Titanium White highlights on the stamens and all backlit edges on the tepals, bud, pad and those spines that catch direct light.

See also

Drawing, pages 14–17
Using Gel, page 22

special detail painting cactus spines

▲ *Paint the spine with Yellow Ochre, Raw Umber, Titanium White and a tiny amount of the background mixture, establishing the shapes.*

▲ *Add more Raw Umber to deepen the shadows.*

▲ *Create emphatic shadows with plenty of Raw Umber added. Make the highlights distinct with more Titanium White in the mixture.*

▲ *With a small round brush, paint a Titanium White highlight on the edge of the spines where they catch direct light. Do not paint Titanium White highlights on the shadowed spines.*

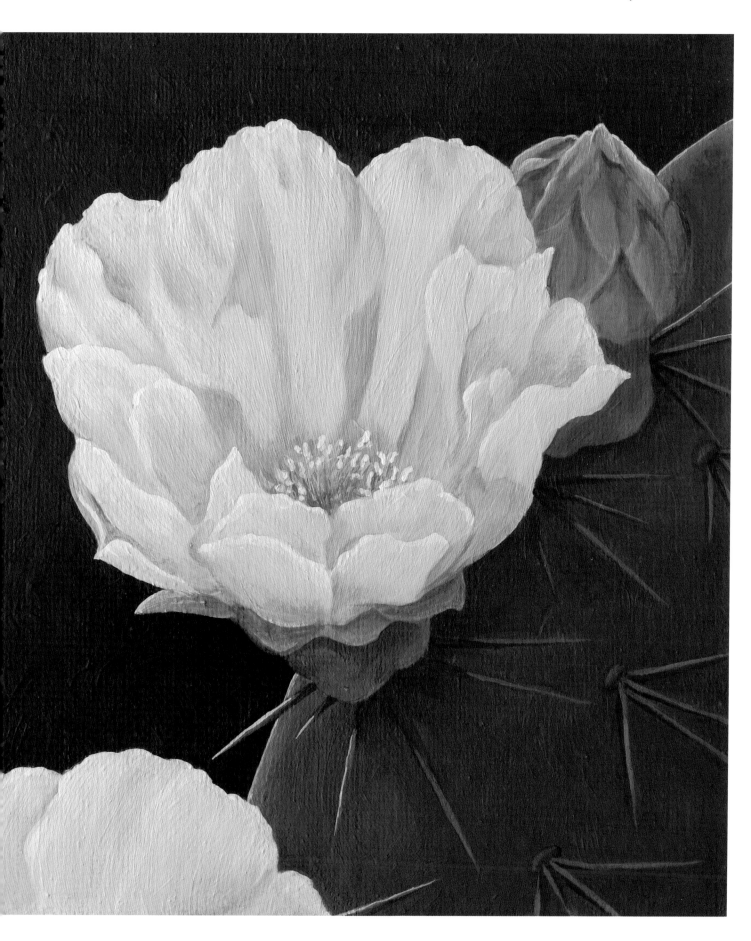

Osteospermum Osteospermum

These rich green, shrubby plants produce a profusion of daisies throughout the summer. The flowers bloom in all colours except blue. Light splashes through the petals and foliage, making a host of patterns. Notice the colour changes as the rounded curves in the petals move from light into shadow. In the shadows, highlighted areas still show the form, but in more subdued tones. Direct sunlight produces far more brilliant highlights as those same curves come out of shadow. Painting these flowers is truly an exercise in understanding values.

- petal
- stamen
- disc
- bud

Palette

Titanium White

Lemon Yellow

Cadmium Yellow Medium

Raw Umber

Perinone Orange

Quinacridone Magenta

Quinacridone Violet

Carbazole Violet

Indanthrone Blue

Green Gold

Permanent Green Light

Chromium Green Oxide

Mars Black

sequence start to finish

Underpainting

1 Use a pencil to sketch the flowers and foliage. Mix Carbazole Violet, Perinone Orange and Titanium White, and paint the background a clean light grey. Mix Green Gold and Chromium Green Oxide with Titanium White, and paint the lighter areas of the leaves, stems and buds. Use Chromium Green Oxide and Raw Umber to paint the shadows in the foliage.

2 Mix Quinacridone Magenta and Titanium White, and paint the petals. Observe the play of light on the flowers and carefully establish the shadows. Use pure Indanthrone Blue to paint the disc of the flower. Add a few Cadmium Yellow Medium stamens around the edges.

Using gel

3 Using a hog-bristle brush, paint the gel on the background, creating a nice texture (see Using Gel on p. 22). Paint the gel following the forms of the flower petals and foliage.

Building richness

4 Repaint the background to dispel the milky look of the gel. Paint the deep shadows in the foliage with Chromium Green Oxide, Raw Umber and Mars Black. Mix Chromium Green Oxide, Permanent Green Light, a little Raw Umber and Titanium White, and paint the brighter parts of the foliage.

5 Use Green Gold and Titanium White for the tips of the sepals on the buds. Use a small amount of Quinacridone Violet with Quinacridone Magenta to add intensity to the shadows in the petals. Blend Quinacridone Magenta and Titanium White to soften the transitions in the brighter shadow areas. Paint a soft highlight in the disc with a tiny amount of Titanium White mixed with Indanthrone Blue. Paint the highlights in the disc with Lemon Yellow mixed with Titanium White.

Completing the detail

6 Using the mixtures from previous steps, blend the colour transitions in all the petals carefully, smudging fresh paint with your finger or a wet paper towel. Make the pattern of light falling across the petals distinct. Use Cadmium Yellow Medium and a tiny amount of Perinone Orange to add accents to the stamens on the disc. Use all the mixtures of greens in previous steps to complete the detail in the foliage.

Finishing

7 With a small round brush, paint the highlights on the petals in Titanium White. Notice how these highlights create a clear sense of light falling across the flowers. Do not paint Titanium White highlights on the foliage as this would make them distract from the flowers, which are the focal point of this painting.

> *See also*
>
> Drawing, pages 14–17
> Using Gel, page 22

special detail painting value changes

◀ *Use varying mixes of Titanium White and Quinacridone Magenta to paint the petals, establishing shadows. Add Quinacridone Violet in the darkest shadows. Mix a soft grey with Perinone Orange, Indanthrone Blue and Titanium White, and paint the shadows of the white parts of the petals. Blend tonal variations in the shadows of these colour mixtures.*

◀ *Continue using these mixtures to blend colour transitions. Smudge the paint with your finger or a damp paper towel to give a soft look, blending into the lower layer of paint. Be careful to continue the curved shapes from the sunlit areas into the shadows, changing tones as the light changes.*

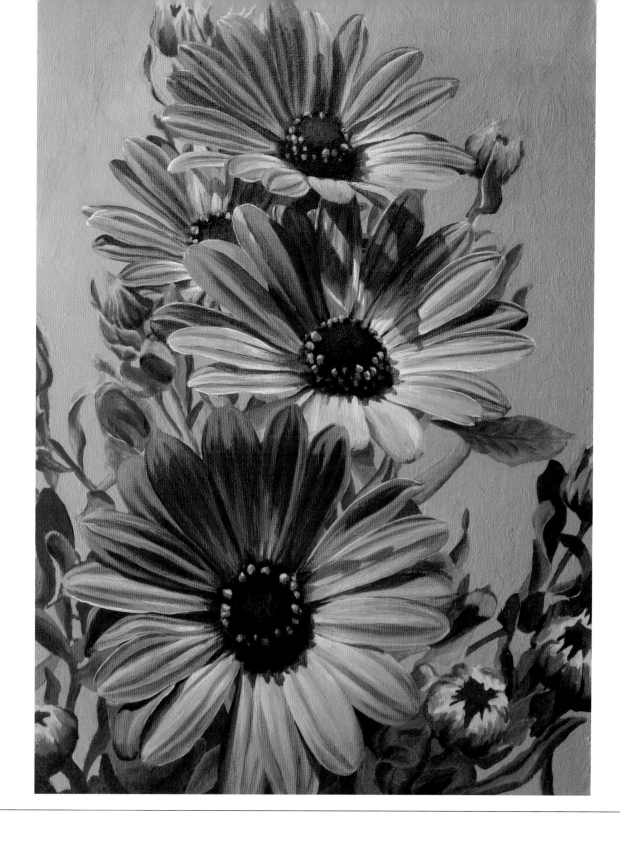

◀ Brighten the more intense areas of colour in the shadows with Quinacridone Magenta and a little Titanium White. Smudge this across some of the shadow on the white splotch to soften the transition from the coloured part of the petals.

◀ Use Titanium White for the highlights. With a small round brush, paint carefully to accent the most brilliantly lit areas of the petals.

Papaver nudicaule Iceland Poppy

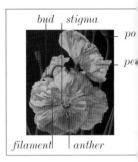

bud stigma

po

pe

filament anther

Iceland poppies are biennials or tender perennials with large, crinkled, papery flowers. The delicate petals can appear in a wide range of orange, yellow, pink and white shades. Painting these flowers invites the artist into a great expression of light in subtle colours and textures. The buds and pods add much visual interest as they provide a fine contrast to the flowers, both in form and colour. Notice the effects of changing light on these flowers as you compose your painting.

Palette

- Titanium White
- Lemon Yellow
- Cadmium Yellow Medium
- Yellow Ochre
- Raw Umber
- Perinone Orange
- Quinacridone Coral
- Anthraquinoid Red
- Green Gold
- Permanent Green Light
- Chromium Green Oxide
- Mars Black

sequence start to finish

Underpainting

1 Sketch all flowers, bud, pods and stems in pencil. Paint the background a dark olive green using Chromium Green Oxide, Raw Umber and Titanium White with a tiny amount of Mars Black. Mix Chromium Green Oxide, Raw Umber and Titanium White for the bud, pods and stems. Paint a little Mars Black into the deep shadows on the stigmas on top of the pods.

2 Mix Cadmium Yellow Medium, Quinacridone Coral, and Titanium White in varying mixtures to paint the petals. Add Titanium White for the lighter areas. Carefully indicate the shadows as you work. Paint the centre parts of the flowers with a mixture of Green Gold, Chromium Green Oxide and Titanium White. For the shadows around the stigma in the large flower, add Raw Umber to the mixture.

Using gel

3 Use a hog-bristle brush to coat the painting with gel (see Using Gel on p. 22). Follow the forms of the petals, bud, pods and stems with the brushstrokes. Allow to dry.

Creating form

4 Paint the background again. Mix Chromium Green Oxide, Permanent Green Light, Raw Umber and a small amount of Titanium White, and paint the stems, pods and bud.

5 Continue using the previous mixtures for the petals. Add a little Perinone Orange to the mix for the darker shadows. Emphasize the linear shadows as you work. Paint the centres of the flowers with the first mixture, making the shadows a deeper green.

Refining detail

6 Paint soft highlights on the stems, pods and bud with Green Gold and Titanium White, blending into the lower layer. Continue refining details in the petals with the previous mixtures. Increase the amount of Perinone Orange in the broader vibrant shadow areas. Use a little Yellow Ochre in the mix to paint the shadow in the lower left petal of the large flower. Carefully blend the colour transitions by smudging with your finger or a wet paper towel.

7 Add Anthraquinoid Red to this mix and paint distinct shadows in the darkest parts of the flower. Add intensely dark shadows around the stigma radiating into the petals. Blend into the petal colours using multiple layers of paint. Add anthers and filaments and highlights in the stigma with varying mixtures of Green Gold, Lemon Yellow, Yellow Ochre and Titanium White.

Finishing

8 Mix Raw Umber and Yellow Ochre, and paint a few dark anthers. Use Green Gold, Lemon Yellow and Titanium White to paint highlights on part of the filaments and anthers. Lightly drag a brush with Titanium White across the broader highlights in the petals.

9 Use a small round brush to paint Titanium White highlights on the petals.

See also

Drawing, pages 14–17
Using Gel, page 22

special detail adding anthers and filaments successfully

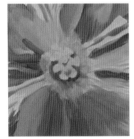

▲ *Paint the petals and stigma with the mixtures specified in the painting sequence. Do not add anthers and filaments yet, so that the radiating brushstrokes for the petals can be smoothly sweeping.*

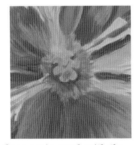

▲ *Once again, work with the mixtures given in the painting sequence. The petals and stigma must be nearly completed before adding anthers and filaments.*

▲ *Using the mixtures in the painting sequence, complete the petals and stigma. Now begin painting the anthers and filaments with mixtures of Green Gold, Lemon Yellow, Yellow Ochre and Titanium White.*

▲ *Paint a few dark anthers with Raw Umber and Yellow Ochre. Add Green Gold, Lemon Yellow and Titanium White highlights on part of the filaments and anthers. Add touches of Titanium White highlights to the petals.*

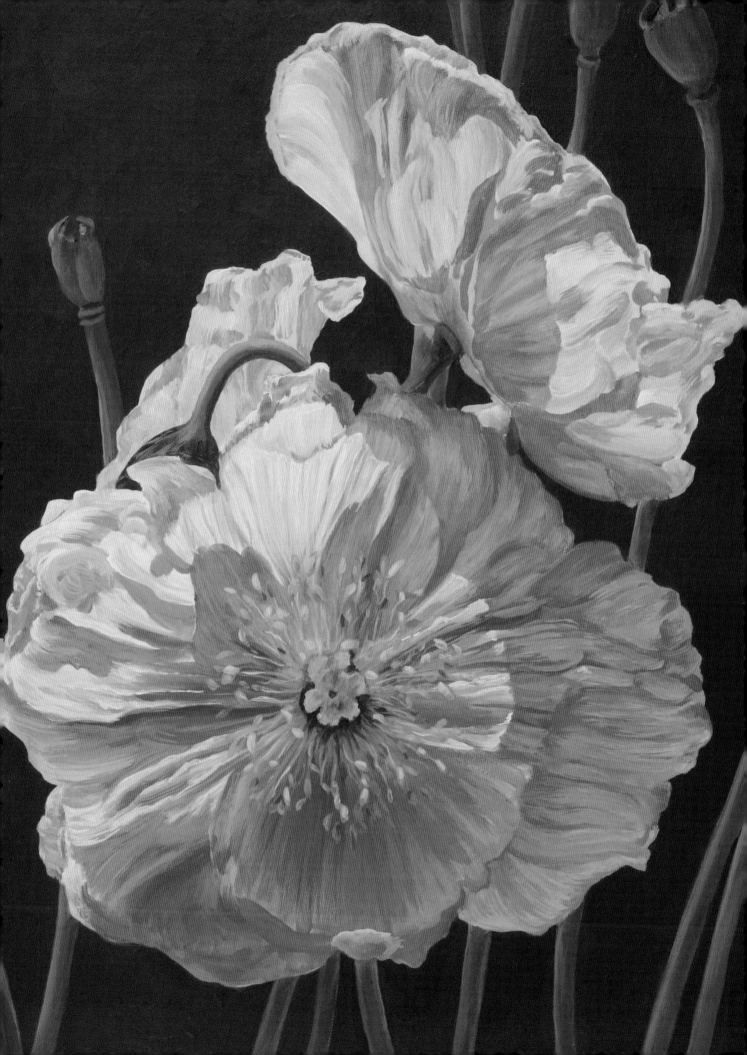

Papaver rhoeas Shirley Poppy

Perhaps the most remarkable of all flowers in the dawn light, Shirley poppies blaze forth in a glorious range of reds, pinks and whites, with the occasional lavender. The blooms are ephemeral, as the slightest breeze can begin scattering the petals soon after the flowers open at first light. Graceful curving petals surround the pistil, a capsular form adding distinction to the centre of the flower. The stamens radiate in multiple whorls around the pistil, creating shadows of interest to the artist as they fall across the petals. Remember the magic of dawn light as you paint such flowers.

Palette

Titanium White

Lemon Yellow

Nickel Azo Yellow

Cadmium Yellow Medium

Yellow Ochre

Raw Umber

Perinone Orange

Quinacridone Coral

Anthraquinoid Red

Alizarin Crimson

Permanent Red

Quinacridone Magenta

Quinacridone Pink

Quinacridone Violet

Green Gold

Permanent Green Light

Chromium Green Oxide

Mars Black

sequence start to finish

Underpainting

1 Sketch the flower, pod and stems in pencil. Paint the background Mars Black for maximum contrast. Mix Chromium Green Oxide, Raw Umber and a little Mars Black, and paint the shadows in the stems, pod and pistil. Add Titanium White and paint the lighter areas. Use Green Gold and Titanium White to paint a blush of colour around the base of the pistil.

2 Mix Quinacridone Pink and Titanium White and paint the petals of the flower, establishing the shadows. Paint Alizarin Crimson into the deepest shadows. Use Lemon Yellow, Yellow Ochre and Titanium White mixtures to paint the anthers.

Using gel

3 Use a hog-bristle brush to paint gel on the background, creating a strong texture (see Using Gel on p. 22). Paint the gel following the forms of the flower, pod and stems. Allow to dry before continuing.

Building rich colour

4 Paint the background texture again. Paint the stems with a Chromium Green Oxide, Raw Umber and Mars Black mixture. Add Titanium White to the mixture for the lighter edges of the stems, pod and pistil. Carefully blend the colours into the lower layer by smudging. Add a tiny amount of Permanent Green Light and paint the shadows in the stigma, smudging into the lighter areas. Use Nickel Azo Yellow with the previous yellow mixture to add detail to the anthers.

5 Paint the deep shadows in the petals with Alizarin Crimson mixed with a little Permanent Red. Use Quinacridone Magenta, Quinacridone Violet and a little Titanium White to add intensity to the medium shadows. Use a pale mixture of Quinacridone Violet and Titanium White in the shadowed part of the white petal areas.

Creating luminosity

6 Paint Anthraquinoid Red in the shadows of the petal to the furthest right and its shadow on the petal below it, as well as on the front shadowed curl of the bottom petal. Smudge it evenly, allowing the paint underneath to glow through it. Use the same process with Quinacridone Coral in the vibrantly glowing parts of the shadows in the other petals. Add a tiny amount of Perinone Orange to Cadmium Yellow Medium and paint a few glowing areas in the anthers.

Finishing

7 Paint the styles with a small round brush, carrying Green Gold and Titanium White in varying mixtures. With the same brush, paint the highlights in Titanium White using varying thicknesses of strokes, and allowing broken and skipped areas to create a natural look.

See also

Drawing, pages 14–17
Using Gel, page 22

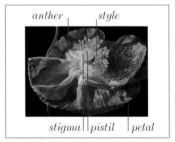

anther style

stigma pistil petal

special detail painting the pistil with its stigma

◄ *Use Chromium Green Oxide, Raw Umber and a small amount of Mars Black, and paint the shadows in the pistil. Add Titanium White and paint the highlights. Make sure the ribbed forms begin to emerge.*

◄ *Mix Green Gold, Chromium Green Oxide and Titanium White, and paint the stigma, carefully following the ribbed forms. Paint Chromium Green Oxide, Permanent Green Light and Raw Umber into the shadows of the ribs.*

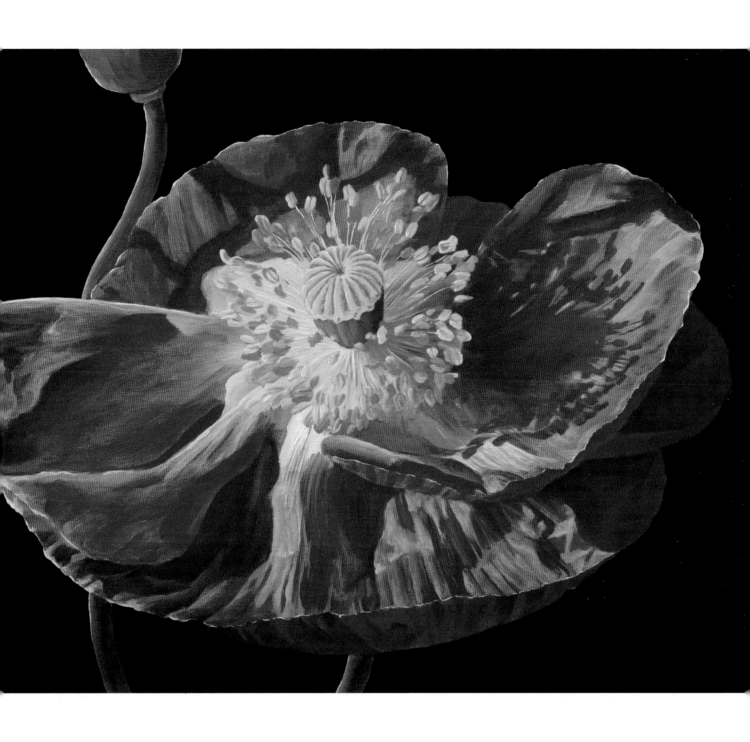

◄ *Show the direction of light by placing the highlights and shadows correctly. Continue to refine the blends with the previous mixtures and deepen the shadows.*

◄ *Stipple a Permanent Green Light, Green Gold and Titanium White mixture into the shadows in the ribs, creating a more natural, textured appearance. With a small round brush, paint small white highlights to accent the direction of light.*

Papaver somniferum Opium Poppy

These poppies are the drama queens of the poppy realm. The blooms can be huge, intense, fringed, multicoloured and altogether captivating. They have self-seeded for years in old-time gardens, continuing to bring forth their glories every summer. In this particular flower, rich purples dance with vibrant orange, making the artist yearn for the brushes. The fact that this ageing flower has lost a petal impairs its beauty not a whit, but merely reveals a view we would not have otherwise seen. Secrets of reflected light shine forth and we begin to paint.

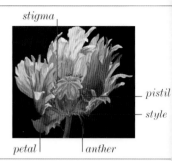

stigma

pistil

style

petal anther

Palette

Titanium White

Nickel Azo Yellow

Yellow Ochre

Raw Umber

Perinone Orange

Quinacridone Coral

Permanent Red

Carbazole Violet

Permanent Green Light

Chromium Green Oxide

Mars Black

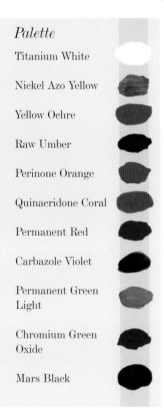

sequence start to finish

Underpainting

1 Use a pencil to sketch the flower. Paint the background Mars Black for maximum contrast. Mix Chromium Green Oxide, Raw Umber, and a little Mars Black, and paint the shadow in the stems and pistil. Add Titanium White to the mixture and paint the highlights. Paint Nickel Azo Yellow, Yellow Ochre, Raw Umber and Titanium White on the ridges of the stigma. Use Chromium Green Oxide and Raw Umber to paint the darker green areas of the stigma.

2 Mix Permanent Red, Perinone Orange and Titanium White, and paint the petals of the flower, establishing the shadows. Mix Carbazole Violet with Titanium White in varying mixtures and paint the purple areas in the petals, allowing it to blend into the orange mixture from the previous step.

Using gel

3 Paint the gel with a hog-bristle brush, following the forms with brushstrokes (see Using Gel on p. 22) Allow to dry.

Creating form and colour

4 Paint the background Mars Black again. Paint the stem and pistil with the Chromium Green Oxide, Raw Umber, Titanium White and Mars Black mixture, carefully blending the highlights into the shadows. Carefully blend the colours into the lower layer by smudging. Mix a tiny amount of Permanent Green Light added to Chromium Green Oxide, Raw Umber and Titanium White, and soften the shadows in the stigma, smudging into the dark areas. Paint Nickel Azo Yellow on the ridges of the stigma.

5 Paint the deep shadows in the petals with Permanent Red, smudging softly into the lower layer of paint. Continue refining the detail and values in the petals, using the previous mixtures (see Values on p. 19).

Refining detail

6 Mix a lot of Titanium White into a mixture of Chromium Green Oxide, a little Raw Umber and Mars Black to make a light grey-green. Use this to lighten the highlighted flat areas below the ridges on the stigma. Use a small amount of Quinacridone Coral and paint the shadowed glowing area around the pistil and stigma. Smudge

it evenly, allowing the paint underneath to glow through it. Do the same on the stigma, but only on the outer edges. Paint the anthers and styles with the same mixtures of paint used in the petals. Notice that the styles can be purple at one end and pink at the other, which requires smoothly blending the transition.

Finishing

7 With a small round brush, paint highlights in Titanium White using varying thicknesses of strokes, and allowing broken and skipped areas to create a natural look. These highlights should be where the light touches, not shadowed parts such as the stem.

See also

Drawing, pages 14–17
Values, page 19
Using Gel, page 22

special detail painting reflected light

◀ *Mix Chromium Green Oxide with Raw Umber and paint the shadows in the stigma. Add Titanium White and paint the broad lighter areas. Combine Nickel Azo Yellow, Yellow Ochre, Raw Umber and Titanium White for the ridges on top of the stigma.*

◀ *Mix Chromium Green Oxide, Raw Umber and Titanium White with a tiny amount of Permanent Green Light and smudge into the shadows. Paint Nickel Azo Yellow into the ridge highlights to soften the look.*

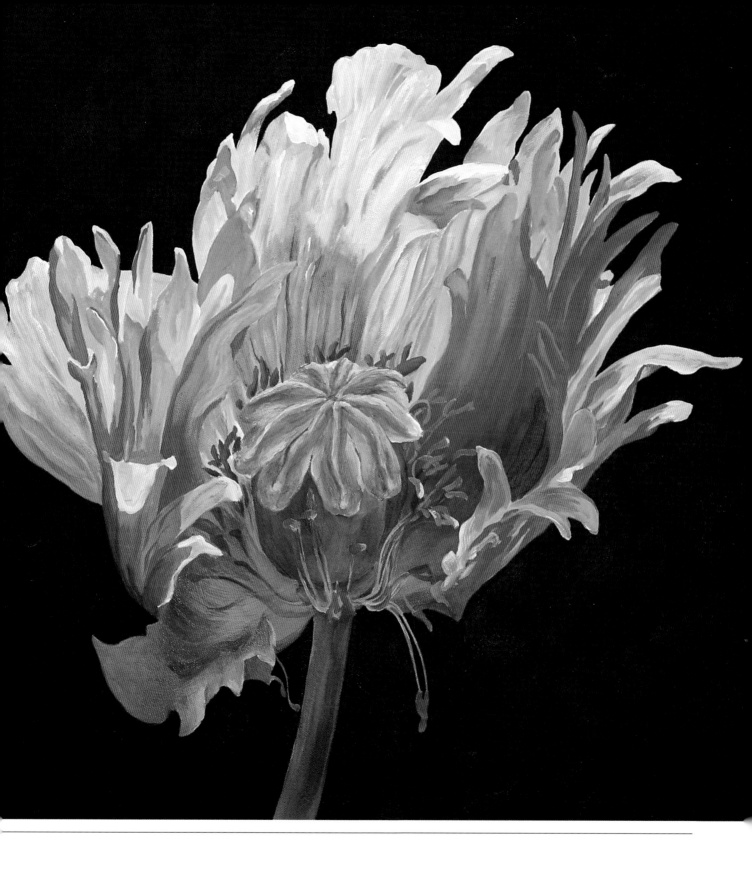

◄ *Make a light grey-green with Titanium White mixed into Chromium Green Oxide, a little Raw Umber and Mars Black, and paint the highlighted areas.*

◄ *Smudge Quinacridone Coral into the parts of the stigma that glow with a reddish reflected light. This is done when all else is completed.*

Pelargonium Geranium

Johnson's Blue geranium is an extremely hardy wild geranium, with blue flowers. This low-growing, durable plant tolerates winter temperatures of −34.4°C (−30°F) and still manages to thrive. In the spring, the leaves emerge first and then blossoms rise above the foliage, each accented by a rich magenta centre. Every bloom displays ten stamens in a bold central column. The five petals have distinct veins radiating outward from the ten stamens. Of great interest to the artist is the intriguing texture of the petals. In the right light, the colours of the flower sparkle with a myriad tiny highlights.

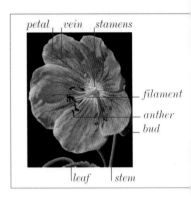

petal vein stamens

filament
anther
bud

leaf stem

Palette

Titanium White

Raw Umber

Perinone Orange

Quinacridone Magenta

Cerulean Blue

Indanthrone Blue

Ultramarine Blue

Permanent Green Light

Chromium Green Oxide

Mars Black

sequence start to finish

Underpainting

1 Use a pencil to sketch the flower, leaf, bud and stems. Paint the stems with Chromium Green Oxide, Permanent Green Light, a little Raw Umber and Titanium White. Paint the deepest shadows in the bud and stems with Chromium Green Oxide and Raw Umber.

2 Mix Ultramarine Blue, Cerulean Blue and Titanium White, and paint the outer part of the petals, establishing the shadows. Use Quinacridone Magenta and Titanium White in the centre area of the flower, blending outward into the blue.

3 Mix Indanthrone Blue, Perinone Orange and Titanium White to make the greys for the centre column of stamens. Paint light grey and dark grey streaks radiating from the centre column into the magenta area. Mix some of the grey mixture with Mars Black and paint the anthers.

Using gel

4 Apply the gel with a hog-bristle brush (see Using Gel on p. 22). Follow the forms of the petals and foliage. Create a nice texture in the background. Allow to dry.

Blending layers of colour

5 Emphasize the shadows in the stems, bud and leaf with Chromium Green Oxide and Raw Umber mixed with a small amount of Titanium White. Blend into the previous layer. Mix a tiny amount of Raw Umber with the Chromium Green Oxide, Permanent Green Light and Titanium White, and paint the highlighted areas.

6 Use the Ultramarine Blue, Cerulean Blue and Titanium White mixtures to refine the detail in the petals. Blend more Ultramarine Blue in the shadows. After the blue has dried, paint Quinacridone Magenta and Titanium White into the centre of the flower, radiating outward into the blue again. Lightly smudge this mixture into broader areas of the blue, allowing it to show through the magenta. Refine the centre stamen column and filaments with the previous grey mixture.

Creating texture

7 With either a 'bad hair day' brush or a small round brush, begin to stipple the paint into the petals. Use the Ultramarine Blue, Cerulean Blue and Titanium White mixtures first. Stipple strong shadow areas overlapping into lighter areas, allowing

different shades of stipples to intermingle.

8 Switch to the Quinacridone Magenta and Titanium White mix and continue stippling. Use both blues and magentas in overlapping layers until a richly textured look is achieved. Paint radiating veins in Quinacridone Magenta. Add a slight blush of Chromium Green Oxide, Permanent Green Light and the grey mixture to the base of the centre column of the stamens.

Finishing

9 With a small round brush, paint small highlights in Titanium White on the foliage and filaments, and stipple the Titanium White highlights in the petals.

See also

Drawing, pages 14–17
Using Gel, page 22

special detail making sparkling colour in a petal

◀ *Paint the petal with the mixtures specified in the painting sequence. Blend the different mixtures into each other.*

◀ *Continue working with the previous mixtures and soften the blends smoothly.*

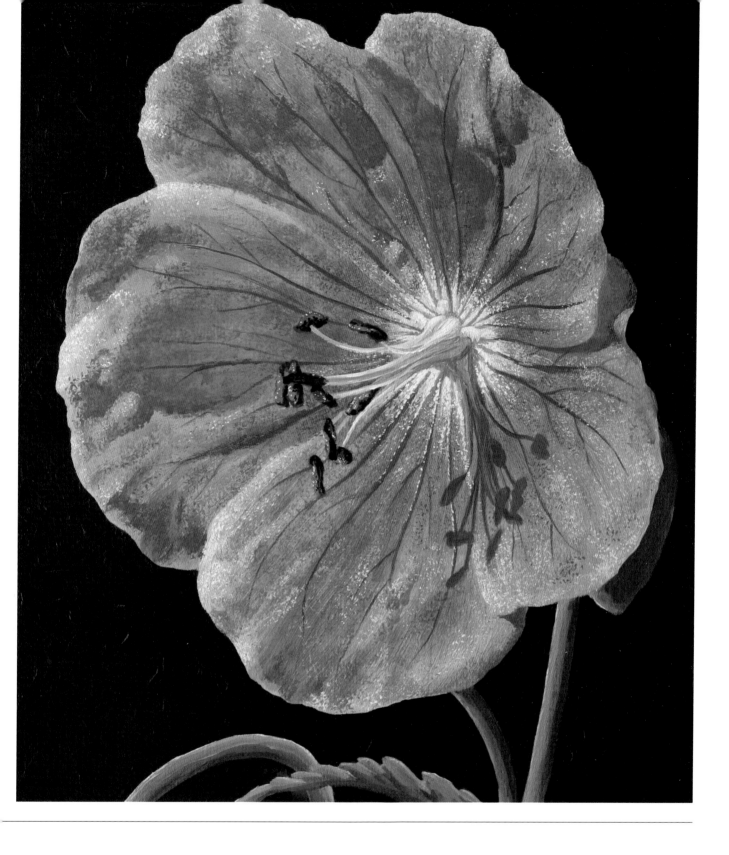

◄ Stipple the previous mixtures
 into the petal with either a
 small round brush or a 'bad
 hair day' brush. Create rich
 layers of colour and texture.
 Paint the veins with
 Quinacridone Magenta.

◄ Use the small round brush or
 the 'bad hair day' brush to
 stipple Titanium White
 highlights on the petal. This
 completes the sparkling look.

Portulaca Moss Rose

Originally from South Africa, this low-growing, succulent plant loves dry, sunny, locations. The leaves and stem are round and fleshy, holding vibrant flowers in a wide array of colours. These bright blooms only open for sunlight and are about 2.5cm (1 in.) in diameter. The curving petals hold light and shadow in the most interesting ways. Stamens with their red filaments add a striking accent to the flower. Notice the direction of light and its effect on the flower.

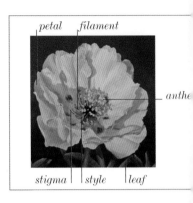

petal filament

anther

stigma style leaf

Palette

Titanium White

Nickel Titanate Yellow

Nickel Azo Yellow

Cadmium Yellow Medium

Yellow Ochre

Raw Umber

Perinone Orange

Anthraquinoid Red

Permanent Red

Permanent Green

Chromium Green Oxide

Mars Black

sequence start to finish

Underpainting

1 Use a pencil to sketch the flower parts, leaves and stem. Paint the background a soft grey-brown using Raw Umber, Yellow Ochre, a tiny amount of Mars Black and Titanium White. Use Chromium Green Oxide, a little Raw Umber and Titanium White to paint the leaves and stem.

2 Mix Nickel Titanate Yellow and Titanium White, and paint the lighter areas of the petals. Add Nickel Azo Yellow for the darker areas. Mix Cadmium Yellow Medium, Yellow Ochre, Titanium White and a tiny amount of Perinone Orange to paint the anthers. Use Anthraquinoid Red and a little Titanium White to paint the filaments and the style.

Using gel

3 Use a hog-bristle brush to coat the painting with gel (see Using Gel on p. 22). Follow the forms of the leaves, stem and petals with the brushstrokes. Allow to dry.

Creating form

4 Repaint the background. Mix Chromium Green Oxide, Permanent Green, Raw Umber and a little Titanium White, and paint the leaves and stem.

5 Continue refining the petals, using more Nickel Azo Yellow in the shadowed areas. Mix a small amount of Raw Umber with Nickel Azo and paint the darkest shadows, smoothly blending the gradations of shadow. Paint the splotches with Permanent Red, lightly smudging with a finger or a wet paper towel.

6 Use Permanent Red and Titanium White to paint the upper parts of the filaments and the style. Mix Yellow Ochre and a little Perinone Orange to paint the lighter areas of the anthers.

Building rich colour

7 Increase the highlights in the leaves and stem by adding more Titanium White to the previous mixture used. Combine Nickel Azo Yellow, Cadmium Yellow Medium and a tiny amount of Titanium White in varying mixtures, and paint into the petal shadows, blending with your finger or a wet

paper towel. Use a combination of Nickel Azo Yellow and Raw Umber to deepen the darkest shadows.

8 Use Anthraquinoid Red and Raw Umber to paint a shadow at the base of the filaments. Paint Permanent Red on the upper parts of the filaments and the splotches. Add Perinone Orange and Cadmium Yellow Medium to the anthers to give more intensity.

Finishing

9 Smudge a small amount of Raw Umber over the splotches to give them a shadowed look, using your finger or a wet paper towel. Lightly drag a brush with Titanium White across the broader highlights in the petals. Use a small round brush to paint Titanium White highlights on the leaves and petals. Leave skipped and broken sections of line on the edges to give a natural look.

See also

Drawing, pages 14-17
Using Gel, page 22

special detail painting shadows within shadows

◀ *Use Nickel Titanate Yellow and Titanium White for the lighter parts of the petals. Add Nickel Azo Yellow and paint the darker shadows, blending into the lighter mixture.*

◀ *Continue working with the shadows, adding more Nickel Azo Yellow to the mixture. Combine Nickel Azo Yellow and a small amount of Raw Umber for the darkest shadows. Blend the transitions smoothly. Paint the splotches with Permanent Red, lightly smudging with a finger or a wet paper towel.*

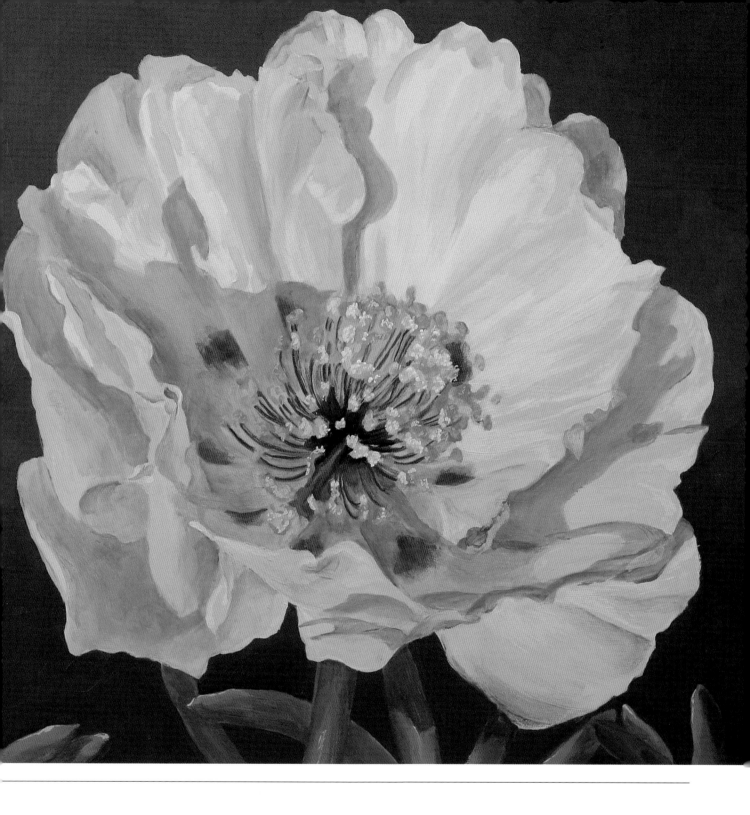

 ◀ Use mixtures of Nickel Azo Yellow, Cadmium Yellow Medium and a tiny amount of Titanium White to add rich colour to the petal shadows. Continue to blend carefully. Paint more Nickel Azo Yellow and Raw Umber to deepen the darkest shadows.

 ◀ With a small round brush, paint Titanium White highlights sparingly on only the parts where the light glances across the flower. Notice that the highlighted areas not in direct light are not given Titanium White accents, which allows them to recede into shadow.

Rosa Rose

Roses are ancient flowers and rose fossils have been found dating back 35 million years. The Chinese were probably the first culture to cultivate these plants. The Romans grew extensive rose gardens for medicine and perfume. In the seventeenth century, roses were so desired that they were considered to be legal tender. Today, modern roses come in an array of colour blends and fragrances. The artist delights in the folds, curls and glowing shadows in the petals of these magnificent flowers.

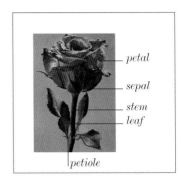

petal

sepal

stem

leaf

petiole

Palette

Titanium White

Cadmium Yellow Medium

Raw Umber

Perinone Orange

Quinacridone Coral

Anthraquinoid Red

Perylene Maroon

Quinacridone Magenta

Rich Green Gold

Green Gold

Chromium Green Oxide

sequence start to finish

Underpainting

1 Use a pencil to sketch the rose, leaves and stem. Paint the background pale green using Chromium Green Oxide, Raw Umber and Titanium White. Mix Perylene Maroon and Raw Umber for the stem and sepals, establishing the shadows. Use Chromium Green Oxide and Raw Umber in the leaves, sepals and top of the stem. Add Titanium White for the lighter areas.

2 Mix Cadmium Yellow Medium, Quinacridone Coral and Titanium White in varying mixtures to paint the petals. Carefully indicate the shadows as you work. Add Quinacridone Magenta to this mix in the shadows where the magenta hue appears in the flower.

Using gel

3 Use a hog-bristle brush to coat the painting with gel (see Using Gel on p. 22). Follow the forms of the leaves, stem, sepals and petals with the brushstrokes. Allow to dry.

Adding fullness to the colour

4 Repaint the background. Use the Perylene Maroon and Raw Umber mixture for the stem and sepals again, adding a little Titanium White for the lighter areas. Mix Chromium Green Oxide, Green Gold and a tiny amount of Raw Umber with Titanium White, and paint the leaves and upper stem.

5 Mix Cadmium Yellow Medium and a tiny amount of Perinone Orange to make a medium orange. Add Quinacridone Coral and paint some of the mid-tones in the petals. Omit the Perinone Orange for the lighter areas. In the most yellow areas, use very little Quinacridone Coral. Add Quinacridone Magenta in the areas where those hues appear. Carefully blend as you work.

Adding intensity

6 Paint Perinone Orange mixed with Cadmium Yellow Medium in the petioles and some of the points on the edge of the leaves. Use Rich Green Gold and Titanium White to blend a lighter area at the bottom of both upright

leaves. Paint the leaves with the previous mixtures, adding Rich Green Gold in the glowing areas of the upright leaves.

7 Continue refining details in the petals with the previous mixtures. Add a little Anthraquinoid Red and Perylene Maroon to this mix, and paint more distinct shadows in the darkest parts of the flower. Carefully blend the colour transitions by smudging with your finger or a wet paper towel.

Finishing

8 Lightly drag a brush with Titanium White across the broader highlights in the leaves. Use a small round brush to paint Titanium White on the highlighted parts of the leaves and petals. Leave skipped and broken sections of line on the edges to give a natural look.

See also

Drawing, pages 14–17
Using Gel, page 22

special detail painting a glossy leaf

◄ *Mix Chromium Green Oxide and Raw Umber, and paint the leaf. Add Titanium White to the mix for the lighter areas.*

◄ *Add Chromium Green Oxide, Green Gold and a tiny amount of Raw Umber to a little Titanium White, and paint the leaf, establishing the glowing areas in the shadows. Add a little Rich Green Gold and Titanium White to paint the lower area at the base of the petiole.*

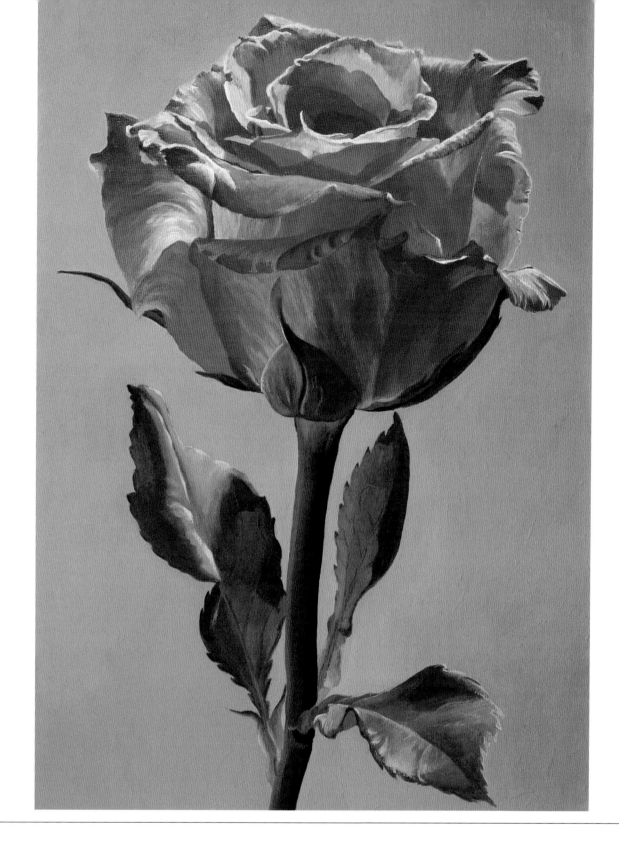

◄ Use Perinone Orange mixed with Cadmium Yellow Medium to paint the petiole and veins of the leaf. Paint a little of the green mixture over the veins to soften the look.

◄ Lightly drag a brush with Titanium White over the highlights, blending into the lighter area. With a small round brush, paint distinct bright Titanium White highlights. Notice how the sharp highlights and deep shadows make a glossy look.

Tropaeolum Nasturtium

Nasturtiums have dramatic yellow, orange and red flowers, which are both spurred and funnel-shaped. These striking flower shapes contrast well with the flat round leaves. The slightly curling leaves cast deep shadows, but the flowers inevitably triumph over the darkness with their brilliant colour – a beautiful study in luminosity. Leaves and flowers alike are edible on this plant, giving a peppery snap to salads, reminiscent of their visual snap in the garden. The artist can enjoy painting these flowers boldly.

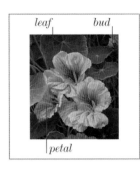
leaf bud
petal

Palette

Titanium White

Nickel Titanate Yellow

Cadmium Yellow Medium

Raw Umber

Perinone Orange

Anthraquinoid Red

Green Gold

Permanent Green Light

Chromium Green Oxide

Mars Black

sequence start to finish

Underpainting

1 Using a pencil, sketch out the flowers and foliage. Paint the background shadows a mixture of Chromium Green Oxide, Raw Umber and a tiny amount of Mars Black. Use a mixture of Green Gold, Permanent Green Light and Chromium Green Oxide with either Titanium White for lighter areas or Raw Umber for darker areas, and paint the leaves and stems. Establish the shadows, noticing the direction of light as you paint.

2 Mix Cadmium Yellow Medium and Perinone Orange to make a medium orange mixture, and paint the petals. Paint the highlights with Cadmium Yellow Medium and Nickel Titanate Yellow, delineating the shadows. Paint more Perinone Orange in the throat of the flower.

Using gel

3 Texture the foliage and flowers with gel using a hog-bristle brush (see Using Gel on p. 22) Use the gel fairly smoothly. Allow to dry.

Developing form and colour

4 Paint the background shadows again with the previous mixture. Subtly indicate deeply hidden leaves in those shadows. Refine the shadows and highlights in the leaves and stems with the green mixtures from the previous step. Carefully blend the darker greens to create natural-looking leaves. Paint the light-coloured radiating veins in the leaves with Green Gold, Permanent Green Light and Titanium White.

5 Paint the shadows in the petals with varying mixtures of Cadmium Yellow Medium and Perinone Orange. Use Cadmium Yellow Medium and Titanium White for highlighted areas. Do not use this lighter colour in the shadows. Gently blend the transitions of colour by smudging with your finger or a damp paper towel. Add more Perinone Orange to Cadmium Yellow Medium in the more brilliant areas of shadow.

Adding detail

6 Look at the painting and check that the shadow areas do not have bright highlights, but still show lighter

areas within them. Make sure that the brightly lit areas do have significantly lighter highlights. Begin adding little touches to complete the painting, such as painting Anthraquinoid Red deep in the throat of the petals. Mix it with Perinone Orange and paint the radiating veins. Smudge a Cadmium Yellow Medium and Perinone Orange mixture over them to soften the look.

Finishing

7 Taking care to maintain the direction of light already established, use a small round brush to paint Titanium White highlights on the edges of the petals and leaves, allowing spaces and breaks in the strokes for a natural look. Use these highlights sparingly for maximum effectiveness, placing them only where the sun is directly hitting the leaves and petals.

See also

Drawing, pages 14–17
Using Gel, page 22

special detail painting highlights on rolled petals

▲ *Use Cadmium Yellow Medium and Perinone Orange to paint the shadow areas. Paint Cadmium Yellow Medium and Nickel Titanate Yellow to lighten the brighter areas.*

▲ *Paint Perinone Orange into the deepest shadows, continuing to blend the colours into the previous paint layer. Add more highlights to increase the contrast.*

▲ *Paint Cadmium Yellow Medium into the blend between shadows and highlights. Increase the highlights and soften the shadows using the previous paint mixtures.*

▲ *With a small round brush, add a few Titanium White highlights.*

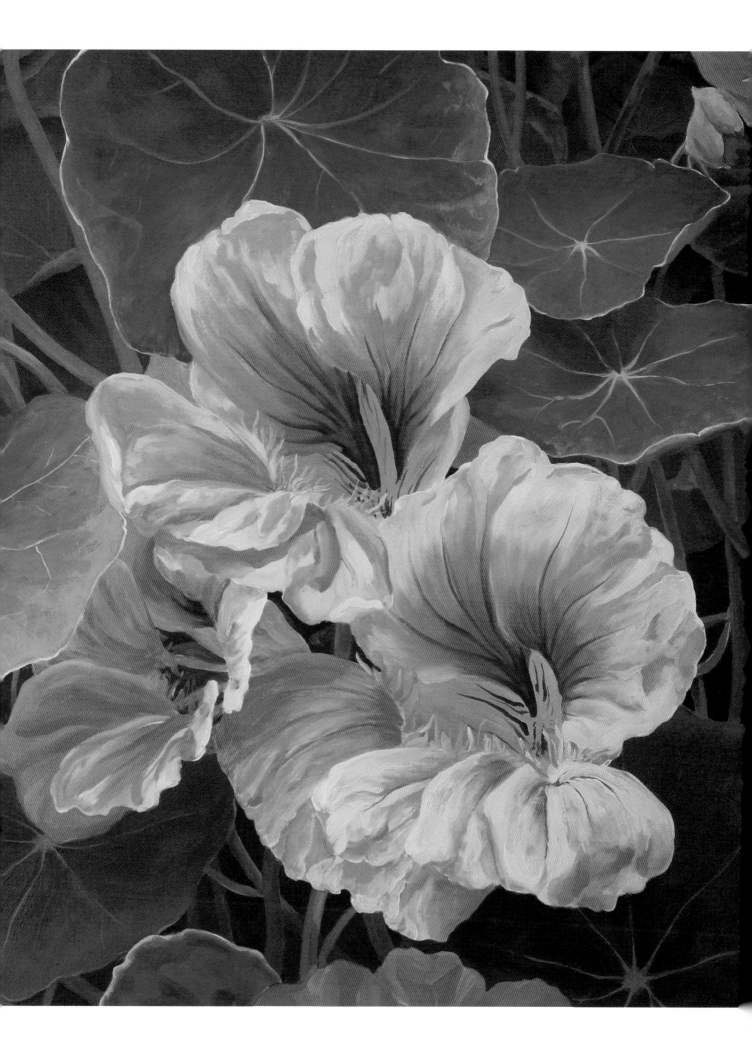

Tulipa Tulip

In the 1700s, a speculative tulip-buying frenzy hit the Netherlands. Prices rose to enormous levels, with homes and land being traded for single bulbs. As all such bubbles do, this one eventually burst. However, Holland still produces vast quantities of bulbs that brighten spring gardens in a rainbow of colours. The cup-shaped flowers of these plants rise above the leaves and can be virtually any colour except blue. Slightly stiff green leaves roll and curve with interesting forms to complement the blooms.

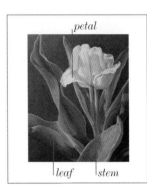

petal

leaf stem

Palette

Titanium White

Lemon Yellow

Nickel Titanate Yellow

Nickel Azo Yellow

Cadmium Yellow Medium

Yellow Ochre

Raw Sienna

Raw Umber

Perinone Orange

Carbazole Violet

Green Gold

Permanent Green Light

Chromium Green Oxide

Mars Black

sequence start to finish

Underpainting

1 Sketch the flower, stems and leaves with pencil. Combine Carbazole Violet, Perinone Orange and Titanium White, making a pinkish grey. Then mix Raw Umber, Yellow Ochre, Mars Black and a little Titanium White, add a little of the pink-grey mixture, and paint the background. Keep it dark in the lower right corner and blend lighter in the upper left.

2 Mix Chromium Green Oxide, Permanent Green Light, Titanium White and a tiny amount of Raw Umber, and paint the brighter green areas of the foliage. Use a mixture of Chromium Green Oxide, Raw Umber and a tiny amount of Mars Black to paint the deeper shadows in the foliage. For the slightly greyed areas of the leaves, add some of the pink-grey mixture to the green.

3 Mix Cadmium Yellow Medium, Nickel Azo Yellow and Titanium White in varying mixtures and paint the petals, establishing the shadows. Use Lemon Yellow and Titanium White for the highlighted areas.

Using gel

4 Paint the background with an interesting texture in gel using a hog-bristle brush (see Using Gel on p. 22). Paint gel on the leaves, stems and petals, following their forms with the brushstrokes. Allow to dry.

Refining blends

5 Repaint the background. Continue working with the yellow mixtures to soften the petal shadows and blend the colour transitions. Do the same with the green mixtures in the leaves, smudging the colour transitions with your finger or a damp paper towel. Make sure you are using shadows to define the forms, creating a dimensional look. Mix Cadmium Yellow Medium with Raw Sienna to paint more of a glow in the petals. Use Nickel Titanate Yellow and Titanium White in the highlighted areas of the petals.

Adding intensity

6 Mix Chromium Green Oxide, Permanent Green Light and a small amount of Raw Umber and Titanium White, and gently smudge the stems and some of the more vibrant parts of

the leaves. Accent the highlights in the stems and lower leaf with Green Gold mixed with Lemon Yellow and Titanium White. Carefully blend the colour transitions by smudging with your finger or a wet paper towel.

Adding highlights

7 Use Cadmium Yellow Medium and Raw Sienna to accent vibrant areas of glow in the petals. Lightly drag a brush with Titanium White across some of the textured areas of the leaves that need highlighting.

Finishing

8 Use a small round brush to paint strokes of varying thickness of Titanium White on the edges of the leaves, stems and petals. Leave skipped and broken sections of line to give a natural look.

See also

Drawing, pages 14–17
Using Gel, page 22

special detail creating form with line and shadow

◄ *Block in the leaf with a mixture of Chromium Green Oxide, Permanent Green Light and small amounts of Raw Umber, Mars Black and Titanium White. Use the mixture with varying amounts of the colours for different areas of the leaf. Add a little of the Carbazole Violet, Perinone Orange and Titanium White mixture to paint the grey-green areas. Use Chromium Green Oxide and Raw Umber in the deepest shadow.*

◄ *Continue refining the blends in the leaf with the mixtures. Take care to create soft blends by smudging the paint gently. Gradually increase the intensity.*

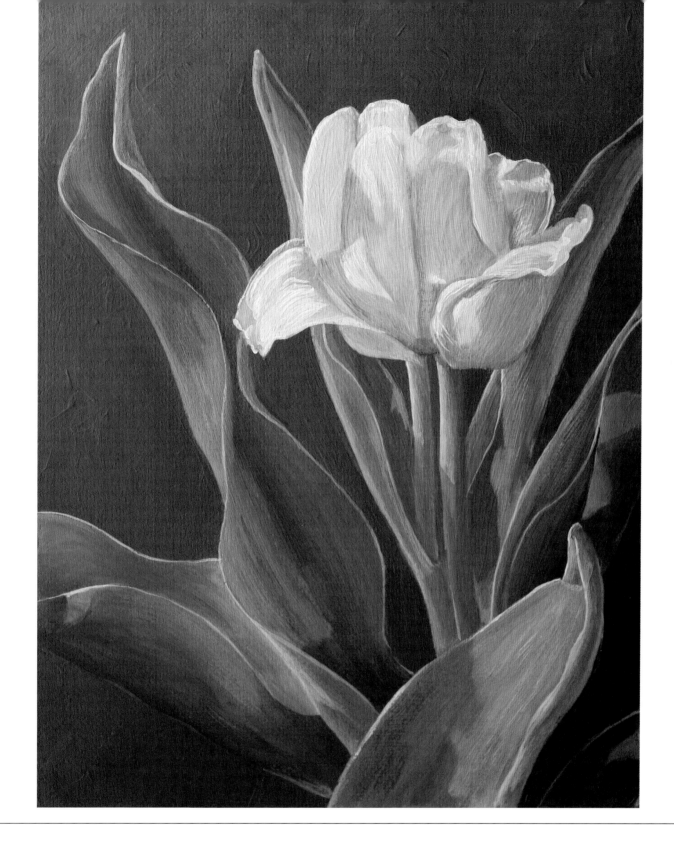

◄ Deepen the shadow inside the leaf with
Chromium Green Oxide and Raw Umber.
Add a little Permanent Green Light and
deepen the lighter area of the inner leaf
shadow, leaving a highlighted area.

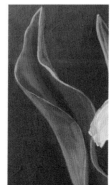

◄ Soften the grey-green area, blending it
lighter on the left side of the leaf. Add
Titanium White highlights. Notice how
using them along the edges of the leaf
completes the feeling of dimensional space.

Viola tricolor Wild Pansy

Violas are all violets, many of them cold-loving plants that bloom well in adverse conditions. They have five petals and a 'face' – the contrasting blotch of colour in the centre of the flower. Flowers have many surprises and there are actually some members of this genus that bloom with colourful, infertile flowers and self-pollinate in hidden flowers that never even open! Fortunately for us, they do manage to reproduce, however they go about it. In this flower, the contrasts between the yellow nectary, blue face and purple velvety petals make an appealing subject for the artist to paint.

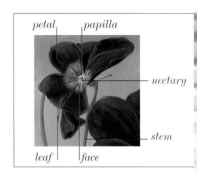

Palette

Titanium White	
Cadmium Yellow Medium	
Raw Umber	
Perinone Orange	
Quinacridone Magenta	
Carbazole Violet	
Cerulean Blue	
Green Gold	
Permanent Green Light	
Chromium Green Oxide	

sequence start to finish

Underpainting

1 Use a pencil to sketch the flowers, buds and foliage. The background is painted a light pinkish grey made of Carbazole Violet, Perinone Orange and Titanium White. Mix Carbazole Violet, Quinacridone Magenta and Titanium White, and then paint the purple part of the petals.

2 Use Cerulean Blue and Titanium White to lightly paint the face. Paint Cadmium Yellow Medium into the nectary. Then use the mixture for the purple part of the petals to paint the radiating lines in the nectary and face. Add more Titanium White to the background grey and paint the papilla.

3 Mix Green Gold and Chromium Green Oxide with Titanium White, and paint the foliage. Use Chromium Green Oxide and Raw Umber to paint the shadows in the foliage.

Using gel

4 Use a hog-bristle brush to paint gel on the background (see Using Gel on p. 22). When painting gel on the

flowers and foliage, make sure the brushstrokes follow the forms of the petals and foliage.

Building form

5 Paint the background again to cover the milky look of the gel. Mix Chromium Green Oxide, Permanent Green Light, a little Raw Umber and Titanium White, and paint the brighter parts of the foliage, smoothly blending into the lower layer of paint. Use Green Gold and Titanium White to add some soft highlights.

6 Blend varying mixtures of Carbazole Violet, Quinacridone Magenta and Titanium White into the petals to soften the look. Use a small amount of Carbazole Violet with Quinacridone Magenta to add intense shadows in the petals. Paint Chromium Green Oxide mixed with Raw Umber in the small area deep in the nectary behind the yellow splotch. Use a lot of Titanium White and a tiny amount of Quinacridone Magenta to paint small highlights on the papilla. Paint Cerulean Blue and Titanium White in the face. Then carefully blend the

transitions between the yellow nectary, blue face and purple parts of the petals. Smudge with your finger or a damp paper towel as needed.

Refining detail

7 Using the mixtures from previous steps, continue to gently refine the colour transitions in all the petals. Make sure the pattern of light on the petals is distinct. Use Cadmium Yellow Medium and a tiny amount of Perinone Orange to create a shadow in the nectary. Add a darker mixture of Cerulean Blue and Titanium White to the face. Use all the mixtures of greens in the previous steps to complete the detail in the foliage.

Finishing

8 With a small round brush, paint the highlights on the petals in Quinacridone Magenta with a lot of Titanium White. Notice how these highlights keep the soft, velvety look. Pure Titanium White highlights would be too harsh in this painting.

See also

Drawing, pages 14–17
Using Gel, page 22

special detail making soft, velvety petals

◀ *Block in the petal with the underpainting colours.*

◀ *Use Carbazole Violet, Quinacridone Magenta and Titanium White, and paint the purple part of the petals. Use Cerulean Blue and Titanium White for the shadowed areas of the face. Add more Titanium White to this mixture and soften with blended highlights. Use this mixture to blend the colour transition into the face.*

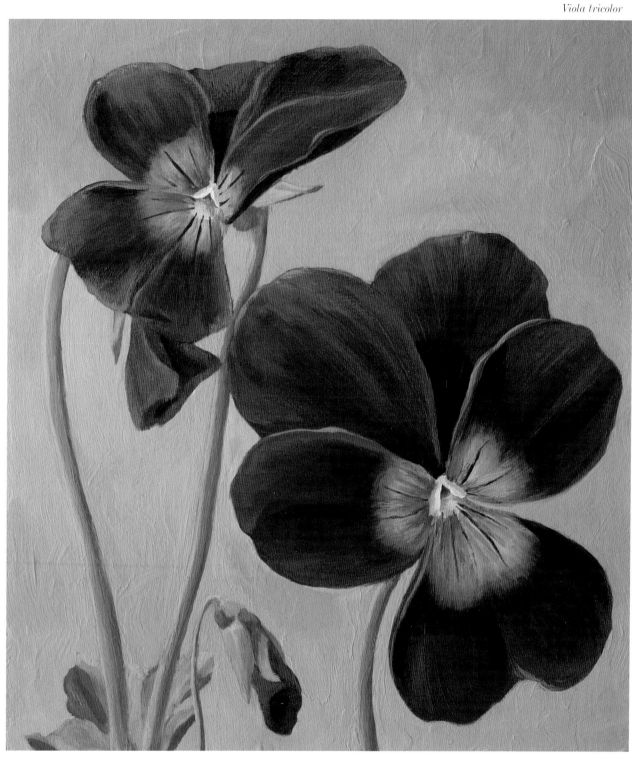

◄ Smudge the paint with your finger or a damp paper towel to give a soft look, blending into the lower layer of paint. Deepen the shadows with Carbazole Violet, Quinacridone Magenta and a little Titanium White. Softly blend into the brighter areas with this mixture.

◄ Use a Quinacridone Magenta and Titanium White mixture for the highlights. Once again, use soft blending to finish the velvety look.

Zantedeschia Calla Lily

The calla lily originates from South Africa, and is utterly elegant with its simple form outlined in gracious curves. The smooth sweep of the petal-like spathe encloses the columnar stamens, capturing shadows and holding light in the most enticing ways. When preparing to paint one of these beauties, study the direction of light and how it interacts with the definite lines of the flower. When you paint, think of the smoothness of the petals and the way shadows follow the curving shape.

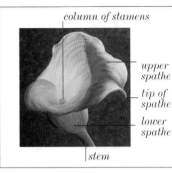

column of stamens

upper spathe

tip of spathe

lower spathe

stem

Palette

Titanium White

Nickel Azo Yellow

Nickel Titanate Yellow

Cadmium Yellow Medium

Iridescent Antique Gold

Raw Sienna

Raw Umber

Perinone Orange

Permanent Red

Carbazole Violet

Green Gold

Permanent Green

Permanent Green Light

Chromium Green Oxide

Mars Black

sequence start to finish

Underpainting

1 Use a pencil to outline the form of the calla lily. Paint the background with Iridescent Antique Gold. Use small brushstrokes in different directions to catch the light. Use Permanent Green and Permanent Red in varying mixtures of greys to paint the upper spathe. Add a lot of Titanium White to this mixture and paint the whiter parts of the spathe, blending into the shadows.

2 Mix Chromium Green Oxide, Raw Umber and Titanium White, and paint the stem and lower spathe. Use Chromium Green Oxide, Green Gold and Titanium White for the lighter part of the lower spathe. Paint a little of this mixture into the inner glowing area of the upper spathe. Use Nickel Titanate Yellow and Titanium White, and blend into this same area.

Using gel

3 With a hog-bristle brush, paint gel onto the spathe and stem, following the shape and form with the brushstrokes (see Using Gel on p. 22). Do not apply gel to the background. Allow the gel to dry.

Building form

4 Use the Chromium Green Oxide and Raw Umber mix to paint the darkest shadow of the stem and lower spathe. Paint Nickel Azo Yellow and Titanium White into the middle area of the lower spathe. Use a mixture of Chromium Green Oxide, Green Gold and a little Permanent Green Light, and paint the middle part of the stem. Add Titanium White and paint in streaks over the now dry middle part of the lower spathe. Use Carbazole Violet, Perinone Orange and Titanium White in varying mixtures of soft greys to paint the upper spathe, allowing a little of the previous layer to show.

Adding detail

5 Continue working with the previous green mixtures and paint in layers on the stem and lower spathe. Use Cadmium Yellow Medium, Raw Umber and Titanium White to paint the tip of the upper spathe. Mix Raw Umber, a tiny amount of Mars Black and Titanium White to make a brownish grey, and paint into the shadows in the upper spathe.

6 Paint a mixture of Green Gold, Cadmium Yellow Medium and Titanium White into the glowing inner area of the upper spathe. Blend Cadmium Yellow Medium and Titanium White to blend into this glowing area. Paint the column of stamens with a mixture of Raw Sienna and Cadmium Yellow Medium. Highlight with a little Nickel Titanate Yellow.

Finishing

7 Paint the highlights in the whiter part of the upper spathe with Titanium White. With a small round brush, paint a little pure Cadmium Yellow Medium along the edge of the tip of the upper spathe, then paint the Titanium White highlights on the light edge of the stem and lower spathe. Mix Perinone Orange and Cadmium Yellow Medium, and paint a few intense shadows into the column of stamens.

See also

Drawing, pages 14–17
Using Gel, page 22

special detail painting a round stem

◄ *Use a mixture of Chromium Green Oxide, Raw Umber and Titanium White to paint the stem, establishing the shadow on the left edge.*

◄ *Deepen the shadow with Chromium Green Oxide and Raw Umber. For the middle of the stem, blend a mixture of Chromium Green Oxide, Green Gold and a little Permanent Green Light into the shadow, leaving a light-coloured edge on the right.*

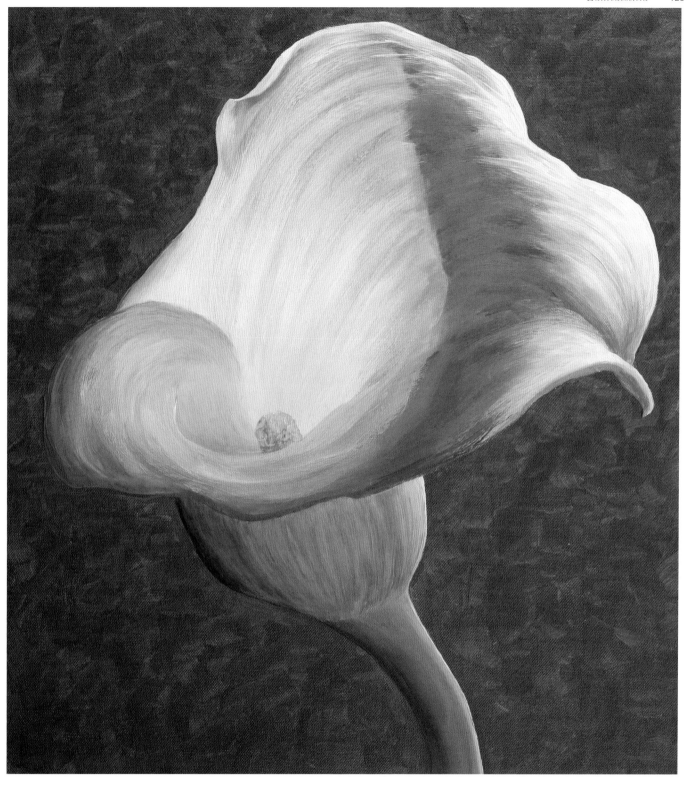

◄ *Mix Chromium Green Oxide, Titanium White and a small amount of Raw Umber, and softly blend into the stem, working from the light-coloured right edge into the middle part of the stem.*

◄ *With a small round brush, add the Titanium White highlight on the right edge.*

Zinnia Zinnia

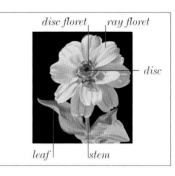

disc floret ray floret

disc

leaf stem

Looking into the disc, one can see the beautifully varied disc florets that add visual interest to the bloom, and contrast well with the ray florets radiating in layers around them. In this example, the leaves seem to ladder up to the bloom, catching sunlight as they go. Keep a constant awareness of the direction of light while painting for best results.

Palette

Titanium White

Nickel Titanate Yellow

Nickel Azo Yellow

Cadmium Yellow Medium

Raw Sienna

Raw Umber

Perinone Orange

Carbazole Violet

Indanthrone Blue

Green Gold

Permanent Green Light

Chromium Green Oxide

Mars Black

sequence start to finish

Underpainting

1 Sketch the plant in pencil. Paint the background Mars Black for maximum contrast. Use Green Gold, Chromium Green Oxide, Titanium White and a small amount of Raw Umber for the leaves and stem.

2 Mix Carbazole Violet with Perinone Orange and Titanium White to create a light grey, slightly tinted pink for the ray florets. Carefully establish the shadows. Then mix Indanthrone Blue with Perinone Orange and Titanium White to make a light grey, tinted slightly blue, and paint part of the shadows in the ray florets. In the centre of the disc paint a combination of Nickel Azo Yellow, Raw Sienna and some of the blue-grey mixture. The central shadow should be mainly dark blue-grey.

3 For the outer part of the disc, paint the disc florets with varying mixtures of Nickel Titanate Yellow, Cadmium Yellow Medium, Raw Sienna and Titanium White. Add a tiny amount of Perinone Orange for the more vibrant areas.

4 Using a hog-bristle brush, paint the gel onto the painting, following the shapes and forms of the foliage and bloom (see Using Gel on p. 22). The background can have a more definite texture. Allow the gel to dry.

Building richness

5 Paint the background Mars Black again. Mix Green Gold, Chromium Green Oxide, a little Permanent Green Light and Titanium White, and paint the brighter areas of the leaves and stem. Add Raw Umber to this mixture for the shadows. Continue painting the ray florets with both the pink and blue-grey mixes used in step 2. Softly smudge a little of the green mixture into the ray florets both near the disc and at the little splotches near the floret tips. Continue adding detail to the disc florets with the paint mixtures.

6 Use a mixture of Chromium Green Oxide, Permanent Green Light and Raw Umber to paint more distinct deep shadows in the leaves and stem. Blend the mixture of Green Gold, Chromium Green Oxide, Permanent Green Light and Titanium White into the lower layers of paint to create softly rounded forms in the leaves. Paint Nickel Titanate Yellow mixed with Titanium White into small highlights on the disc florets to create sparkle.

Finishing

7 Paint the highlighted leaf and ray floret areas with Titanium White. Drag the brush softly, using the gel texture to create sparkle. Using a small round brush, paint the Titanium White highlights on the edges of the leaves and ray florets, allowing skips and breaks, and unevenness in the strokes.

See also

Drawing, pages 14–17
Using Gel, page 22

special detail painting a richly coloured disc

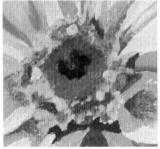

▲ *Mix Indanthrone Blue, Perinone Orange and a little Titanium White, for the central dark shadow. Around this shadow paint a mixture of Nickel Azo Yellow and Raw Sienna. Smudge some of the lighter blue-grey mixture in the upper half for a shadowed effect.*

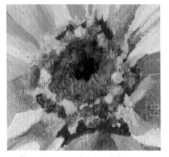

▲ *Continue working with the previous mixtures to add detail to the disc florets. Use Nickel Titanate Yellow and Cadmium Yellow Medium to add rich colour.*

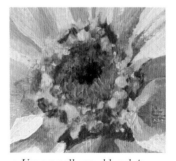

▲ *Use a small round brush to paint highlights with a mixture of Nickel Titanate Yellow and Titanium White. Use Cadmium Yellow Medium and Raw Sienna to add additional rich colour.*

▲ *With a small round brush, paint Titanium White highlights, allowing the strokes to vary in width and break in places.*

Index

Credits

Quarto would like to thank the following artists, who are acknowledged beside their work:

Jennifer Bowman
www.jenniferbowman.com

Christine Derrick
www.christinederrick.com

Parastoo Ganjei

Rebecca Henkel
www.rebecca1955.de

Hanne Lore Koehler
www.koehlerart.com

John Stoa
www.johnstoa.com